American Modernism

Graphic Design 1920 to 1960

R. Roger Remington
with Lisa Bodenstedt

Laurence King Publishing

Contents

1 2 3

Preface 6
Notes 185
Bibliography 188
Picture credits 192
Acknowledgements 192

**The Basis for the New:
The Cradle of Modernism**

1850–1899

7

**A New World Forming:
The Impact of Modernism**

1900–1919

15

**American Design
in Transition:
Traditional to Modernism**

1920–1929

33

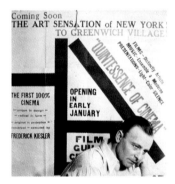

American Modernism

LAURENCE KING

Published in 2003 by
Laurence King Publishing Ltd

71 Great Russell Street
London WC1B 3BP
United Kingdom
Tel: +44 20 7430 8850
Fax: +44 20 7430 8880
e-mail: enquiries@laurenceking.co.uk
www.laurenceking.co.uk

A catalogue record for this book is
available from the British Library.

ISBN 1 85669 345 7

Designed by Brad Yendle
Design Typography, London

Printed in China

4

Into the Design Scene:
Modernism Arrives
in America

1930 – 1939

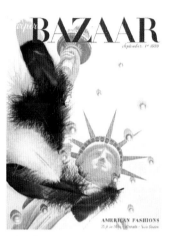

47

5

At War and After:
The Creative Forties
in America

1940 – 1949

83

6

A New Style:
American Design at
Mid-Century

1950 – 1959

135

7

Design Since Mid-Century:
Diversity and
Contradiction

1960 – 1999

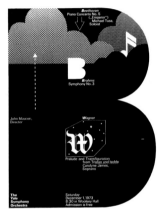

157

Preface

'The historian, too, stands in time, not above it. He has lost his pedestal in eternity ... Past, present and future are for us an uninterruptible process. However, we do not live backwards but forwards. Though the past strengthens us with the assurance that our wills are not limited and individual, the future, come what may, appears of greater consequence to us.'

Sigfried Giedion

Looking to the past, there are many ways in which the history of a profession can be viewed. One can see the history of graphic design as a series of lenses bringing into focus different points of view on the same content. One might look at graphic design history through the lens of the philosopher, the psychologist or the anthropologist. One might use cultural context, style or great circumstances as points of view. For this book, I have chosen chronology, great exemplars and master designers as a way to present, in word and image, the emergence and significance of Modernism in mid-twentieth-century graphic design in America. Woven through this content are the threads of advertising design, information design, print design, magazine design, dimensional design and identity design.

At the outset it is important to define clearly the subject of this book. The master designer Paul Rand provided the best Modernist definition of graphic design: 'To design is much more than simply to assemble, to order or even to edit: it is to add value and meaning, to illuminate, to simplify, to clarify, to modify, to dignify, to dramatize, to persuade and perhaps even to amuse. To design is to transform prose into poetry.'[1]

I have dedicated much of my career to collecting, studying and interpreting the products of the period 1920 to 1960. This motivation had two purposes: to preserve the physical artefacts of this seminal era and to present this history as a part of the education of my design students. It is my firm conviction that, without knowledge of this unique time in American graphic design, it is impossible to understand fully what happened, to have a context for what is occurring now or to look ahead with confidence.

1

1850–1899

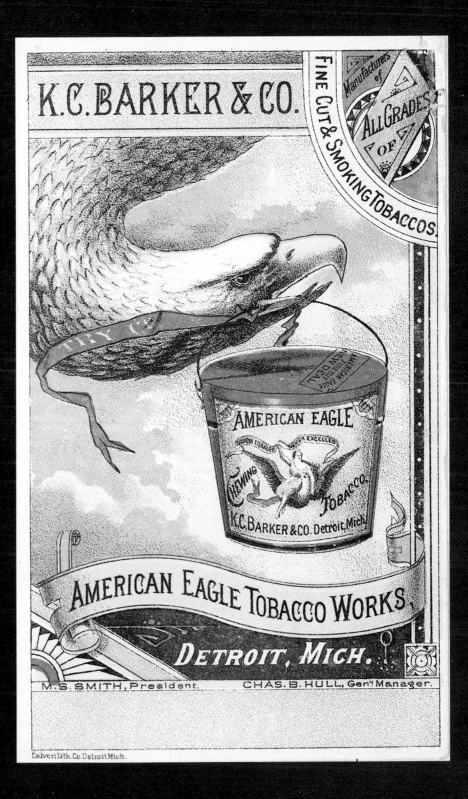

1

The Basis for the New:
The Cradle of Modernism 1850 – 1899

One's-Self I Sing
**One's-self I sing, a simple separate person,
Yet utter the word Democratic, the word En-Masse.**

**Of physiology from top to toe I sing,
Not physiognomy alone, nor brain alone, is worthy for the Muse,
I say the Form complete is worthier far,
The Female equally with the Male I sing.**

**Of life immense in passion, pulse, and power,
Cheerful, for freest action form'd, under the laws divine,
The Modern Man I sing.**

Walt Whitman, *Leaves of Grass* [1]

THE MECHANICAL PARADISE

In the 1800s, America mirrored the rest of the world – it did not have its own national identity. The dominant influences of the era were the emerging technological revolution and the entrenched Victorian values. Both of these factors were present in the style of American design of the 1800s. The expatriate writer Gertrude Stein, when looking homeward, said of America, 'There is no there there.' [2]

The years between 1880 and 1930 were characterized by the art critic Robert Hughes as 'the mechanical paradise'. [3] The progress and achievements of the Industrial Revolution were demonstrated in Britain's Great Exhibition of 1851, perhaps the most spectacular physical manifestation being the Crystal Palace designed by Sir Joseph Paxton. Britain's 'cathedral of the machine' was a transparent building of glass walls held together by the finest of iron frameworks. [4] A new technology had brought into being a new aesthetic of lightness. This exhibition began a tradition in which World's Fairs and expositions would signal new directions in design, particularly in art and architecture; in a larger sense, these international events introduced new social, political and economic ideas as well.

As the Crystal Palace became the symbol of the Industrial Revolution, so, forty years later, at the Paris World's Fair of 1889, the French unveiled their monument to manufacture, technology and transformation: the Eiffel Tower, designed by the engineer Gustav Eiffel. The structure represented the triumph of the modern present over the traditional past. In Paris in the 1890s, 'You could not escape the tower.' [5] Then and now, the tower remains a unique structure that dominates the skyline, and indeed has become the symbol of the city. The Eiffel Tower served as a dominant beacon of Modernism until 1925, when the Exposition des Arts Décoratif more widely publicized the new.

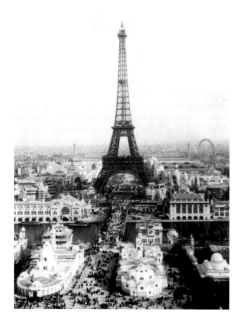

Above The icon of modernity and the machine age, the Eiffel Tower's radical form dominated the Parisian landscape, then as now.

Opposite Americans have always been patriotic people. This American eagle design was cut from wood and was a popular addition to posters and printed matter in the late 1800s.

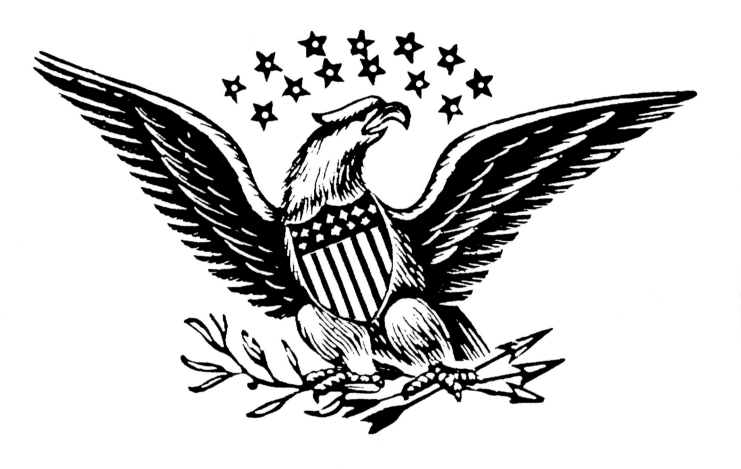

Below The railroad in America was a great manifestation of the industrial revolution. Through this transportation the separate coasts of America were joined and millions of immigrants and others were able to settle. This colourful advertising poster from 1840 was a showcase of the many beautiful woodtype fonts available for poster printers.

Right In 1890, the latest picture-taking technology could be yours for $25. Manufactured by the Eastman Dry Plate & Film Company in Rochester, New York, the Kodak camera was user-friendly, promising 'anybody can use it'. And they did.

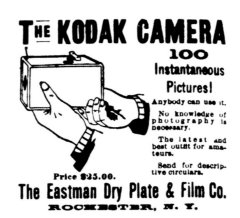

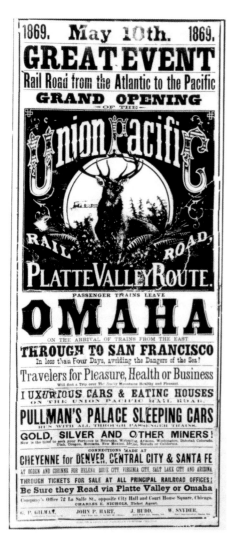

The availability of energy fuelled the Industrial Revolution, beginning in the late 1700s with Watts's steam engine. The progress in industrialization caused many people to leave their rural lives and move to towns and cities in order to gain work in the new factories and industries. This influx caused cities to expand, wealth to increase and communications to improve. Science, in this era, also supported the development of technology. Political power shifted from the landed gentry to the capitalists – with supply and demand being the new rule. This growth inevitably led to a widespread optimism and an accelerated rate of change in all areas of human discourse. Just looking at the twenty-two-year period between 1883 and 1905, the global changes and innovations are staggering:

1883	Invention of the first synthetic fibre
1884	Steam turbine
1885	Coated photographic paper
1888	Kodak camera
	Pneumatic tyre
	Electric motor
1889	Cordite (dynamite)
1890	Movies and sound recording
1892	Diesel engine
1893	Ford automobile
1894	X-ray
	Radio telegraphy
	Motion picture camera
1903	Wright Brothers' airplane
1905	Einstein's Special Theory of Relativity

Unfortunately, with these changes came heavy social costs such as low pay for workers, tenement housing, unhealthy and unsafe working conditions and

excesses in child labour. In the main, mechanical processes were replacing the traditional handicrafts, mass production wiping out cottage industries. The French painter Fernand Léger wrote, 'The machine has altered the habitual love of things.'[6] The Industrial Revolution ushered in more materialistic and social interests as well. In England, Charles Darwin wrote *On the Origin of Species* while in Vienna, Sigmund Freud probed the human psyche. Caught up in this new environment and in the hopeful prospects of a new century and great prosperity, creative people in Europe not only saw change as possible but as something they could implement themselves.

THE VICTORIAN ERA

Queen Victoria's rule in Great Britain spanned two-thirds of the nineteenth century and ran concurrent with the beginnings of the Industrial Revolution. This era was exemplified by the qualities of strength, morality and religion, and the Victorians sought a design form to symbolize their times. This process was difficult, and, as has been true in other periods, contradictory opinions arose. Some preferred looking to the past while others wanted to look ahead to the future of technology. The majority looked back to ornamental styles of the past, particularly the medieval period, for a solution. The Victorian love of decoration was exemplified by Owen Jones in his book, *The Grammar of Ornament*, published in 1856. Jones identified the dominant syntax of Victorian style as being characterized by complexity, natural forms, fussiness, decoration and a love for the ornamental. Against this aesthetic and in reaction to this culture, Modernism was to establish its foundations.

TOWARDS AN AMERICAN STYLE

In the 1800s the United States did not have its own national cultural form – it relied instead on the prevalent Victorian style from Britain and Europe. As the century progressed, with more and more technological innovations came the need for the design and production of visual communications forms. The communications environment created by popular advertising, posters, newspapers, magazines and print materials was directly tied to the dominant style of the times, to the realities of reproduction technology, the railroad and to America's dynamic growth westwards to the Pacific.

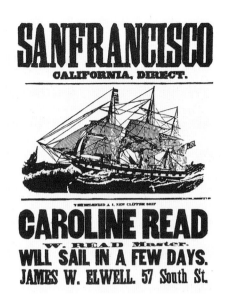

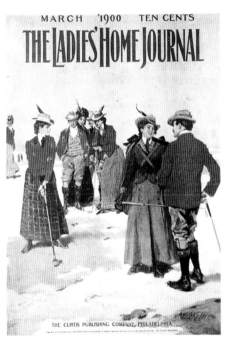

Above top In the 1850s, Americans were busy trying to fill the great spaces available in North America. Many were also eager to get to California to mine for gold and become instantly rich. A fast way to make this trip was by clipper ship around South America. This poster from the 1850s was advertising the clipper, *Caroline Read*. The poster is composed of period wood types and a woodcut illustration of the ship.

Above bottom *The Ladies Home Journal* magazine was popular among Americans around the turn of the century. It featured literature and news articles of interest in this era which was influenced by the Victorians. This cover appeared in 1900 and idealized the American woman as trim, fashionable and sporty.

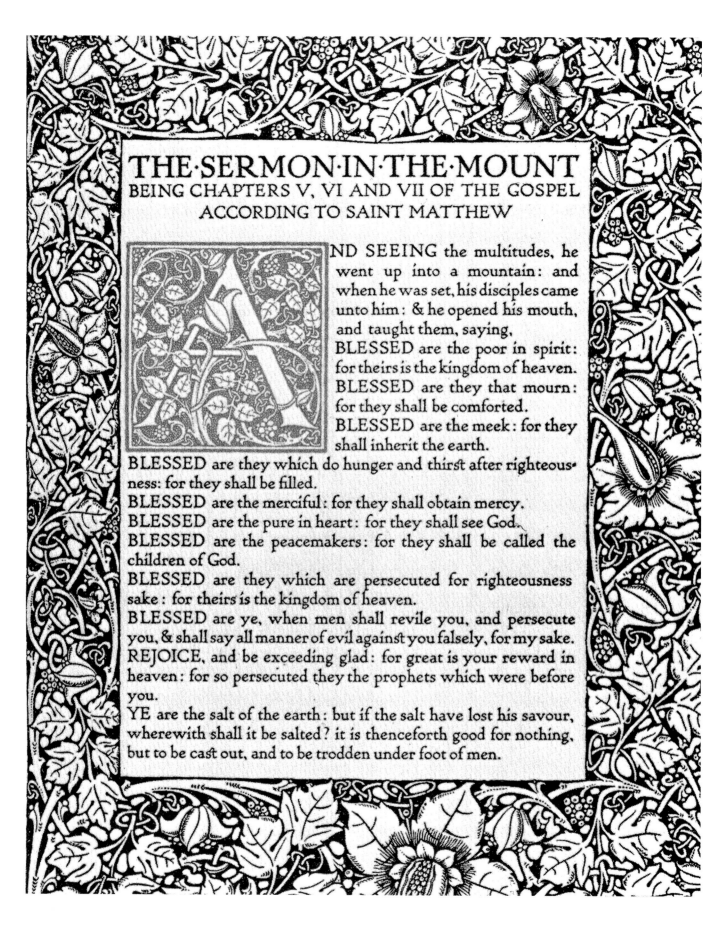

THE·SERMON·IN·THE·MOUNT
BEING CHAPTERS V, VI AND VII OF THE GOSPEL
ACCORDING TO SAINT MATTHEW

AND SEEING the multitudes, he went up into a mountain: and when he was set, his disciples came unto him: & he opened his mouth, and taught them, saying,

BLESSED are the poor in spirit: for theirs is the kingdom of heaven.

BLESSED are they that mourn: for they shall be comforted.

BLESSED are the meek: for they shall inherit the earth.

BLESSED are they which do hunger and thirst after righteousness: for they shall be filled.

BLESSED are the merciful: for they shall obtain mercy.

BLESSED are the pure in heart: for they shall see God.

BLESSED are the peacemakers: for they shall be called the children of God.

BLESSED are they which are persecuted for righteousness sake: for theirs is the kingdom of heaven.

BLESSED are ye, when men shall revile you, and persecute you, & shall say all manner of evil against you falsely, for my sake.

REJOICE, and be exceeding glad: for great is your reward in heaven: for so persecuted they the prophets which were before you.

YE are the salt of the earth: but if the salt have lost his savour, wherewith shall it be salted? it is thenceforth good for nothing, but to be cast out, and to be trodden under foot of men.

In the world of typography and printing, the ornamental letter became a symbol for the era, 'mirroring the values of the Victorians in its vitality, ingenuity and love of ostentatious display. The great number of decorative typefaces in American print shops indicated the taste of the rising middle class and the nouveaux riches. The subject matter frequently reflected the political and industrial attitudes of the era.'[7] Frederick W. Goudy was a typographer who designed his first font in 1903. In his private press printing he used modern letterpress technology, but his aesthetics were rooted in the tradition of William Morris, the leader of the Arts and Crafts Movement in England. Medieval patterns and natural forms predominated. Commercial artwork was supplied by illustrators, the best of whom had been trained at fine-arts schools. The technology of printing continued to control the look of publications. By 1840, a process called chromolithography allowed images in multiple colours to be printed from separate polished stone surfaces. The use of colour printing enhanced posters – particularly those representing the consumer products of the Industrial Age. Advertising had entered the modern world.

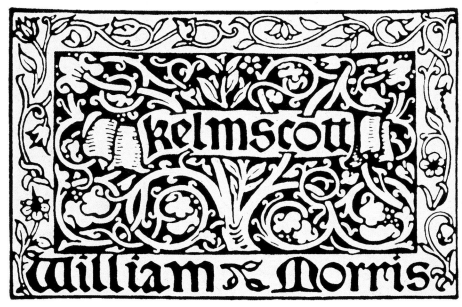

Opposite Frederick Goudy was a prolific American type designer and printer. This page is from a bible that he illustrated and designed in 1918. The page is reminiscent of William Morris's work and shows the strength of traditionalism in design and printing in the United States and the ambivalence of many to the potential of Modernism. Throughout the 1920s there was a duality – one group clinging to the traditional while another was ready to embrace the influence of the European avant-garde.

Above left In England William Morris was a great creative spirit whose ornamental style was influential in the era of the Arts and Crafts movement. Among his many talents was an interest in type and book design. Shown here is the trademark for his private press – the Kelmscott Press – from 1892. The traditional style of this mark was typical of Morris's work in its decorative and ornamental form.

Above right Victorian form was evident in American graphics through many decorative letterforms of the mid-1800s, produced from wood by a pantagraph machine. There were more than 20,000 decorative fonts available to printers. The majority were designed by anonymous craftsmen and reflect the beauty of ornamental print form.

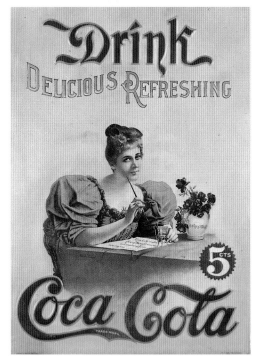

Above left In the mid-1800s, the printing process of chromolithography allowed American food companies to package their products in colour containers which, in many cases, also served as advertisements. The designs often used decorative types and represented popular themes such as patriotism.

Above right Invented in 1886 by Atlanta pharmacist John S. Pemberton, Coca-Cola has become one of the most recognizable logos throughout the world. The original calligraphic-style logo was drawn by Frank Robinson, Pemberton's book-keeper. The logo – drawn in a typical Victorian script – has stood the test of time and remains appropriate and popular to this day.

A NEW PROFESSION FOR A NEW CENTURY

In 1913, the French author Charles Pegay wrote, 'The world has changed less since the time of Jesus Christ than it has in the last thirty years.'[8] The innocence and values of the 1800s were lost as technological developments brought about irreversible changes in society. The mechanical Victorian era was transformed into one of the astoundingly brilliant periods of creative expression in the first third of the twentieth century. The new century was shaped by individuals and events, as Walt Whitman wrote, 'full of passion, pulse and power to bring forth the best and the worst in man'.[9]

By the end of the eighteenth century, the quantity of information and images had grown almost out of control and it became clear that there needed to be a specific profession to take control of all this material. Graphic design came into being at this time, but even as late as the 1960s it was still being called an emerging profession with its roots in commercial art and printing. Artists, architects and printers have their histories, but graphic designers have had to wait longer for theirs. The term 'graphic design' was only coined in 1922, and it was not until 1983 that the first book was published providing a comprehensive historical overview of the field. The history of the field is an amalgam, drawing from other histories which were its sources: art, printing, typography, photography and advertising. Author Robert Jensen described graphic design as 'a mongrel of sorts, but a very important mongrel'.[10]

sutnar

nejmenší dům

A New World Forming:
The Impact of Modernism 1900 – 1919

'Is it not our duty to find a symphonic means to express our time, one that evokes the progress, the daring and the victories of modern days? The century of the aeroplane deserves its music.'

Claude Debussy

THE CULTURE OF NEWNESS

Modernism was more than just the name of a style. It was a philosophy, a view of life, a state of mind. In its broadest sense, Modernism delivered what Frank Lloyd Wright advocated when he said that what was most necessary in architecture was a philosophy, not an aesthetic. Modernism emerged after 1900 as a radical rejection of the traditional values of the Victorians. Everything Victorian was discarded in a dramatic move among progressive thinkers towards a simpler way that was seen as more fitting to the new twentieth century. 'To smash the old visual language and create a new one were the professed aims of the Modernist artist.'[1] Just as the Victorians had embraced complexity and embellishment, the Modernists advocated simplicity. The painter Hans Hofmann said, 'The ability to simplify means to eliminate the unnecessary so that the necessary may speak.' These visionaries also looked for a new kind of functionalism in what Hofmann called 'the necessary'. A new spirit of innovation was in the air and present in all the art and design. By the end of World War I, creative graphic designers, artists and architects were challenging the established forms. The poet Ezra Pound summed it up when he said, 'Make it new!'

MODERNISM IN GERMANY

In Germany, World War I also brought an end to the traditional values and society that had existed in the Prussian Empire. Berlin became a modern, cosmopolitan city which spawned the German Expressionist movement. The group of artists called *Die Brücke* (The Bridge) included Ernst Ludwig Kirchner, Karl Schmidt-Rottluff, Otto Mueller and Max Pechstein. Apocalyptic visions, eroticism and the experiences of World War I were vividly depicted in the paintings and graphic work of Otto Dix, George Grosz and Ludwig Meidner. German Expressionism, in the postwar period, faced head-on the brutality of life, whether it be war, love, sex or death. Dix, Grosz and Beckmann also criticized and unmasked the conditions of the Weimar Republic. Another reaction to the upheavals of the postwar period was the Dada movement. The work of Hannah Hoch, Raoul Hausmann,

John Heartfield, Kurt Schwitters and George Grosz took an ironic and cynical view of society and its values. With an inflammatory and revolutionary view, their art attacked the state, church and military with uncompromising means. Despite the negativity of much postwar art, from all of the turmoil, ashes, rubble and disorganization following World War I came a natural desire for reconstruction, for the creation of a new world based on purer principles. Thus was born in Modernism a utopian view, implicit with the glamour of making something different and new.

Paris was another European capital that created its own version of the new spirit. A cultural depot through which the world's artists and art movements passed, Paris became the centre of the greatest period of artistic ferment in modern times. The Eiffel Tower, that magnificent realization of the industrial age, was a constant reminder of modernity. Now every person could rise into the heavens in this steel tower and expand for the first time his or her viewpoint from high above Paris. Baron Hausmann's rebuilding of Paris along modern and orderly lines paved the way for a truly contemporary city which placed its faith in technology and innovation. Modern architecture flourished alongside art, advertising and design.

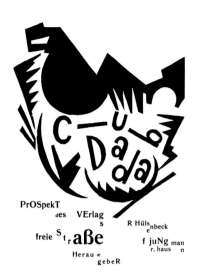

Raoul Hausmann designed this cover for the prospectus *Club Dada* in 1918. Letters, words and shapes tumbled about the cover in what first appeared to be an abstraction but upon reflection became readable. The design perfectly suited the Dada convention of breaking every rule when using words and letters in communication.

THE NEW GUARD

Only in certain European countries did anyone want to produce modern design. Those were countries which had undergone the most dramatic social changes after World War l, particularly Germany and Austria. It also applied to countries which had always had a more fluid internal social structure, where traditions were not so oppressive, such as Holland, Switzerland, Czechoslovakia and Scandinavia. The impetus of the European avant-garde movements in art provided the foundations for the new approach of Modernism in design.

In Russia, the Constructivists sought to disseminate their aesthetic from art into theatre design, poster design, fashion and technology. In France, interests centred more on art, and modern design was limited to a few patrons. In Italy, the Futurists created art, graphic design and architecture inspired by motion and the machine. This dynamic style was characterized as 'Cubism in motion'. In contrast, for most English-speaking countries, Modernism had, as yet, hardly awakened.

In Paris, designers were inspired by the Cubist artists Picasso and Braque, who provided new ways of viewing reality in their art. Their paintings represented three-dimensional objects in such a way that at once simultaneous views were possible in the same plane. Cubism, through its ambiguity of form, was but one art movement at this time that totally rejected traditional ways. Other groups were breaking barriers and accepted boundaries. Manifestos popped up all over Europe, heralding the beginning of new avant-garde groups. Architecture was revolutionized by a new aesthetic

I FUTURISTI PER FIUME ITALIANA
(LA MARCIA DI RONCHI)

Documenti della Marcia su Roma

MARIO CARLI, Capo degli Arditi, sansepolcrista, testa di ferro

Futuristi

GIORNATE del 19: I futuristi Bottai Bolzon, Rocca, D'Alba, Chiti ecc.

MINO SOMENZI
direttore - responsab.

TIP. S.A.I.G.E. - ROMA
Via Cicerone 44

F. T. Marinetti · Mario Carli · Mino Somenzi

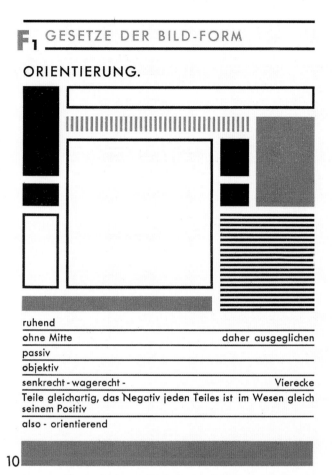

ORIENTIERUNG.

ruhend	
ohne Mitte	daher ausgeglichen
passiv	
objektiv	
senkrecht - wagerecht -	Vierecke
Teile gleichartig, das Negativ jeden Teiles ist im Wesen gleich seinem Positiv	
also - orientierend	

10

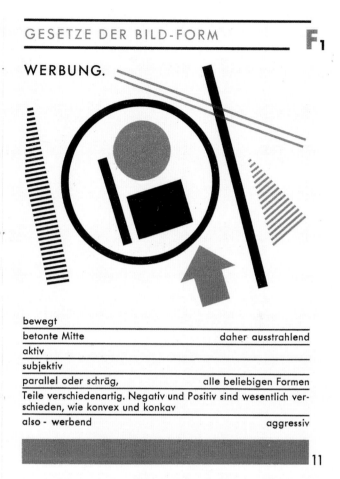

WERBUNG.

bewegt	
betonte Mitte	daher ausstrahlend
aktiv	
subjektiv	
parallel oder schräg,	alle beliebigen Formen
Teile verschiedenartig. Negativ und Positiv sind wesentlich verschieden, wie konvex und konkav	
also - werbend	aggressiv

11

Opposite This design was for the back page of a Futurist newspaper titled *Futurismo*. It was produced in 1938 by Mino Somenzi and was an example of how Modernist graphic design approaches could be used in creating a complex but powerful printed page in support of Fascism in Italy before World War II. This effect is achieved through the complex directional juxtapositions of small text type, bold headline types and colour.

Above This page is from a small booklet designed by Kurt Schwitters in 1930 in an attempt to codify the principles of avant-garde graphic design and advertising. The booklet was in effect a manifesto in which a forceful message was presented to unify standards in the way graphic design (information) and advertising were made. Conceived as one of a series, the booklet included on its back cover a series of principles, entitled 'Typographic Topography', contributed by the Russian Constructivist designer El Lissitzky. Among his offerings from his publication *Merz* was 'The words on a printed page are seen and not heard.'

Overleaf Several avant-garde designers created dynamic advertisements for Pelikan Ink. This ad from 1924, designed by Kurt Schwitters, features dominant directional arrows to control the visual flow on the magazine page. Another Pelikan ink ad, by the Russian Constructivist El Lissitzky, can be seen on page 29.

93

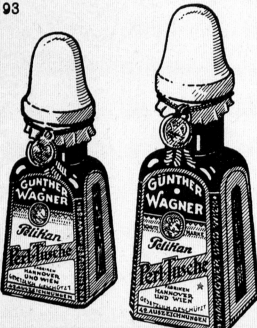

Nr. 302 Nr. 301

PELIKAN-TUSCHE

Unantastbare Güte verschaffte der Pelikan-Tusche ihre große Verbreitung. Stets einwandfreie Gleichmäßigkeit wird ihr die führende Stellung bewahren. Der Pelikan wacht mit ganz besonderer Sorgfalt über diesem, seinem schwarzen Jungen und seinem Geheimnis. Die besonderen Vorzüge der schwarzen Pelikan-Tuschen sind : ▶ die tiefe, gleichmäßige, deckende Schwärze und damit ihre besondere Eignung für Zeichnungen, die vervielfältigt werden sollen; ▶ die völlige Wasserfestigkeit, die ein Übermalen mit Aquarellfarben, ja selbst ein gründliches Abwaschen zuläßt; ▶ die unbegrenzte Haltbarkeit im Glase, die große Leichtflüssigkeit und das lange Flüssigbleiben in der Reißfeder; ▶ die Möglichkeit, die dünnsten Linien auszuzeichnen, ohne daß die Linie Unterbrechungen zeigt oder ausläuft; ▶ die große Radierfestigkeit; ▶ die Lichtbeständigkeit; ▶ die Verdünnbarkeit mit abgekochtem Wasser bis zum hellsten Grau. ▮ Farbige Pelikan-Ausziehtuschen sind von unerreichter Leuchtkraft und Reinheit der Farben; sie werden in 32 Farbtönen geliefert.

Pelikan

TUSCHE IST DIE FÜHREN

MARKE DER WEL

PELIKAN TINTE

94

SIGNETENTWURF FÜR DAS WORT PELIKAN VON KURT SCHWITTERS →

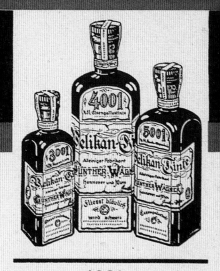

4001 Beste Buch- und Schreibtinte. Eisengallustinte, fließt bläulich, wird tiefschwarz. Liefert Schrift von unbegrenzter Dauer. Angenehm leichtflüssig.
5001 Buch- und Kopiertinte. Eisengallustinte, fließt bläulich, wird schwarz. Liefert auf der Kopierpresse 2 bis 3 Kopien. Kann auch in Büchern verwandt werden, ohne darin abzuklatschen.
3001 Starke Kopiertinte. Echte Blauholztinte, fließt violett-schwarz. Schrift und Kopien dunkeln schwarz nach. Gibt auf der Kopiermaschine 3 bis 6 Kopien. Auch nach längerer Zeit noch kopierfähig. Nicht für Bücher bestimmt.

3001 4001 5001

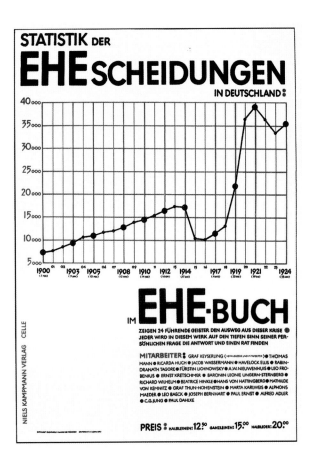

sensibility that went hand in hand with new technologies. Le Corbusier first made the world aware of the Modernist style in architecture with his Citrohan House, designed in 1922. The structure was an architect's vision for an aesthetic devoid of historicism and ornamentation. In addition to Le Corbusier, the architects J.J.P. Oud, Walter Gropius and Mies van der Rohe pioneered modern architecture.

Jan Tschichold made major contributions with his 1928 book *The New Typography*, where he codified principles of Modernism as they applied to typography, printing and the graphic arts. These rules included asymmetric page organization, use of photography rather than illustration, use of primary colours and the adoption of sans serif typefaces, primarily the font Futura. In Germany in 1927, a band of designers led by Kurt Schwitters and Jan Tschichold came together to form the *Ring neue Werbegestalter* or 'circle of new advertising designers'. This group included Willy Baumeister, Walter Dexel, César Domela, Max Burchartz and the Dutch designer Piet Zwart. These typographic designers believed in a new approach to typography and graphic design. Scattered around Germany's major cities, they became advocates for this progressive typographic style by showing their work in exhibits, holding meetings and conferences and practising what they preached in their print work. Important to their Modernist views was

mitteilungen

typographische

zeitschrift des bildungsverbandes der deutschen buchdrucker leipzig ● oktoberheft 1925

sonderheft

elementare typographie

natan altman
otto baumberger
herbert bayer
max burchartz
el lissitzky
ladislaus moholy-nagy
molnár f. farkas
johannes molzahn
kurt schwitters
mart stam
ivan tschichold

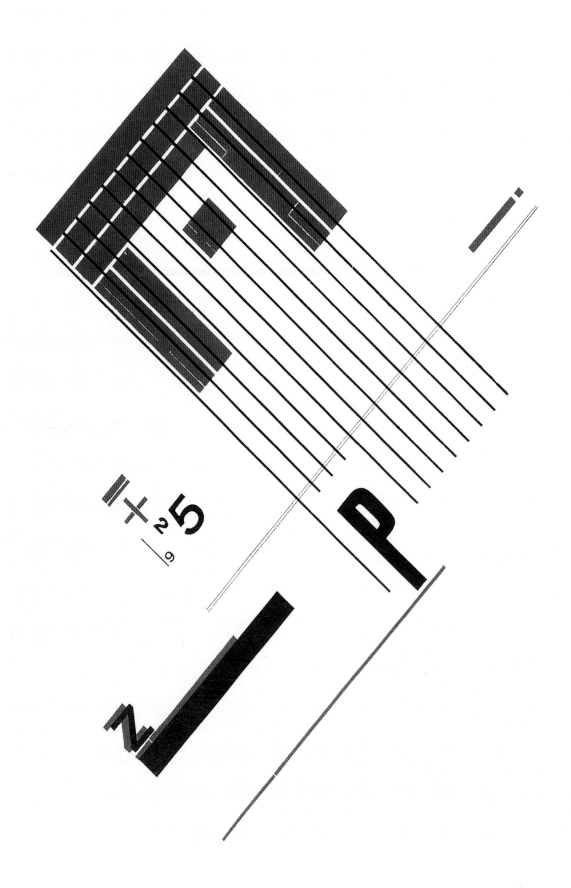

Opposite Piet Zwart was a great experimenter with typography. This page from 1925 was an experimental, limited-edition composition in which he arranged letters, ruled lines and bars from the printer's type case. The diagonal layout provided a dynamic framework in which Zwart arranged the elements with great logic and order. In his typographic portfolio, *The Avant-Garde in Print*, scholar Arthur A. Cohen wrote, 'The master designers were masters, serving the ends of an aesthetic functionalism in the transmission of a language of dynamic, asymmetric, simplified, clear typography where the line between words and forms, type and painting, was diminished and the goal of direct communication elevated as never before.'

Below left Walter Dexel was an important graphic designer in Jena, Germany, in the 1920s and 1930s. A member of the *Ring neuer Werbegestalter*, Dexel advocated the 'New Typography' approach championed by Jan Tschichold. This poster from the 1930s shows the use of Futura types, bold graphic interval bands to organize the format and negative/positive typographic forms.

Below right This poster was designed by Piet Zwart in 1924/5 for a real estate office in The Hague. Zwart was a leader of the Dutch avant-garde and was strongly influenced by the Russian Constructivist designer El Lissitzky to broaden his views beyond those of his native De Stijl movement to wider currents of the graphic design of the period. The small poster was effective because Zwart arranged the text in a manner that maintained its legibility while holding the interest of the viewer by the added colour, lines and shapes.

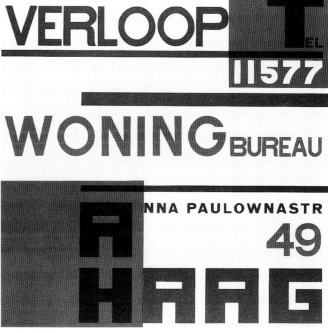

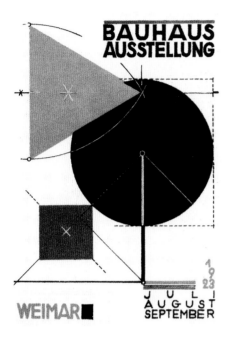

Above This poster was designed to promote the Bauhaus during its first phase in Weimar, Germany. In 1923, designer Herbert Bayer used geometric shapes, basic colours and constructional lines as dominant forms in the composition. It epitomized the Bauhaus interest in simple, pure form and became a classic exemplar of Modernist graphic design which emerged from the Bauhaus.

Opposite Herbert Bayer designed this booklet cover for the Bauhaus in Dessau, Germany in 1928. The dynamically silhouetted photograph of the residence part of the Walter Gropius Bauhaus building highlighted the small balconies which protrude from each room. The cover represented the manner in which Bayer integrated photography as an important imaging element to the typography and colour. In the design, note that the right edge of the building aligned with the letter 'S' in the name Bauhaus to create an important format axis.

the idea of production. Along with many other Modernists, the Ring neue Werbegestalter designers treated the techniques of manufacture not as neutral, transparent means to an end, but as devices equipped with cultural meaning and aesthetic character. For these graphic designers, Futura was the required type font. As Kurt Schwitters said, 'Futura is the appropriate typeface in all sizes and all styles for all purposes.' Henryk Berlewi, a Polish-born avant-garde typographer, wrote that advertising design 'must rest on the same principles as prevail in modern industrial production'.[2] Eventually the Nazis labelled this typography alien, proto-Communist and un-German. Many viewed it as a major new direction for the printed page.

The Constructivists in Russia were a major creative support to a new social and political order through an aesthetic based on structure. Karl Tiege of Prague formulated the main principles of Constructivist or 'The New Typography': a freedom from tradition, the use of geometric types, design following content, organized and structured pages (using the Golden Section/ Golden Mean), a preference for photography over illustration and a close working relationship with printers. The formation of the Deutscher Werkbund in 1907 had given progressive designers the organized support of industry and the crafts for exhibitions, publications and meetings. In Holland, a group called *De Stijl* (The Style) attempted to simplify form in the most pure, basic and concrete way possible. For its members, the vertical and the horizontal became the standard. The Bauhaus, a progressive school in Germany, taught that all art and design lived in a matrix of craft that one learned by doing, and that all the arts should be unified. The teachers at the Bauhaus were among the most progressive artists, designers and architects in Europe, namely Johannes Itten, Josef Albers, Wassily Kandinsky, Laszlo Moholy-Nagy, Paul Klee, Herbert Bayer and Walter Gropius. The Bauhaus building in Dessau featured simple geometric form and walls of glass. It was designed by Gropius in 1926, and remains the 'crystal cathedral' of Modernism.

THE MODERNIST CANON

Public interest and receptivity to Modernism were reflected by the themes of large and influential exhibitions in Europe. Although Art Deco forms had predominated from the 1925 Paris Monza and the first Milan Triennale exhibition, architecture, interior design and product design attracted the most attention. This change was heralded by Le Corbusier's Pavillon de l'Esprit Nouveau at the Paris Exposition des Arts Décoratifs in 1925.

One of the great benefits of Modernism was that it offered a clearly defined set of criteria with which to judge the worth of any design. Prominent among its rules was that geometric forms represented the modern world more accurately and purely than any organic shapes; in this it was clearly differentiating itself from the ideals of the Art and Crafts Movement and Art

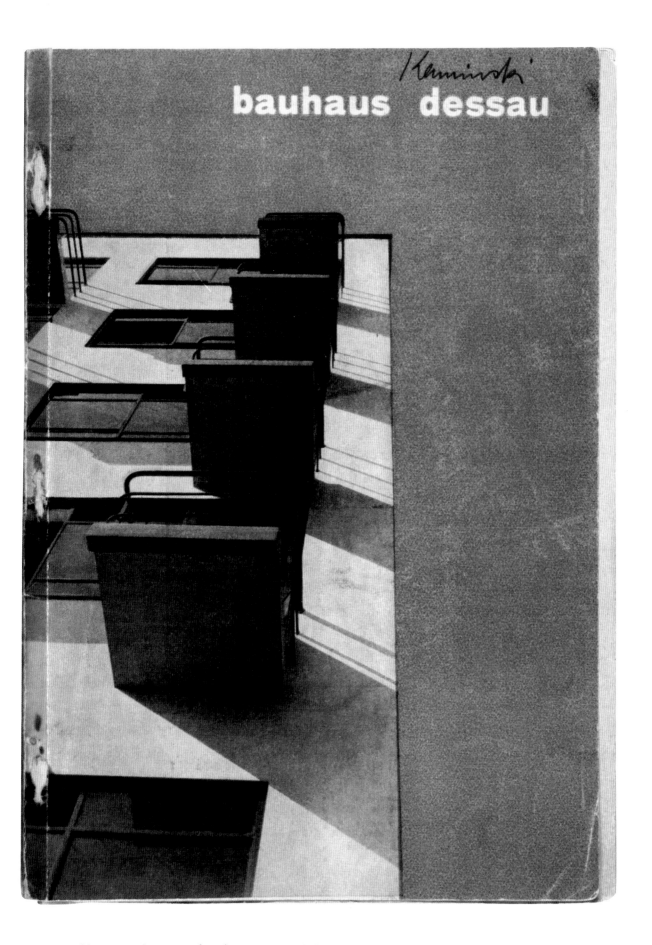

bauhaus dessau

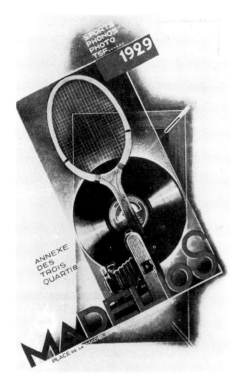

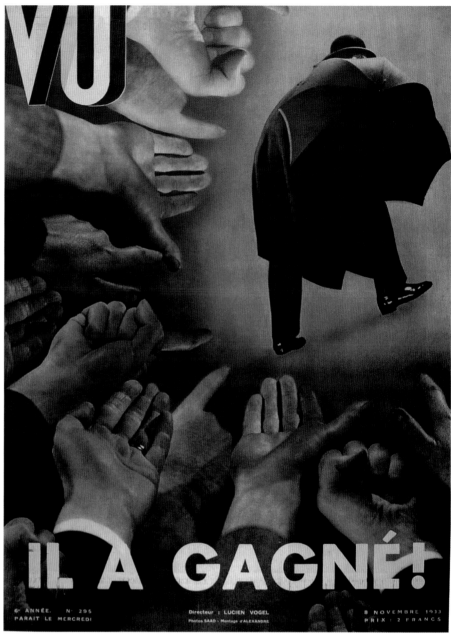

Above Alexey Brodovitch, while establishing his career in Paris in the late 1920s, designed advertisements and catalogues for Madelios, the men's boutique of the Parisian department store Aux Trois Quartiers. He utilized a dramatic diagonal axis to unify the layout. The treatment of the imagery mirrors the Modernist form of the Purist art movement and is reminiscent of the paintings of Le Corbusier and Ozenfant. It also reflects an Art Deco influence.

Right Alexander Liberman designed this cover for the weekly magazine *VU* in Paris in 1933. An early periodical in which photography was predominant, *VU* became a model for what was to soon be popular 'picture' magazines in America such as *Life* and *Look*. Liberman emigrated to the United States in 1940, and for many years was creative director at Condé Nast Publications, including *Vogue* magazine.

Nouveau. Important crossover figures moved around Europe, visiting artists, schools and groups and making them aware of new work and movements. El Lissitzky, the Russian Constructivist artist and designer, was one such influence. Because he knew several languages, he was able to travel widely through Europe, synthesizing and scattering Modernist ideas in new places as he visited the Dadaists, the Bauhaus and the De Stijl group. The author and critic Arthur A. Cohen has called Lissitzky, 'clearly the breakaway figure of the Russian avant-garde', because he was able to synthesize what was going on around him and express the concepts in his own work and to others on his travels. In this way an infrastructure of the Modernists arose. This 'culture of

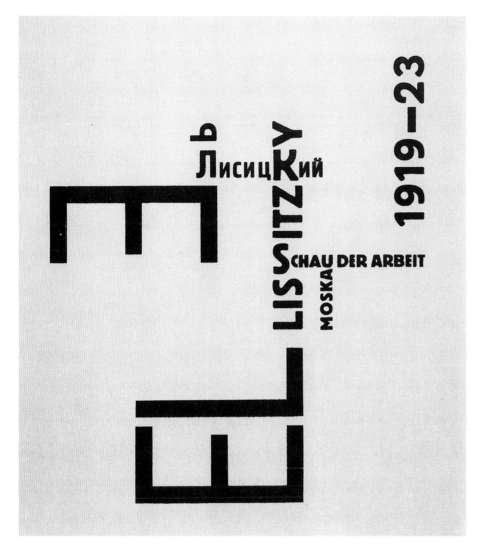

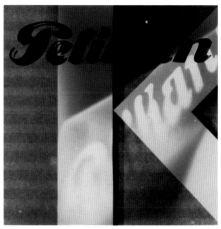

Left This piece was an announcement flyer for an El Lissitzky exhibition in Berlin in 1923. The typographic design is a clever one in which Lissitzky intermixes the Roman and Cyrillic versions of his name and shows how a functional solution to a graphic design problem can be solved with only typographic means.

Above Among other European avant-garde designers, El Lissitzky created imaginative and experimental advertisements for Pelikan Ink. This piece from the 1920s evidenced a visual dynamic in strong angular postures with a combined focus on both Pelikan and Kohlen Papers. Lissitzky applied a useful redundancy concept by showing the Pelikan logo at the top but also in an indexical, shadow effect below, combining it in an orderly manner with the bold letter 'K.' This ad provided clear evidence of Lissitzky's strong sensibilities as a graphic designer in bringing together photography and typography.

newness' was best represented by the unity of spirit in all creative forms in the primary sense of the Bauhaus mission. The canon of Modernism held that whatever the medium, there will be unity, and that form should follow function.

MODERNISM AND GRAPHIC DESIGN

Modernism employed core values but found expression differently in various art and design forms. In 1931, the American architect Philip Johnson described Modernist architecture as, 'The style that is characterized by flexibility, lightness and simplicity. Ornament has no place. Hand-cut ornament is impracticable in the machine age. The beauty of the style rests in the free composition of volumes and surfaces, the adjustment of such elements as doors and windows, and the perfection of machined surface.'[3]

How did the abstract ideals of the Modernist work become translated into tangible graphic form? Was there a 'look' to Modernism? In graphic design, Modernism was not a style but a particular set of principles that, when applied, provided the basis for understanding the movement. It became

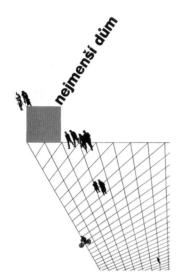

This jacket for the book *Nejmensi dum* (*Minimum Housing*) was designed in 1931 by the Czech Ladislav Sutnar. Influenced by Karel Tiege, Sutnar was a major force in the Eastern European avant-garde. This design synthesized his Modernist approach in its use of sans serif type, the integration of the red square, the linear space frame and the ambiguous manner in which the miniature human figures are placed on the frame.

a formalism, a set of rules, methods and practices which together defined a visual form acceptable to a group of people. These principles include a concern for functionality and a demand that designed pieces reflect their context and content. Another principle holds that the look of a piece honestly reflects the method by which it was printed. Simplicity must be necessary for perceiving form in the Machine Age. The organization of the printed page should reflect a dynamic layout, fitting for modern times. Modernism rejected the past in order to break out into a future of pure, abstract and universal form. Excluding reference to the past, it offered a fresh beginning. The designer Ladislav Sutnar characterized it as 'interest–simplicity–performance'. The German artist and designer Kurt Schwitters stated that design was a logical, deliberate arrangement of text and image form; it was also the creation of relationships in word and image in such a way that they were convincing through their quality and arrangement. Design was unity out of plurality through selection, restriction, structure and rhythm. Generally, Modernist graphic designers believed in a freedom from the past, the exclusion of any decoration, a recognition of the age of the machine and the utilitarian purpose of typography.

THE SYNTAX OF MODERNISM

Modernism has been generally recognized by its simplicity, unbroken lines, the application of pure colours, contrasts in light and shadow and an honesty of materials. In the new language of graphic design, these radical character-istics defined Modernism:

Process values
· to reject traditional forms and decorative elements
· to seek a solution that was simple and direct
· to be concerned with the process by which the designer worked
· to use systematic methods rather than intuitive ones
· to use rational, objective approaches to the solving of a graphic problem
· to think about relationships in form and content

Formal visual values
· to use geometric shapes: the circle, the triangle and the square
· to use primary colours

Typography
· to use sans serif typefaces
· to show contrast in typographical material
· to base work on pragmatic issues of printing, paper sizes, photo-engraving, standardization

Imagery
· the use of photographs and photomontage rather than drawings
 or illustrations
· the use of silhouetted photographs with white backgrounds
· the use of maps and diagrams
· the use of graphic symbols and icons

Organization
· the use of asymmetric page layout
· the use of a grid or clearly delineated page-organizing method
· to apply a planned visual hierarchy in the manner in which the graphic
 elements were integrated
· to know and apply perceptual laws (i.e. keeping elements grouped)
· to apply continuity in page flow

THE EMERGENCE OF GRAPHIC DESIGN

'Graphic design is strongly grounded in the historic evolution of writing, symbols, letterforms, typography, book design, printmaking, posters and art movements.'[4] Based in this tradition of graphic arts and typography, graphic design became known as 'commercial art', a profession composed of a mixture of typography, printing, art, photography, illustration and advertising. Sometimes it has been seen as a subset of advertising design. The earliest comprehensive description of graphic design was presented in the book *Graphic Design* by Leon Friend in 1936. In this book, Friend defined graphic design as, 'that creative endeavour which finds expression through the medium of printing ink'.[5] Widespread acceptance of the name for the profession came in the 1950s with the advent of the Graphic Design programme at Yale University. Because its roots were in art, dynamic changes such as the emergence of the avant-garde movements in the 1920s and 1930s would have a considerable impact on the field of graphic design.

To progressive Americans, these changes in Europe were of great interest. Tired of the traditional, mundane and mediocre, and ready for a fresh beginning, young American designers such as Paul Rand, Lester Beall and Bradbury Thompson began looking for a new aesthetic: something more than just surface style and cosmetics. They were beginning to be inspired by graphic design pieces coming in from Europe which exemplified the ideals of the avant-garde and Modernism. What they found were forms that were exciting and direct. Beall felt that Civil War recruiting posters and Jan Tschichold's *The New Typography* shared a common graphic strength. He remembered that in the early 1930s, with the challenge of the Great Depression, designers were also searching for answers. The designer William Golden was a pragmatist who thought that design solutions must

come from the content of the subject. He said, 'I believe the designer won his new status in the business community because he had demonstrated that he could communicate an idea or a fact on the printed page at least as well, and often better, than the writer, the client or his representative. And he could demonstrate this only if he was at least as faithful to content as well as style.'[6] Golden's view of the designer was simple and straightforward: 'A graphic designer is employed, for a certain sum of money, by someone who wants to say something in print to somebody. The man with something to say comes to the designer in the belief that the designer with his special skills will say it more effectively for him.'[7] The functional purposes of Modernism were central to the role of this emerging designer. The most satisfying solution to a graphic problem comes from its basic content. It is unnecessary and offensive to superimpose a visual effect on an unrelated message. These values were fundamental to this new form of design.

In the 1930s Frank Lloyd Wright wrote of American Modernism, 'I realized that America does have a very definite character of its own – that in all we make here is a distinct visual pattern decidedly different from anything that Europe does. Although our work is usually crude and raw, we seem to have our own conception of scale and it is grander than the European conception; our use of form is bolder and more vital; our use of color is distinctly our own.'[8] The designer Louis Danziger remembered that, in America, Modernism was a faith, a religion and a mission. Designers committed themselves to it with passion and zeal.

Modernism has always had its sceptics. One critic, concerned with so much innovation, suggested that the Modernist aesthetic makes us feel uneasy because it asks us to join a desperate battle to maintain the illusion of perpetual youth. Le Corbusier characterized it best when he said, 'A great epoch has begun. There is a new spirit.' Once it had taken root, Modernism had a fertile new place for growth in graphic design in America. It took 'the New World' to embrace this 'culture of newness' and bring it to a place of relevance and appropriateness for business and industry. 'Modernist pursuits of function, simplicity, clarity, honesty and timelessness will remain priorities, because these qualities are integral to the evolution of our species.'[9] These utopian benefits of Modernism endured throughout its life in America and elsewhere in the world.

1920–1929

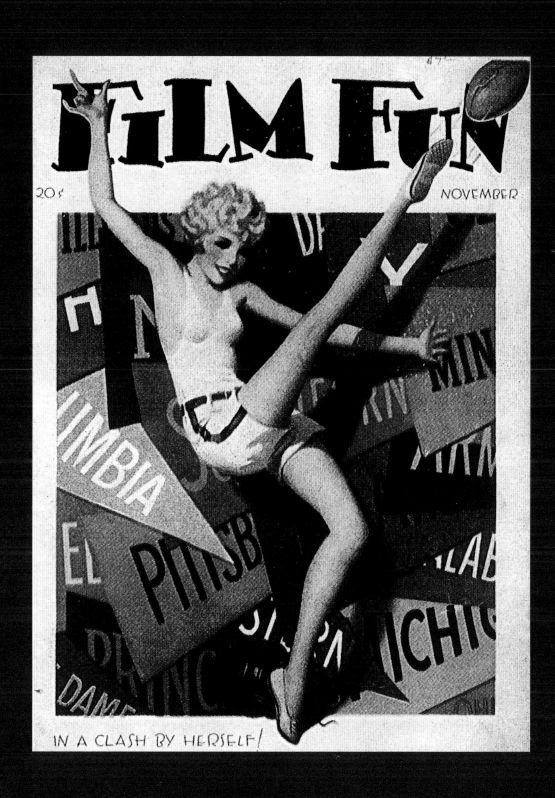

American Design in Transition: Traditional to Modernism 1920–1929

'Either the well was very deep, or she fell very slowly, for she had plenty of time as she went down to look about her, and to wonder what was going to happen next.'

Lewis Carroll, *Alice's Adventures in Wonderland*

AMERICA AND THE ROARING TWENTIES

The 1920s was a decade of change, contrast and continuity. After twenty years of economic, political and social reform and war, in the 1920s Americans were ready to settle down to what President Warren G. Harding promised would be a normal life. Harding's presidency was cut short by his death in 1923. Succeeding him in office was Calvin Coolidge, who pledged to clean up scandals of government with big business and allow American life to return to its regular pace.

This stability soon resulted in an economic boom. The average annual income rose more than thirty-five per cent during this period, allowing more people than ever before to own automobiles. In 1920 a new Ford automobile cost the consumer $335. The widespread installation of electricity allowed for the proliferation of inventions and advances in technology, which led to new products for the home such as vacuum cleaners, washing machines, toasters and fans. With the government's hands-off policies toward business and industry, advertising flourished. In 1927, the air age began with Charles Lindbergh crossing the Atlantic alone from New York to Paris.

The 'roaring' twenties was the age of youth and its culture. Cartoon characters such as Mickey Mouse and Betty Boop became household names. Men wore extra-wide trousers and sported slicked-down hair. Women cut their hair into short bobs to match the shorter dresses of the period. Couples danced the Charleston and the song 'Runnin' Wild' was the most popular. The symbol of the 1920s woman was the flapper. Women had more active roles: taking jobs, going to college, driving cars and smoking

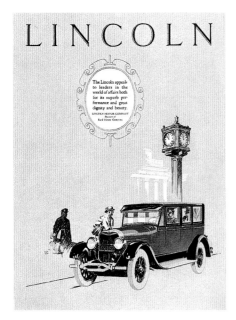

Above There was a sense of elegance associated with advertising high-cost objects such as automobiles, especially the smart models made by Lincoln. This ad from 1925 is simple in text and imagery in contrast to other inexpensive products such as cigarettes. The copy refers to Lincoln cars as 'superb, dignified and beautiful' as a way of verbally reinforcing how luxurious this product was compared to its competition.

Opposite top This full-page advertisement for Onyx Hosiery appeared in *Vogue* magazine on 1st September 1925. The layout was conservative in its symmetrical imagery and typography. The shoe pointing to the headline 'Onyx Pointex' is an effective design device. The copywriting for this ad was well crafted. While the ad was traditional and typical for the American market, it was realized with a sense of elegance on the page of this high-fashion magazine.

Opposite below Betty Boop was a popular cartoon character in the 1930s. Her creator, Max Fleischer, made this model sheet to present the standard ways in which Betty Boop must appear from different views and angles. It also suggested the basic construction of the cartoon character.

cigarettes. The Eighteenth Amendment, known as Prohibition, ushered in a ban on the manufacture and sale of alcohol. This legislation led to an illegal underground run by such lawless mobsters as John Dillinger and Al Capone in Chicago. The 1920s became known as the Jazz Age: the carefree spirit of the music, capturing the lively spirit of the times, helped to reach a large audience. Radio and the movies spread the latest ideas about fashions and lifestyles. Sports stars such as Babe Ruth, Gene Tunney and Bobby Jones became national heroes, known in every household. The author F. Scott Fitzgerald caught the spirit of the 1920s when he wrote, 'The uncertainties of 1919 were over. America was going on the greatest, gaudiest spree in history.'[1] The forms of Art Deco, which had started as a 'high' style reserved for the very rich, were soon to be seen everywhere, from architecture to product design. New York's Chrysler Building, designed in 1928 by William van Alen, was a dominant symbol of this form. By 1929, however, dark clouds were appearing on the horizon for American business and industry. On 29th October 1929, 'Black Tuesday', the U.S. stock market crashed, beginning the economic downturn known as the Great Depression. As was true of everything in the country, the stock market crash ended most advertising and design activity for the time being.

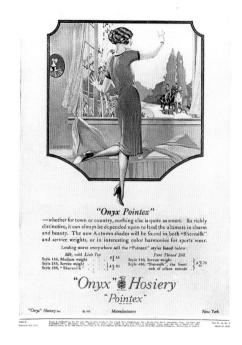

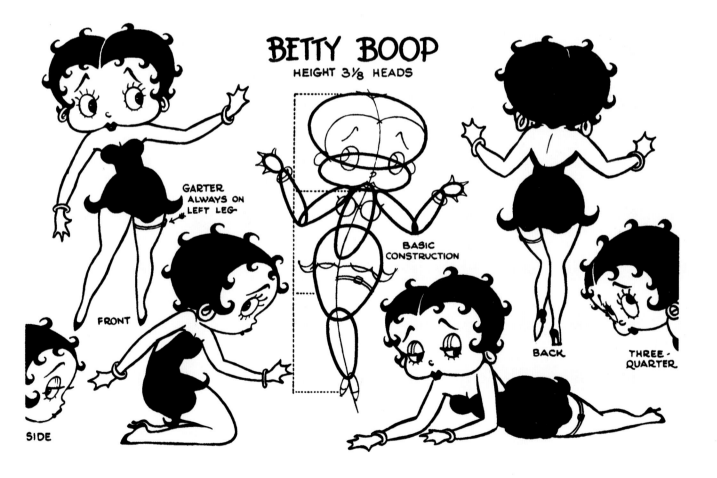

VOGUE

SEPTEMBER 1, 1925. 35 CENTS A NUMBER

H·MESEROLE·

© C N P

Autumn Fabrics and Original Vogue Designs

September 1 1925

Price ~ 35 Cents

The Condé Nast Publications Inc.

Opposite This cover of American *Vogue* appeared on 1st September, 1925. *Vogue* was also published in several European cities, notably Berlin and Paris. Simplicity was dominant in this cover, as was an attempt to suggest a formal Modernist quality. It was, however, superficial in that the sans-serif font of the masthead lacks the purity of Futura, and the imagery relied on an illustrative approach. Modernist designers preferred photography to hand-painted illustration. The awareness of and tendency towards Modernism is significant.

Below left Cigarette smoking in the 1920s was fashionable, especially for women. This ad for Lucky Strike cigarettes is typical of the print advertising of the decade. Unbelievably, the copy for this ad made reference to Lord Tennyson, human anatomy and the scientific means by which the tobacco was treated with 'ultra violet rays'. The ad was conventional in both its form and content.

Below right This issue of *Film Fun* magazine appeared in November 1925. The illustration combined the public love of football with a flapper girl in a design which is lively but traditional.

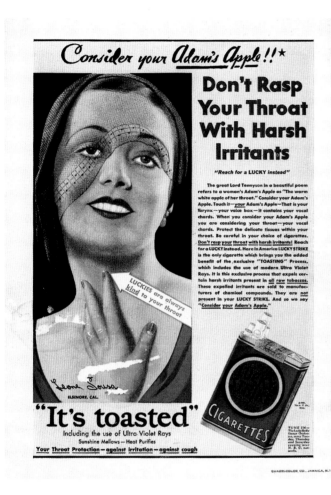

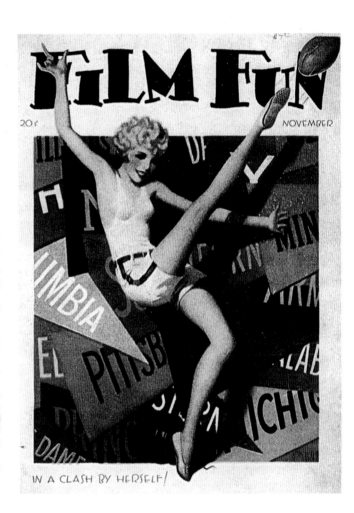

IN A CLASH BY HERSELF!

DESIGN IN THE TWENTIES

By 1900, over $500 million a year was spent on the promotion of consumer goods. National advertising provided support for the burgeoning magazine business. By the 1920s, the opportunities for advertising and publishing were substantial. During this period advertising and commercial art were in one camp while book design, printing and typography were in another. Book designers and typographers often worked on their own private press activities, following the spirit of the earlier Arts and Crafts Movement. These presses were usually traditional printing shops with foundry types and letterpresses.

This title page was designed by Bruce Rogers in 1933 for a translated reprint of a fifteenth-century book on letter design, with an introduction by Stanley Morison.

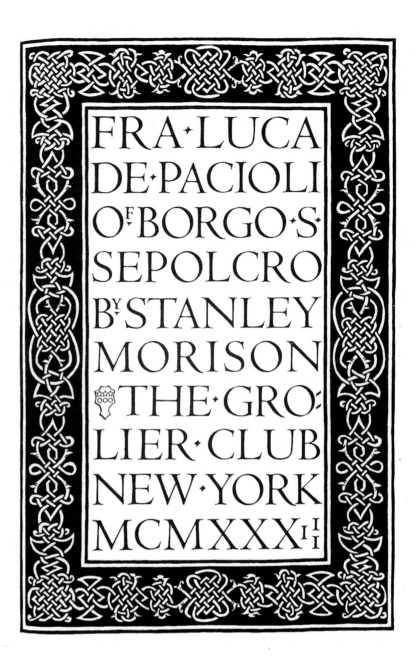

FRA·LUCA DE·PACIOLI OꟷBORGO·S SEPOLCRO Bʸ STANLEY MORISON ⬠THE·GROLIER·CLUB NEW·YORK MCMXXXII

Activities also involved papermaking, type design, book and printed ephemera. Frederick Goudy operated the Village Press and R. Hunter Middleton ran the Cherryburn Press. Melbert B. Cary Jr, a prominent type importer, also worked at the Press of the Woolly Whale. Frequently individuals would emerge from this enclosed field to design and produce books for commercial publishers. Bruce Rogers was the most important book designer of the early twentieth century. He was able to combine his talent for book design with the needs of commercial graphics. Rogers's approach to design was to establish an important basis for graphic designers. He saw design clearly as an objective, decision-making process in which the designer must determine

format, paper, typography, etc. The disciplines of advertising and book design remained separated during the 1920s, only to begin to come together into graphic design as the 1930s progressed with the influx of Modernist ideas from Europe.

Although sans-serif typefaces had been around for years, two new typefaces from Germany set off a revolution in 1927. Futura, a font designed by Paul Renner, and Kabel, designed by Professor Rudolph Koch, featured the considerable reproportioning of letters instead of relying on uniform widths. Among graphic designers in America, these typefaces found immediate interest and application. For example, magazine pages of *Vanity Fair* in the 1930s, designed by Dr M.F. Agha and his staff, uniformly used Futura types. American Type Founders issued a competing sans serif typeface named Bernhard Gothic in 1929. This font was designed by Lucian Bernhard, who had been an influential poster designer in the early twentieth-century German Plakastil style.

The advertising of 1920s' America was largely traditional in appearance, the creative force coming mainly from the copy. The copywriter was king; he was responsible for the concept and then developed the idea for the ad. His job was to translate the selling proposition in a way that was memorable and effective. Several key copy-oriented ad slogans of the 1920s were as follows: 'You press the button we do the rest', by L.B. Jones for Eastman Kodak Company; 'Often a bridesmaid, but never a bride', by Milton Feasley for Listerine; and '99.44/100% pure', for Ivory Soap. Although new products were coming onto the market, advertising was not moving with the times and remained traditional, with layouts composed of headline, illustration, text and signature. Echoes of the Art Nouveau style persisted in the books and ads of the 1920s; natural and elegant forms predominated. As Americans became more affluent and values changed, smoking became popular. Advertising reflected these changes, as did many ads for breath fresheners. The ad business was not sure what to do with Modernist ideas. Lester Rondell, president of the New York Art Directors Club, cautioned designers: 'It is the art director's responsibility to be wary and wise in his use of an extreme point of view. There are as many ways of solving an art problem as there are artists.'[2]

This decade saw the emergence of a young art director in Philadelphia named Charles Coiner. Born in California, Coiner worked in Chicago before he settled at N.W. Ayer in Philadelphia in 1929. Coiner's advertising design in the 1920s fitted into the traditional mould. A decade later, under the influence of Modernist ideas, Coiner was to become one of America's leading creative figures to accept, practice and promote Modernism. Coiner soon referred to the graphic designer as the architect of the printed page. His contributions to the field went far beyond advertising as he welcomed

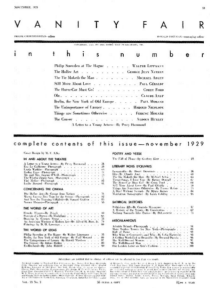

This contents page for a 1929 issue of *Vanity Fair* magazine used Futura type with excessive letterspacing and black ruled lines which stabilized the page elements. Douglas McMurtrie, in his book *Modern Typography and Layout*, characterized the style of this spread as 'a courageous innovation indeed in this country at this time'.

and hired newly arrived immigrant design talents, and then mentored them. Coiner also carried out major pro-bono design projects for the federal government and counselled huge U.S. companies such as the Container Corporation of America toward progressive approaches to corporate identity, advertising and promotion. Although his roots were in advertising, Charles Coiner was among the first major Modernist American graphic designers.

BOOKS, ILLUSTRATION AND TYPE

The book design and typography of this period remained conservative and classical in look. Historic typefaces such as Caslon, Bodoni and Garamond were revived by American Type Founders (ATF), largely through the efforts of Morris F. Benton. This interest in classicism was especially evident in the illustration of the era. Book illustrators such as Rockwell Kent and George Salter designed books, and book designers created illustrations without any delineation between the functions. Other important illustrators of the decade were Will Bradley, Maxfield Parrish and Edward Penfield, whose work was, more often than not, nostalgic and romantic.

An increasingly important part of this emerging field of graphic design was photography. Because the technology of the 1920s was limited in terms of quality halftone reproduction, designers preferred line art, which meant the use of illustration. An important figure in the history of photography and the introduction of Modernism into the United States was Alfred Stieglitz, who championed photography as an art form. At his gallery in New York, called 'An American Place', he presented the work of many European Modernist artists such as Picasso, Matisse, Brancusi and Picabia. His publication, *Camera Work*, was instrumental in disseminating progressive ideas in the United States. Stieglitz paved the way for American artists and photographers such as Paul Strand and Edward Steichen to become recognized. In Europe, the more experimental, avant-garde applications of photography and photomontage were moving rapidly away from simply capturing reality. It was now seen that his new image form could contribute in a dynamic way to the intended idea or message. Modern typographers and designers in Germany were specifying that photography was much preferred over illustration. The Constructivist Laszlo Moholy-Nagy and the Surrealist Man Ray made important contributions to this new direction in imaging which was to blend into graphic design in the next decade.

A seminal work, *Printing Types Their History, Forms & Use*, by Daniel Berkeley Updike appeared in 1922. A scholar from Harvard, Updike produced a definitive history of typography in this traditional volume. Quite apart from Updike, several American book designers in the 1920s and 1930s saw the potentials of Modernism. Merle Armitage, an Iowa-born book designer, was a fascinating man with many interests. During his life he was

****EDITED AND
****DESIGNED BY
MERLE ARMITAGE
WITH ARTICLES BY

1938

GEORGE
GERSHWIN

PAUL WHITEMAN ★ OLIN DOWNES ★ WALTER DAMROSCH
GEORGE GERSHWIN ★ MERLE ARMITAGE ★ OTTO H. KAHN
ARNOLD SCHOENBERG ★ WILLIAM DALY ★ HAROLD ARLEN
OSCAR HAMMERSTEIN II ★ ISAMU NOGUCHI ★ DAVID EWEN
NANETTE KUTNER ★ LESTER DONAHUE ★ ISAAC GOLDBERG
ERMA TAYLOR ★ GILBERT SELDES ★ J. ROSAMOND JOHNSON
RUDY VALLEE ★ LEONARD LIEBLING ★ ALEXANDER STEINERT
ALBERT HEINK SENDREY ★ JEROME KERN ★ DUBOSE HEYWARD
HENRY A. BOTKIN ★ SAM H. HARRIS ★ ROUBEN MAMOULIAN
EVA GAUTHIER ★ FERDE GROFÉ ★ LOUIS DANZ ★ TODD DUNCAN
BEVERLEY NICHOLS ★ IRVING BERLIN ★ S. N. BEHRMAN
GEORGE ANTHEIL ★ IRA GERSHWIN ★ SERGE KOUSSEVITZKY

LONGMANS, GREEN & CO·LONDON·NEW YORK·TORONTO

(6)

The weather changed in November: the skies turned gray and sullen, the last warmth of autumn died out of the air, and the rains began. Blown by the wind, the cold rains drenched the city and darkened the streets. Gales boomed above the housetops, signs rattled, hats, umbrellas, and bits of paper sailed through the sky; while in the park the wet trees bowed to the wind and gave up their last sodden

also a civil engineer, set designer, concert promoter, gourmet, art collector and author. Between 1949 and 1954, he was art director of *Look* magazine. Armitage wrote, 'I became more and more convinced that posters, advertisements in newspapers and magazines, as well as thousands of announcements and circulars used by a concert manager, must reflect the quality of the performer not only in text but, more important, in the design.'[3] Armitage both authored and designed more than two dozen volumes, including *Rockwell Kent*, *So-Called Modern Art* and *George Gershwin: Man and Legend*.

THE CHANGING WORLD OF BOOK DESIGN

The typographer William Addison Dwiggins, a proponent of the new aesthetic, coined the term 'graphic design' in 1922. While at the time few knew what this title meant, it was accepted and gained meaning as Modernism itself was popularized. Dwiggins's innovative design skills were evident in the many books he designed for the publisher Alfred A. Knopf in the 1920s. *Layout in Advertising*, his own book, was printed in 1929 and looked ahead to the 1930s and 1940s. In the conclusion to this book he wrote, 'Modernism is not a system of design – it is a state of mind. It is a natural and wholesome reaction against an overdose of traditionalism.'[4] In 1935, Dwiggins designed the font Electra. It introduced a set of italic letters that appear more as simple, slanted romans than as flowing, calligraphic forms. In 1938, he designed the typeface Caledonia, which became one of the most popular fonts for book publishing.

S.A. Jacobs was another outstanding book designer of the 1920s. Writing in *Books For Our Time* in 1951, Jacobs poetically referred to the process of

This title page for the book *Orphan of Eternity* by Carl Heinrich was designed by S.A. Jacobs in 1929 for Louis Carrier & Co. Publishers. The page represented, in type, all that Modernism was about: namely the use of sans-serif type, asymmetric page organization and using type in multiple directions.

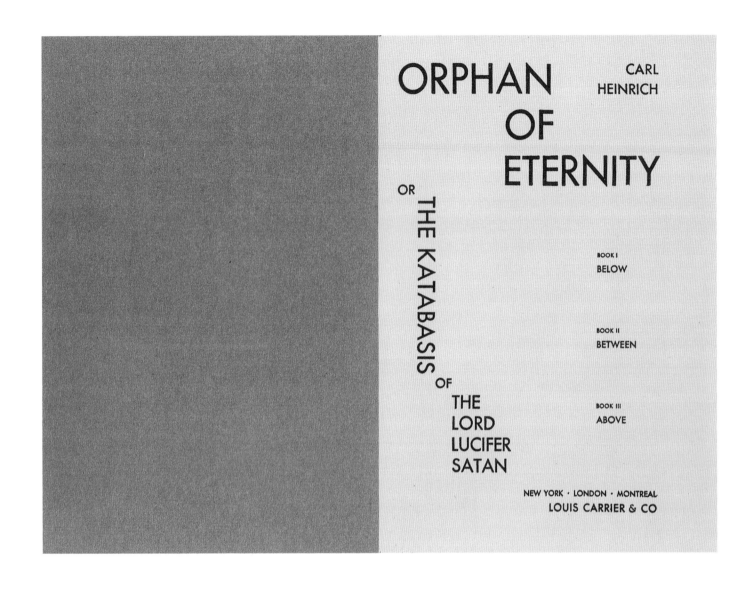

ORPHAN OF ETERNITY

CARL HEINRICH

OR THE KATABASIS OF THE LORD LUCIFER SATAN

BOOK I
BELOW

BOOK II
BETWEEN

BOOK III
ABOVE

NEW YORK · LONDON · MONTREAL
LOUIS CARRIER & CO

book design: 'Nobody has a monopoly on ideas, especially borrowed ones. And there is nothing original about the ideas borrowed from the ancient – ideas borrowed, put through modern washing machines, ironed by new methods and sold as contemporary products.'[5] The organization of the printed page was an important function of the designer.

Jay Hambidge published *The Elements of Dynamic Symmetry* in 1920. Dissatisfied with the incoherence of design, Hambidge studied nature in art and in design. This work, extending over a period of twenty years, resulted in the identification of two types of symmetry in layout, called active and passive. His research brought an interest in structure to art and the design of the printed page. Edmund Guess was also anticipating the emergence of Modernism in America when he wrote in his 1927 book, *Fashions in American Typography*: 'I believe that when our American designers and typographers take hold of this new expression, there will evolve an American typography along fresh and new lines that will stand up among the efforts of the Old World. I have faith in our craft. We will not be satisfied merely to follow.'[6]

Some Examples of the Work of American Designers, published in 1918 by Dill & Collins, presented the work of thirty designers and typographers, including Bruce Rogers, Frederick W. Goudy, Walter Dorwin Teague and Egbert Jacobson. Its purpose was to be a showcase of what was current, to value excellence in design and typography and to support the practices of the represented designers. This important portfolio shows the transition that was taking place in the 1920s in America between traditional forms and Modernist sensibilities. Overall, the work in the book is quite traditional, but there are, as in the case of Egbert Jacobson, glimpses of Modernist work. Its acceptance is grudgingly given by the author when referring to

S.A. Jacobs was a prominent book designer in the 1920s and 1930s. This four-page sequence was from *Ampersand* by e.e. cummings, published privately in 1925. The modular use of the repetitive rectangles created a sense of simultaneity not possible on a single page.

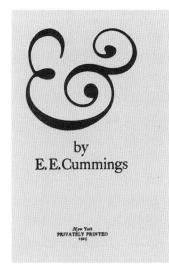

PACK MY BOX WI|123

PACK MY BOX|123

PACK MY BOX WITH FIVE D|

Pack my box with five dozen ju|123

Pack My Box With Five D|123

Pack My Box With Five Dozen Ju|123

PACK MY BOX WITH F|

Pack my box with|1234

PACK MY BOX WITH FIVE DOZEN JUGS|A

Pack my box with five dozen jugs|12345678

PACK MY BOX WITH FIV|

Pack my box with five doz|123

Pack My Box With Five Dozen|123

Jacobson: 'Despite his unpopularity at the moment in some fields of human endeavor, credit must be given to the German for a unique art of design.'[7] This comment reflected a lingering post-World War I attitude in America. Jacobson, an immigrant from Germany, would move from New York to Chicago in 1936 and become the first design director at Container Corporation of America. In 1924, Joseph Sinel published *A Book of American Trade-Marks & Devices*, in which he presented a comprehensive display of symbols and marks of the 1920s. The marks shown represent both the traditionalism of the time and a few glimpses of Modernist work in the way in which corporations and businesses identify themselves.

Seeing the vast potential for progressive design in the generally conservative United States, other immigrant designers started to arrive. The Italian artist and designer Fortunato Depero, through his Futurist roots, was a proponent of radical ideas in this period, as was Frederick Kiesler in his exhibition design applications. Their works were characterized by asymmetry in layout and the use of sans serif typefaces. As the 1920s waned, American type foundries were caught off guard with the introduction of daring advertising typefaces from progressive European foundries such as Stempel, Deberny & Peignot and Klingspor. Melbert B. Cary of the Continental Typefounders was instrumental in the influx of new fonts such as Koch Antigua, Eve and Rivoli.

By the end of the decade, America was sinking deeper into economic depression. Design continued to value traditional forms but was beginning to show glimmers of change. Although Modernism was on the doorstep, there was still a lingering ambivalence. This was never more clear than in the writings of William Addison Dwiggins at this time. On the one hand he supported Modernism by stating: 'Actual Modernism is a state of mind that says: Let's forget about Aldus, Baskerville and William Morris, and take these types and machines and see what we can do with them on our own. Now. The graphic results of this state of mind are extraordinary, often highly stimulating, sometimes deplorable. The game is worth the risk.'[8] In contrast, Dwiggins wrote about book design: 'You can ignore tradition. You can change the margins, move the type rectangle about – and if you are in

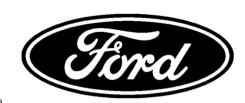

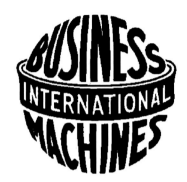

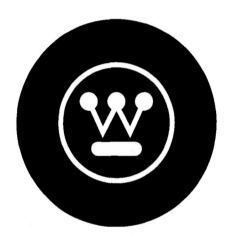

Opposite The popular type fonts among printers and advertisers of the 1920s in America were exemplified in this selection of one-line specimens. Against this American context of conventional typography, the Modernists cast aside eclecticism, stylishness and tradition for the pure, direct and unadorned use of geometric fonts such as Futura.

Above top In the 1920s Americans were in love with the automobile. Henry Ford and others provided the product that gave mobility to the populace. This simple logotype, designed c.1900, has endured to the present. Contemporary

designer Paul Rand was asked in 1966 to submit an identity redesign to Ford. His proposal was evaluated and rejected in favour of maintaining the original logotype.

Above middle American corporations understood early on the value of having their own identity marks to adorn products, advertising and print materials. This undistinguished and traditional symbol for International Business Machines (IBM) was used throughout the 1930s. It suggested, through its round configuration, the global nature of the business.

Above bottom Starting in 1900, the Westinghouse Electric Company identified itself with a bold geometric circle and typography. Then, in 1910, the letter 'W' was added in addition to the company name. The programme would be modernized in the 1920s and ultimately in the 1960s by Paul Rand. In the case of this corporation, it is important that the present mark represents a long tradition of similar designs that have evolved logically over the years.

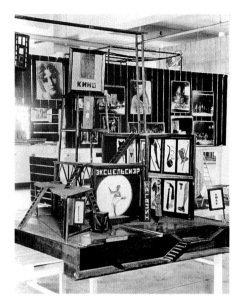

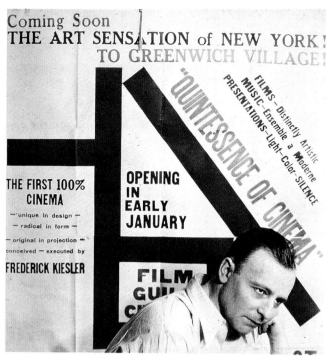

Above left Frederick Kiesler was among the early European immigrant designers to arrive in America, bringing Modernist ideas from Europe to New York in the late 1920s. This design was for an international theatre exposition in New York which was held at Steinway Hall in 1926. The viewer was invited to move up and into the space created by the structure in order to view the images and text which were presented on differing planes in space.

Above right Frederick Kiesler (in the foreground) designed this poster in 1928. The bold, graphic poster was to promote the Film Guild Cinema in New York. A part of the New York avant-garde, Kiesler was able to promote Modernism through his exhibit design, graphic design and stage sets.

harmony with the music of space, you may come out with something fine! But the full blown Modernist necessity to strike only for dramatic pattern and startling novelty can't quite be counted as playing fair with the function of the book – or with the reader!'[9] These differing views were typical of the transitional period of the 1920s.

The fields of printing, typography, book design, photography and advertising were slowly coming together into what would be fully understood as graphic design. Design historian Philip B. Meggs has said of this decade, 'The modern approach slowly gained ground on several fronts: book design, editorial design for fashion and business magazines catering to the affluent, and promotional and corporate graphics.'[10] The American photographer Walker Evans remembered his own Modernist context which featured 'atonality and cacophony in music, abstractions and various distortions in painting, incommunicative subjective imagery in poetry and automatic writing in prose'.

Signs of change were definitely on the horizon. In introducing the *Ninth Annual of Advertising Art*, published in 1930 by the Art Directors Club of New York, art director Harry Eckhardt wrote, 'This annual, more than any of its predecessors, proclaims that modern advertising art is growing decisively decorative in style; that is, it is growing decidedly dramatic in subject.'[11] More and more European designers looked to America for greater creative opportunities. They wanted to be part of the dramatic transition from traditionalism to the look of the new.

4 1930–1939

4

New York is noisy.
New York is overcrowded.
New York is ugly.
New York is unhealthy.
New York is outrageously expensive.
New York is bitterly cold in winter.
New York is steamy hot in summer.
I wouldn't live outside New York for anything in the world.

From the first issue of *The New Yorker* magazine, 1925

THE GREAT DEPRESSION

In contrast to the liveliness of the 1920s, the 1930s were marked by world economic crisis, constantly rising unemployment and the growth of Fascism in Europe. Chaos, rather than control, was the norm. Life in the United States was consumed with coping with the economic depression that was limiting life in every way. Many Americans wondered from day to day where the next meal would come from. The writer W. H. Auden called the 1930s 'that low-dishonest decade, when the civilized world was working itself up yet again for one of its paroxysms of self-destruction'. Artists were mirroring these difficult times. John Steinbeck, in his 1939 novel *The Grapes of Wrath*, vividly showed the plight of the farmers in Oklahoma as they struggled with both economic problems and natural disasters such as the tremendous dust storms in the midwestern United States. Photographers Dorothea Lange, Ben Shahn, Walker Evans and Edward Weston, among others, documented these dark days in their classic black-and-white photographs of the Dust Bowl farmers and the poverty in America.

In 1936, President Franklin Delano Roosevelt headed a nation where one-third of the population was ill-housed, ill-clad and ill-nourished. Unemployment in the United States reached an all-time high. Nearly thirty per cent of the nation's workforce was without pay cheques. Roosevelt sought to heal the Depression with his New Deal policies, which in large part were designed to put Americans back to work. This legislation included the National Recovery Act and, in 1935, the Works Progress Administration (WPA) was instituted, which provided jobs by building parks, roads and public facilities. The programme also put artists to work painting murals for government buildings and designers creating new guidebooks for cities. As these governmental efforts began to have a positive effect, the shadows of totalitarianism in Europe and the Far East darkened the horizon. Despite the strong movement toward isolationism, worldwide war was inevitable by the end of the decade.

Opposite left *The New Yorker* magazine has consistently through the years featured illustration on its covers. Frequently, these are humorous and filled with irony. This cover was painted in 1938 by Constantin Alajalov and represented a common Depression concern for making ends meet.

Opposite right Charles Coiner was among the first Modernist designers in America to donate his professional expertise to the U.S. Government service. In 1933, he designed this symbol as an identity mark for the government's National Recovery Act, a development programme to counteract the economic depression. The 'Blue Eagle', as it was known, was widely seen in store windows, on poster boards and on the covers of national magazines such as *Vanity Fair*. The NRA was a controversial programme and lasted only four years. The symbol remains as an early innovation in design for public service.

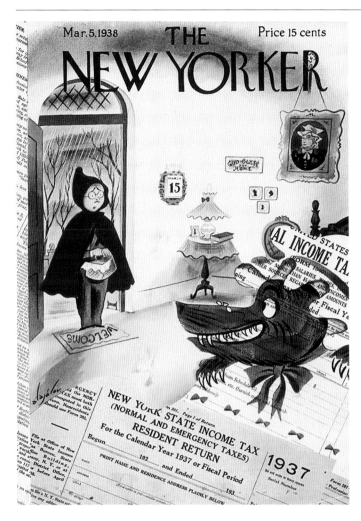

THE AMERICAN NORM

With the times continuing to be difficult in the 1930s, many in the United
States, particularly those working in the media, maintained a positive outlook.
Advertisements and products were designed and produced to give hope for a
better world to come. A period of great tension caused by deep conflicts can
unleash the best as well as the worst in society. Traditionalism in American
graphics still lingered during the 1930s, even as the fresh movement toward
Modernism became apparent. Optimistically, the Walker Art Center in
Minneapolis began publishing *Design Quarterly*, a magazine which featured
articles on modern design, crafts and architecture. Over the years many
designers contributed issues and cover designs. An issue of *PM* magazine
from as late as 1938 featured a major insert on 'The Bauhaus Tradition and
the New Typography' written by L. Sandusky and designed by Lester Beall.
Examples of Modernist design selected by Beall complemented the text. The
same issue had an accompanying article on type specimens from Frederick
Goudy's private press. These pages were traditional in the dominance of
symmetry in the page layout and the use of antique serif typefaces.

This two-page spread from a 1938 issue of *PM* magazine, designed by Lester Beall, contained an historical essay on 'The Bauhaus Tradition and the New Typography'. It was through articles such as this that American designers learned about Modernism and the work of the European avant-garde artists and designers.

The New York designer Clarence P. Hornung has remained largely unrecognized for his innovative and versatile work in this period. Starting in 1920, he designed trademarks, packaging, books, exhibits and publications. By 1937, Hornung had designed over 300 marks, and commented in an interview, 'At this time I became interested in the sore need for re-styling American trademarks, and this form, more than any other, fascinated me.'[1] In 1930, Hornung published a limited-edition book entitled *Trade=Marks*, an extensive and elegant collection of his own trademark designs. In the introduction to the book he wrote, 'The designer of marks for modern business must think beyond the printed page into all the materials of manufacture'.[2] This visionary statement predicts the golden age of corporate identity in American graphic design of the 1950s. Hornung's book was similar to one entitled *XX Eigen=Marken*, which had been published in Germany in 1921, showing marks and symbols designed by members of the *Bund Deutscher* (*Deutscher Werkbund* or German Work Federation).

During his career, Hornung wrote more than a dozen books on design, including *Handbook of Designs and Devices* in 1932. This reference book presented more than 1,800 of his sample symbolic designs organized by

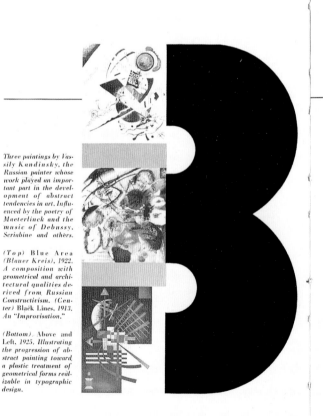

Three paintings by Vassily Kandinsky, the Russian painter whose work played an important part in the development of abstract tendencies in art, Influenced by the poetry of Maeterlinck and the music of Debussy, Scriabine and others.

(Top) Blue Area (Blauer Kreis), 1922. A composition with geometrical and architectural qualities derived from Russian Constructivism. (Center) Black Lines, 1913. An "Improvisation."

(Bottom). Above and Left, 1925. Illustrating the progression of abstract painting toward a plastic treatment of geometrical forms realizable in typographic design.

By L. Sandusky

The Bauhaus Tradition and the New Typography

1

In September of last year the Association of Arts and Industries announced the establishment in Chicago of a "new" Bauhaus, with L. Moholy-Nagy as Director. The following month its doors opened to a group of American students, who began, a little uncertain, one would imagine, to grope their way toward a new philosophy of art and industry. It has now completed its first year. In the minds of many who had been interested in the Bauhaus as a cultural and historical phenomenon its re-establishment suggests far-reaching implications. Among other things, it brings to the fore again the problem of Continental modernism, which in printing and advertising design has made uneven progress in America.

The bodily presence of an American version of the internationally famous German school, which played so conspicuous a part in the development of the "New Typography," makes it timely and worth while to re-examine the set of circumstances which made it what it was. For the story of the Bauhaus is the story of how a considerable body of contemporary American printing and advertising came to be what it is.

formal design similarities and differences. A transitional designer with his feet solidly on both traditional and modern sides, Hornung's move to Modernism began in 1925 with work that he saw from the Paris Exposition. In this period, the ambivalence of style continued, with the traditionalists retreating to the comfort of their historically conservative private presses and book design. In contrast, the Modernists, working primarily in the advertising and print worlds, saw opportunities available to explore more creative and experimental solutions which had been inspired by the European avant-garde.

Several other important books on Modernism in design were published in the 1930s. *Horizons*, by the industrial designer Norman Bel Geddes, appeared in 1932. A visionary designer, Bel Geddes's words and text in this volume clearly articulated his progressive ideas as well as his global views of the benefits of Modernist design. Sir Nikolaus Pevsner, the British art and architectural historian, published *Pioneers of the Modern Movement* in 1936. Although this small book was centred on architecture, it made a contribution to the understandings of Modernism in allied design disciplines.

With this emphasis on the new came revised responsibilities for graphic designers, now accepted as professionals in their own right. Graphic designers accepted the challenge to bring order, clarity and directness to the printed page. By the end of the decade, more and more typography was designed on the layout pad by the designer rather than in metal by the printer. This represented a great change in American typography; now the designer was able to integrate a whole new aesthetic to the printed page. He could 'draw' a page. He found more flexibility in the pencil than in metal. The page became a new medium for the designer.

Below left Clarence Hornung was a prolific designer and author during the 1930s. His 1932 book, *Handbook of Designs and Devices*, for Harpers was a showcase of abstract designs that could be used as a creative resource by designers. The patterns created by these individual graphic devices on the pages in the book created in themselves an exciting visual experience.

Below right Merle Armitage designed this title page spread for the book *Modern Dance* in 1935. It represented the integration of Modernism into American design through its application of Futura type, the wide space between the letters and the way in which the ruled lines supported each line of words. This was an effective example of how typography alone was adequate for the solution of a graphic design problem.

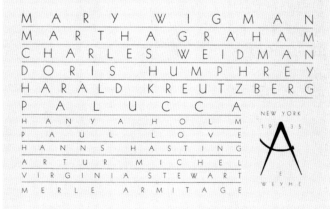

The Sterling Engraving Company was a major client of Lester Beall in the late 1930s. It allowed Beall a great deal of creative freedom in his promotional brochures. This cover from 1938 showed the influence of Dada and Surrealism on Beall's graphic design. The angular dynamics, the contrast of size and direction, the use of overlapping montaged antique engraving images – all these effects combined to make this active cover memorable.

THE WONDERFUL TOWN

Many viewed Berlin in the 1920s as the capital of Modernism. In the 1930s, others saw Paris in this position. However, with the emergence of National Socialism in Germany and the threat of war looming over Europe, the centre shifted to the distant and safe shores of America and to New York. Manhattan, the island of progress, has long held a magic quality for those in all the arts, and was a paradoxical place that some felt added to its magic. It had both the pragmatism of a world economic centre and the dynamism of an international centre of the arts.

For native New Yorkers, as well as those Americans who would move there to seek their fortunes and those who would immigrate from Europe, New York became the new crucible of creativity between 1920 and 1950. This was where Modernism found a home, flourished and matured. The German designer Will Burtin immigrated in 1938. In 1947, reflecting on what he found in New York then, he wrote, 'In the U.S. I found conditions which made the continuation of studies possible: people less biased by narrow interpretations of tradition; devotion to high productivity; a great industrial apparatus.'[3] The environment and the possibilities created a cosmopolitan ambience. Most American businesses, however, possessed a naivety. Into this place, the power of the transplanted Modernist ethic found a receptive home. In the 1930s, the readiness for change was not unlike that of a century earlier when pioneering Americans had ventured west into uncharted territory to create a new life. Those in the design fields, whether they were Americans, immigrants from Europe or native New Yorkers, uncovered possibilities that required risk-taking and courage.

THE ÉMIGRÉS ARRIVE

The formalism of the Modernist aesthetic was brought to the waiting shores of America primarily by the immigrant designers, artists and architects who arrived from Europe in the 1930s. The sheer volume of individual talent that converged upon America in these years was incredible. The spread of Fascism throughout Europe forced many to seek a new, safer home and, for some, the lack of tradition in America was an added attraction, a fresh start. This allowed a full and robust opportunity to express new approaches. They brought a powerful spirit of experimentation which was lacking in America. The existential psychologist Rollo May wrote, 'If you wish to understand the psychological and spiritual temper of any historical period, you can do no better than to look long and searchingly at its art.'[4] An historic photograph taken in New York at the Pierre Matisse Gallery showed Roberto Matta, Ossip Zadkine, Yves Tanguy, Max Ernst, Marc Chagall, Fernand Léger, André Breton, Piet Mondrian, Andre Masson, Amédée Ozenfant, Jacques Lipchitz, Pavel Tchelitchew, Kurt Seligmann and Wallace Berman – a roll call

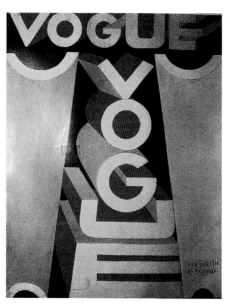

of the differing divisions of Modernist artists. As Alfred Barr acknowledged, 'New York during the war supplanted Paris as the art centre of the Western world.'[5] German-born painter Hans Hofmann's studio on West Eighth Street became the gathering place for the newcomers to America as well as for the members of the New York School. Hofmann became an important inspiration for many at this time. Many of the émigrés were leaders of the Surrealist movement, whose glorification of the irrational, the unknowable and the world of dreams struck a responsive chord with the New York School painters. In particular, Surrealism's advocacy of 'automatism' – trying to paint straight from the subconscious – seemed to confirm and validate their own ideas about the creative power of the unconscious. Other Surrealists in New York were Marcel Duchamp, Hans Arp, Wilfredo Lam, Hans Bellmer, Alberto Giacometti, Frida Kahlo, René Magritte, Paul Klee, Joan Miró and Henry Moore. For the struggling and still largely anonymous painters of the New York School, the presence of the 'big boys' from Paris in their midst was inspirational. During this decade some 717 artists, 380 architects and 100 graphic designers made the exodus to America. The presence of such luminaries in America and the tradition of intellectual and aesthetic authority they brought with them had a profound effect on further developments of avant-garde design and art in the United States. Its most effective task was in breaking down traces of parochialism in the American cultural scene.

Among designers, several arrived early in the 1930s. Cipe Pineles arrived as a child with her family from Vienna in 1932. The Italian Futurist Fortunato Depero came to the U.S. in 1928. During this visit he produced some memorable covers for *Vanity Fair*, *Vogue* and *The New Yorker* magazines,

Below left This full-page advertisement appeared in a 1937 issue of *Harper's Bazaar* magazine. Its designer, Alexey Brodovitch, used the visual idea of the fan in his layouts. In this case, the typography integrates perfectly with the lines of continuity in the photograph to establish a unity for the design.

Below right Alexey Brodovitch was art director of *Harper's Bazaar* magazine for twenty-five years, beginning in 1934. This photographic cover from 1939, on the eve of World War II, was a powerfully patriotic image, marrying the dramatic Statue of Liberty with the decorative feathers and pearls. It was an eye-catching cover filled with irony and ambiguity.

Opposite This two-page spread from *Harper's Bazaar* features photography by staffer Leslie Gill. Although he was not particularly interested in experimental typography, Brodovitch was highly skilled at creating continuity and unity between the image and the type.

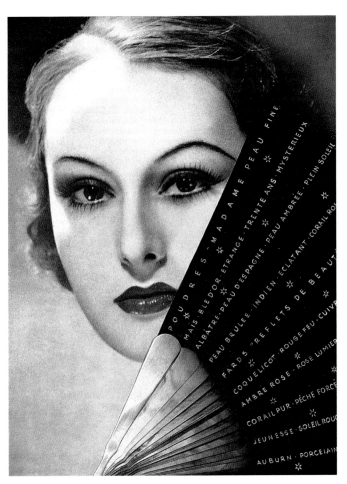

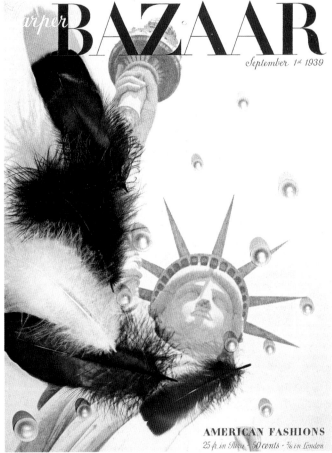

and also designed posters and product promotion. New York, for Depero, was 'the exhalting discovery of the reality of a modern metropolis, though far from the futurible myth, and instead with a different, pestering charm of the consumption just of its experience, real, dynamic, tumultuous, conflictual, glittering and spectacular, but also stressful, tragic as a plunge into a conditioning and crushing machine'.[6]

Alexey Brodovitch, taking advantage of professional opportunities, moved from Paris to teach in Philadelphia. Hearst magazines hired Brodovitch to become art director of its fashion magazine *Harper's Bazaar*. He instigated a whole new approach to magazine design based on the idea of page contrast and flow. He consistently used experimental themes such as cinematic effects, Surrealism, colour, culture, juxtapositions, repetition and silhouette in the pages of *Harper's*. The works of important photographers from Europe and America graced the pages of the magazine. Through his work, Brodovitch showed that the magazine art director was as important a creative force as the editor.

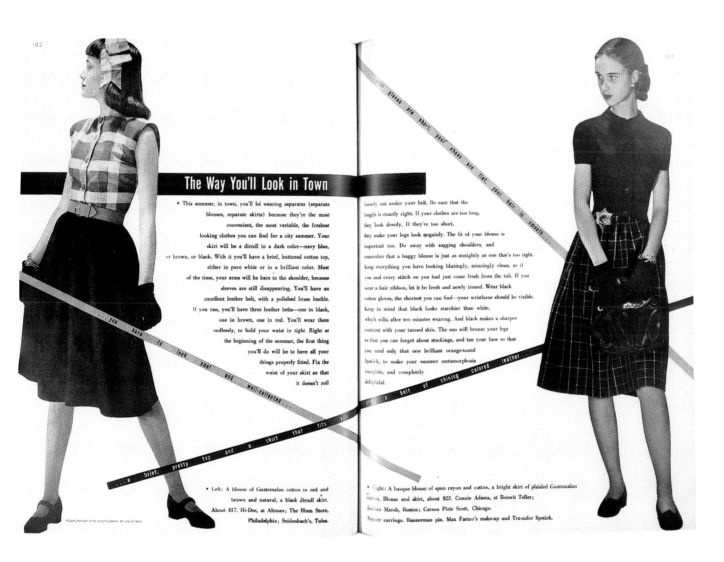

The Way You'll Look in Town

• This summer, in town, you'll be wearing separates (separate blouses, separate skirts) because they're the most convenient, the most variable, the freshest looking clothes you can find for a city summer. Your skirt will be a dirndl in a dark color—navy blue, or brown, or black. With it you'll have a brief, buttoned cotton top, either in pure white or in a brilliant color. Most of the time, your arms will be bare to the shoulder, because sleeves are still disappearing. You'll have an excellent leather belt, with a polished brass buckle. If you can, you'll have three leather belts—one in black, one in brown, one in red. You'll wear them endlessly, to hold your waist in *tight*. Right at the beginning of the summer, the first thing you'll do will be to have all your things properly fitted. Fix the waist of your skirt so that it doesn't roll

loosely out under your belt. Be sure that the length is exactly right. If your clothes are too long, they look dowdy. If they're too short, they make your legs look ungainly. The fit of your blouse is important too. Do away with sagging shoulders, and remember that a baggy blouse is just as unsightly as one that's too tight. Keep everything you have looking blazingly, amazingly clean, as if you and every stitch on you had just come fresh from the tub. If you wear a hair ribbon, let it be fresh and newly ironed. Wear black cotton gloves, the shortest you can find—your wristbone should be visible. Keep in mind that black looks starchier than white, which wilts after ten minutes wearing. And black makes a sharper contrast with your tanned skin. The sun will bronze your legs so that you can forget about stockings, and tan your face so that you need only that new brilliant orange-toned lipstick, to make your summer metamorphosis complete, and completely delightful.

• Left: A blouse of Guatemalan cotton in red and brown and natural, a black dirndl skirt. About $17. Hi-Dee, at Altman; The Blum Store, Philadelphia; Seidenbach's, Tulsa.

• Right: A basque blouse of spun rayon and cotton, a bright skirt of plaided Guatemalan cotton. Blouse and skirt, about $23. Connie Adams, at Bonwit Teller; Jordan Marsh, Boston; Carson Pirie Scott, Chicago. Napier earrings. Bannerman pin. Max Factor's make-up and Tru-color lipstick.

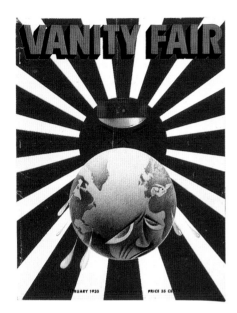

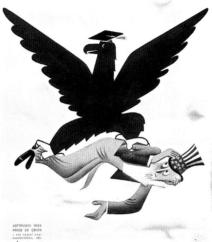

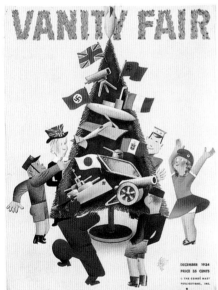

Dr Mehemed Fehmy Agha arrived from Berlin with an offer from magazine publisher Condé Nast to become art director of his magazines in 1929. Looking back, the designer William Golden said, 'What gave graphic design a new direction and style was not purely American. It was men like Agha and Brodovitch. These importations from Europe set a pace that not only changed the face of the magazine and consequently advertising design, but they changed the status of the designer. They did this by the simple process of demonstrating that the designer could also think.'[7] Dr Agha championed Modernism in the pages of his magazines. In a 1932 issue of *Vanity Fair* magazine, he devoted a full page to a diagram showing the chronology of advertising from Impressionism to the 1930s. In the accompanying text he wrote, 'The painful process of training the public eye for the new vision has to be completed first by modern architecture, decoration and typography – only then can the advertising afford to use the new visual language.'[8]

Dr Agha and Brodovitch were already well established when the majority of design immigrants arrived between 1935 and 1940. By then, Nazism terrorized Europe. Hitler closed down the Bauhaus in 1933 because he

Above A selection of *Vanity Fair* magazine covers which mirrored the times. The centre top cover, art directed by Dr. M.F. Agha, made reference to the National Recovery Act's 'Blue Eagle' symbol. It showed Uncle Sam being carried away by the Blue Eagle. The NRA was criticized for bringing too much Socialism into American government. The controversy was well represented in this magazine cover.

Opposite Dr. M.F. Agha innovated the full-bleed photograph in magazines. These images, which extended to the edge of the page, provided dramatic layouts of great contrast, as seen in this cover from a 1940 issue of *Vanity Fair* magazine.

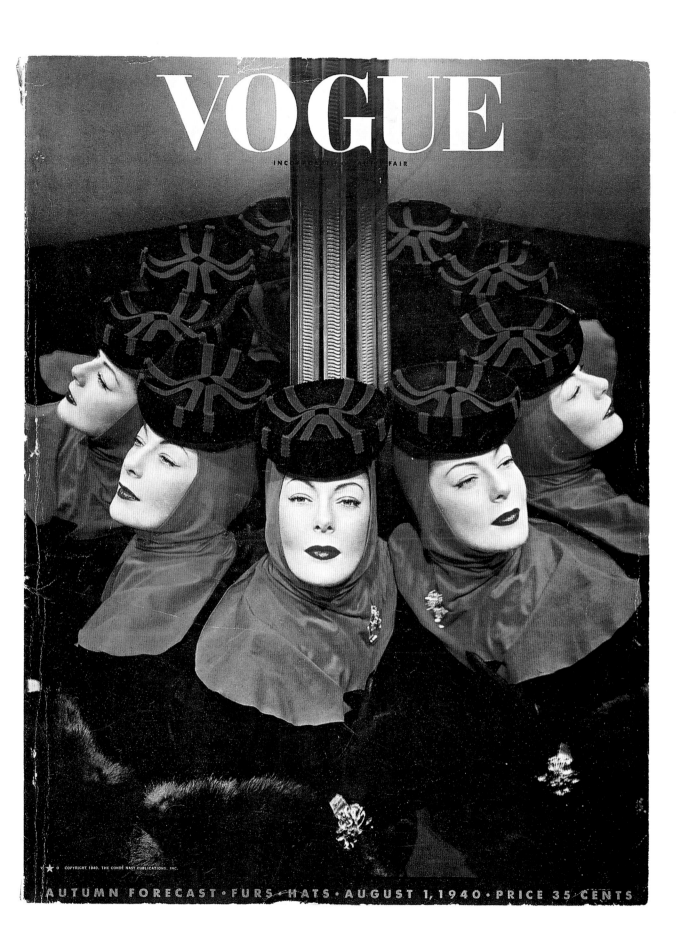

VOGUE

INCORPORATING VANITY FAIR

© COPYRIGHT 1940, THE CONDÉ NAST PUBLICATIONS, INC.

AUTUMN FORECAST · FURS · HATS · AUGUST 1, 1940 · PRICE 35 CENTS

Into the Design Scene: Modernism Arrives in America 1930 – 1939

THE WAR OF SHIPS

considered it 'degenerate'. Josef Albers, Walter Gropius, Herbert Bayer, Laszlo Moholy-Nagy and Marcel Breuer – all colleagues at the Bauhaus – made their way from Germany to London and other safe locations in the mid-1930s. William Golden, reflecting on this era, said, 'Under the twin impact of the functionalism of the Bauhaus and the practical demands of American business, the designer was beginning to learn to use the combination of word and image to communicate more effectively. Under the influence of the modern painters, the designer became aware (perhaps too aware) of the textural qualities of colour values of type as an element of design.'[9]

Each immigrant had his own story to tell. In Berlin in the 1920s, Hans Barschel was a student of George Salter, O.H.W. Hadank and Ernst Böhm. He arrived in New York in 1938 to be welcomed by his former teacher Salter, who was by then an established book designer and illustrator. Barschel had only fifty cents in his pocket and could speak very little English. Soon, with the support of his former teacher and others, he developed a flourishing freelance design business, and by 1939 he had designed his first cover for *Fortune* magazine. György Kepes and Alexander Archipenko worked and taught in New York first and then moved to Chicago to join Moholy-Nagy at the New Bauhaus. Ladislav Sutnar arrived in 1939 from Czechoslovakia to design the Czech Pavilion at the New York World's Fair. He soon learned that his home country had been invaded by Hitler,

Opposite Hans Barschel designed this cover for *Fortune* magazine in 1942, four years after his arrival from Germany. As America was heading for war, the German U-Boats created fear and havoc for transatlantic travel. The illustration, an iconic view of a merchant ship through the submarine's periscope, was rendered in a typical representational style. After publication, the original artwork was donated to an American admiral and went through the war at sea on the wall of his cabin.

Below left This cover for *PM* magazine by Barschel captured the futuristic feeling of the 1939 World's Fair. Barschel was more of a Modernist illustrator and was influenced by the artists of the Purist movement in Paris and the posters of the Frenchman A.M. Cassandre.

Below right Laszlo Moholy-Nagy was a master teacher at the Bauhaus in Dessau and an artist who was primarily interested in light. This led him to produce great quantities of experimental photographic images including this ghostly interior image. The manipulation of the photographic process beyond its normal iconic purpose was an important component of the Modernist aesthetic. American designers such as Lester Beall and Morton Goldsholl were influenced by Moholy-Nagy's work and teaching.

An intimate Journal for Production Managers Art Directors and their Associates No.

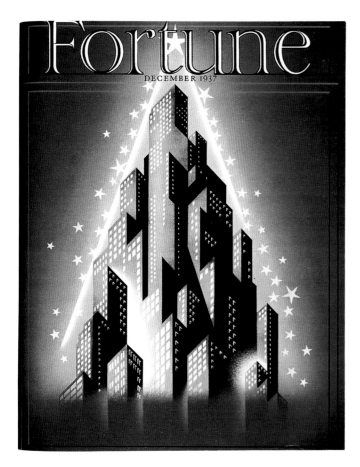

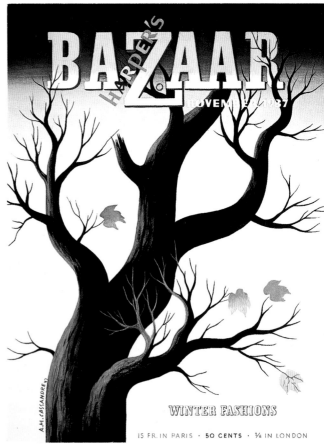

Above left The cover designs of *Fortune* magazine are a 'who's who' of great designers from the 1930s and 1940s. They represent history of American graphic design in itself. This December 1937 cover was designed by Joseph Binder. It represented in visual terms the optimism of the business world that was evident at the end of the 1930s as the American Depression began to wane. The overall symmetry was interrupted by the uneven blacks in the buildings and by the location of the stars.

Above right This cover for *Harper's Bazaar* magazine was one of a series done by A.M. Cassandre in 1937. It was a straightforward illustrative solution, distinguished only by the attempt to experiment with a new form for the magazine masthead.

Opposite The *PM* and *AD* publications of The Composing Room, Inc. were important records of the design and the designers in New York in the late 1930s. This title page from 1939/40 began an insert on the work of the Hungarian immigrant designer György Kepes. His portrait was located in an optical pattern of lines, while below, his name appears. Note the pointing hand which indexically moves the reader onto the next page.

thus making it impossible for him to return. He accepted his circumstances, settled down, began working in New York and spent the remainder of his career there.

A well-recognized designer in Germany, Will Burtin was forced to leave because his wife was Jewish. In 1938, the couple arrived in the U.S. and soon Burtin had established a design office in Manhattan and was working for major clients. Other important immigrants in this period were Joseph Binder, Jean Carlu, George Giusti, Max Gschwind, Albert Kner, Walter Landor, Alexander Liberman, Herbert Matter, Ben Shahn, Xanti Schawinsky and Allen Hurlburt.

Soon, supportive communities of immigrant designers sprang up in New York. Barschel remembered social gatherings of Germans with friends such as the Dada artist George Grosz, Dada poet Richard Huelsenbeck and book designers George and Stephan Salter in attendance. Also, during the waning years of the 1930s, a number of well-known European designers made visits to New York. The French poster designer A.M. Cassandre visited on several occasions. In 1937, at the request of Alexey Brodovitch, Cassandre designed a series of covers for the fashion magazine *Harper's Bazaar*. These covers, while not as outstanding as his famous Paris posters, brought a fresh and

György Kepes

Alex Steinweiss was a pioneer at bringing a Modernist approach to record album design. This album cover from 1941 showed his colourful way of unifying symbolic and typographic parts.

unexpected look to this magazine. Cassandre was also asked by Charles Coiner to develop a series of ads for the Container Corporation of America, promoting the functionality of their paperboard packaging. Another great poster designer from France, Jean Carlu, visited America. He, too, designed advertisements for the Container Corporation of America. Other disparate creative geniuses such as Marcel Duchamp, Francis Picabia and even the Russian poet Mayakovsky visited the United States. The German typographer Jan Tschichold visited New York in 1937 to participate in a symposium called Typography USA, where many young American designers challenged him for recanting on his Modernist views as he returned to a traditional approach.

TOWARDS THE WELCOMING SHORES

During the 1930s, young American designers noticed the look of Modernist graphic design from Europe. Looking for a new approach, they were tired of the traditionalism that had for so long been the norm. Many moved to New York because it was the focus of Modernism in America, it offered them the career opportunities and, most fundamentally, it was where the work was to be found during the Depression. Paul Rand, Gene Federico, William Golden, Saul Bass and Alex Steinweiss were native New Yorkers. Steinweiss would revolutionize the world of record album cover design in the 1940s. Bradbury Thompson came from Kansas to New York and Lester Beall arrived from Chicago. These men freely took certain truths from Modernism and incorporated them into their own distinctly personal languages. [10]

Paul Rand's inquisitiveness had led him to the New York Public Library where, pouring over issues of the German design journal *Gebrauchsgraphik*, he saw the work of Herbert Bayer in Germany and Alexey Brodovitch in Paris. During his long career Rand boldly explored the formal vocabulary of the European avant-garde movements as he paved the way in American editorial design, advertising and corporate identity. A quick learner and an exceptional talent, Rand became art director of *Esquire* magazine while still in his twenties. His covers for *Direction* magazine between 1938 and 1945

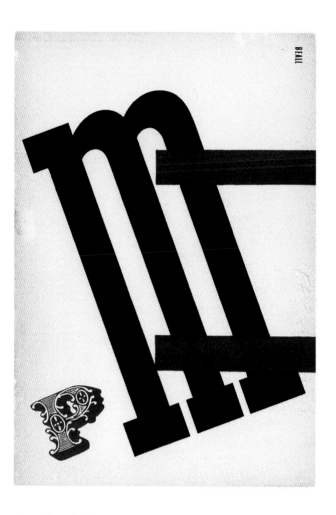

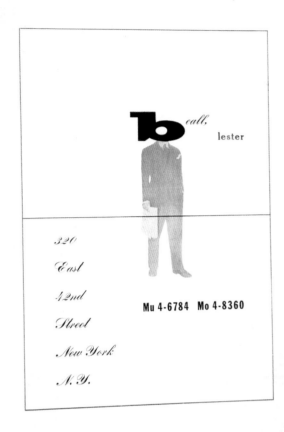

show his skills at integrating Modernist ideas with current commercial design projects (see Chapter 5). Working at the Weintraub Advertising Agency from 1941 to 1954, he produced many outstanding advertising campaigns, such as the programme for Ohrbach's Department Store. After 1955, he worked in his own studio on many graphic design projects while specializing in innovative corporate identity programmes for IBM, Westinghouse and the United Parcel Service (UPS).

Another major synthesizer of European Modernism was Lester Beall, whose career began in Chicago. Beall's development as a designer was greatly influenced by his business partner, Fred Hauck, who had travelled extensively in Europe in the early 1930s and studied painting there with Hans Hofmann. Upon his return, he shared his knowledge of the European avant-garde, thus providing his eager business partner with a new Modernist career direction. Beall moved to New York in 1936, where he was influenced by many Europeans including Herbert Bayer, Laszlo Moholy-Nagy, Kurt Schwitters and El Lissitzky. Beall's early work in New York showed an eclectic approach. At that time, he said, 'The desire to meet the challenge of a new period in our economic and social history was reflected by the search for forms that were strong, direct and exciting.'[11] Beall called himself an

Above left This cover for the graphic arts journal *PM* was designed by Lester Beall in 1937. It showed the interest that Beall had developed in emulating the approach of European Modernist designers. The cover was eye-catching because of its simplicity and contrast. There was contrast evident in both the scale and style of the dominant letterforms. The black and warm red colour scheme is reminiscent of Bauhaus graphics. This issue of *PM* featured an article profiling Beall's graphic design work.

Above right Lester Beall was very effective at promoting his design business throughout his career. He created this print ad for himself in the late 1930s. It is a remarkable example of his imagination. Inspired by Surrealist influences, Beall has replaced his head with the bold letter 'b'. The layout is asymmetric with a contrasting mixture of fonts ranging from the Alternate Gothic to the elegant script face. The whole ad space was controlled by placing all elements within this linear box.

Below left Lester Beall designed three series of posters for the U.S. Government's Rural Electrification Administration between 1939 and 1941. These posters provided Beall with notoriety as they were among the first graphic design work to be exhibited at the Museum of Modern Art in New York. This poster from series one, entitled 'Running Water', referred in simple language to the benefits of having electricity in the home.

Below right This poster from the third series for the Rural Electrification Administration, was designed in 1941 and reflects the move towards World War II.

Opposite Lester Beall designed this poster in 1939 as part of the second series for the Rural Electrification Administration. Beall did the photography as well as the design for this poster. The red, white and blue colour bands echo the structure of the fence and unify the poster. This was an effective patriotic message for Depression-era Americans to bring electricity into their homes.

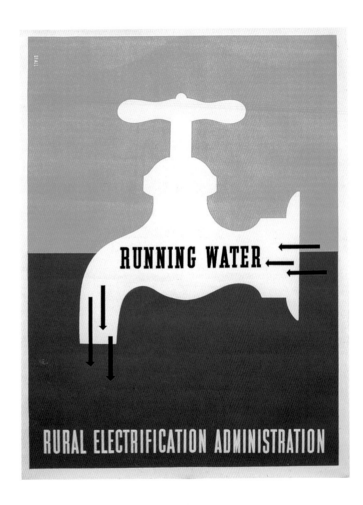

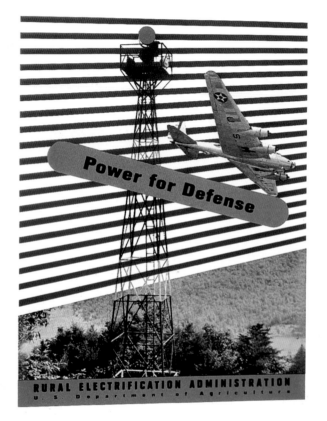

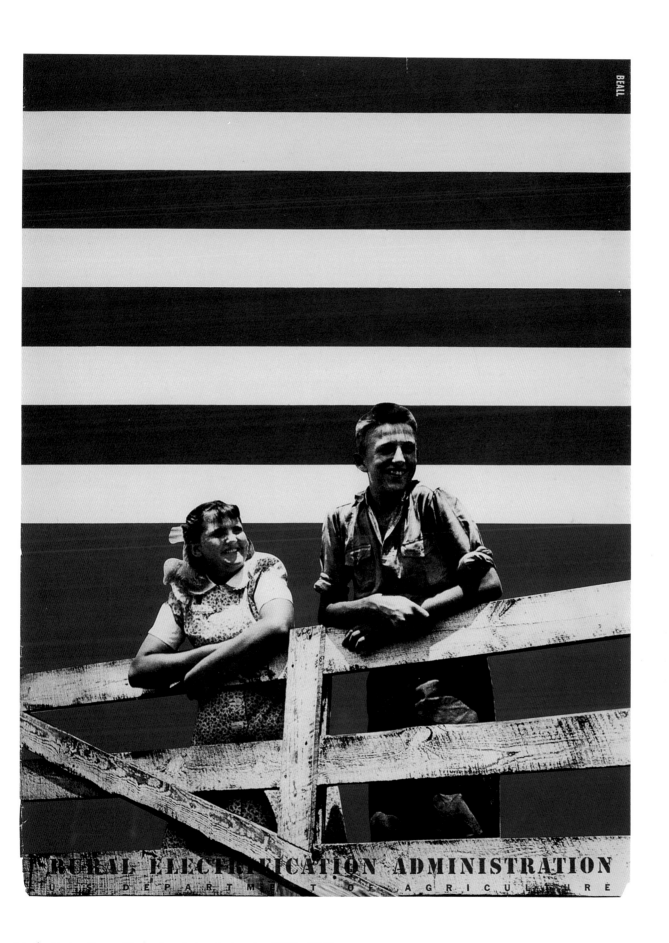

RURAL ELECTRIFICATION ADMINISTRATION
U.S. DEPARTMENT OF AGRICULTURE

Into the Design Scene: Modernism Arrives in America 1930 – 1939

Below left This two-page spread by Ladislav Sutnar was done in 1950 as part of a book *Catalog Design Progress* for Sweet's Catalog Service. The layout is dynamic in its integration of many elements created by other prominent designers of the times such as Paul Rand, Herbert Matter and Charles Eames.

Below right Functionalism in graphic design was a basic aspect of Modernism. Ladislav Sutnar designed several projects for the United Nations after World War II. In this poster-chart of the 'Organs of the United Nations', created in 1946, Sutnar presented the complex working relationships of the units of the United Nations in a clear graphic, diagrammatic language.

'absorbent' designer, one for whom 'the avant-garde had opened up a vast new field in which he could roam at random, picking blossoms haphazardly'.[12] This eclecticism was common among American designers. So enamoured were these young designers of the formal aspects of Modernism, that they were compelled to experiment with it.

Surrealism, too, was an important influence in Beall's design and photography. His great talent was to be able to conceive of experimental Modernist graphic concepts and sell them to staid American businesses for their needs. His poster series for the United States Government's Rural Electrification Administration, produced between 1937 and 1941, launched his career in New York. Other important early clients in New York were Abbott Laboratories, Sterling Engraving and *Collier's* magazine. Beall moved his studio to rural Connecticut by the early 1950s and specialized in innovative corporate-identity projects.

VISITORS FROM AMERICA

Modernist ideas also arrived in America through enlightened American designers who travelled to Europe in the 1930s and then returned to the U.S., changed by their new knowledge and experience. Many Americans sought a visual education among the avant-garde in Europe. Several American designers studied at the Bauhaus, including Howard Dearstyne, who was the first, and later John B. Rogers, who was the last, leaving in 1933. E. McKnight Kauffer, an American by birth, emigrated to England in 1915 and spent a major portion of his career there. He returned to the U.S. in 1940, only to find that his style was no longer appropriate for the American market.

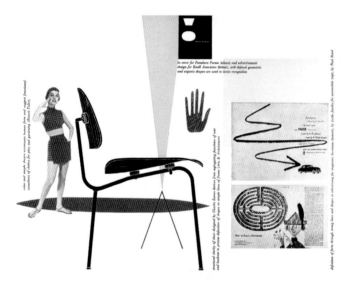

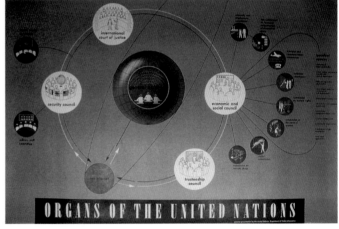

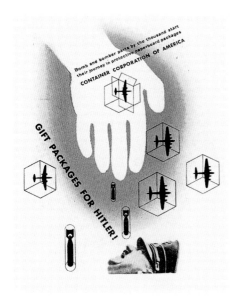
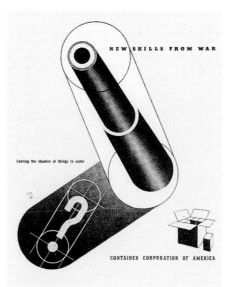
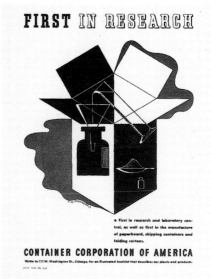

TAKING THE RISK

The new aesthetic in America extended far beyond just graphic design. Architects, painters, sculptors, writers, poets, composers, musicians, dancers and actors immigrated to New York, and their talent blended into the fabric of America, becoming the lifeblood of Modernism. The acceptance of new ideas in America would not have been possible without the support and enthusiasm of progressive leaders of business and industry. These individuals were ready to risk trying something new and radical in their corporate advertising and design as a way of being seen as progressive companies. From this attitude, many emerging designers enjoyed the freedom to propose and implement experimental approaches to graphic design.

In the 1930s, the public was increasingly attuned to the power of the photographic image. Advertising and new printing techniques were bringing photography to an ever-widening audience. The picture magazine, a product of 1920s' Germany, became a cultural watershed with the birth of *Life* magazine in 1936. Documentary photography was becoming more important, thanks in part to the patronage of the Farm Security Administration, which dispatched a corps of photographers to cover the sad condition of rural America. Henry Luce at Time, Inc. began *Fortune* magazine in 1930, and eventually hired Will Burtin to art direct its prime business magazine in 1946. The process then replicated itself as Burtin hired other young American or immigrant talent to create covers, illustrations, photography and information graphics.

Sweet's Catalogs specializes in producing a library of technical publications. A collection of industrial catalogues on different materials used in building and construction, these volumes are used as reference books by architects and engineers. In the 1940s, Sweet's Catalogs hired designer Ladislav Sutnar

Above left & middle The Container Corporation of America consistently presented itself to the public by using the best designers and artists. Much of this was facilitated through the guidance of Art Director Charles Coiner and consultant Herbert Bayer. During World War II, CCA regularly produced advertisements which contributed both to CCA's goals and to its support of the war effort through production of paperboard packaging. This pair of ads from 1943 were designed by Jean Carlu in his bold and direct style.

Above right This advertisement was among the early examples of the Container Corporation of America's series of campaigns. Many of these early ads were designed by the French poster designer A.M. Cassandre through the auspices of the N.W. Ayer Advertising Agency in Philadelphia. In this ad from 1938, Cassandre used two powerful examples of strength and beauty in a simple layout.

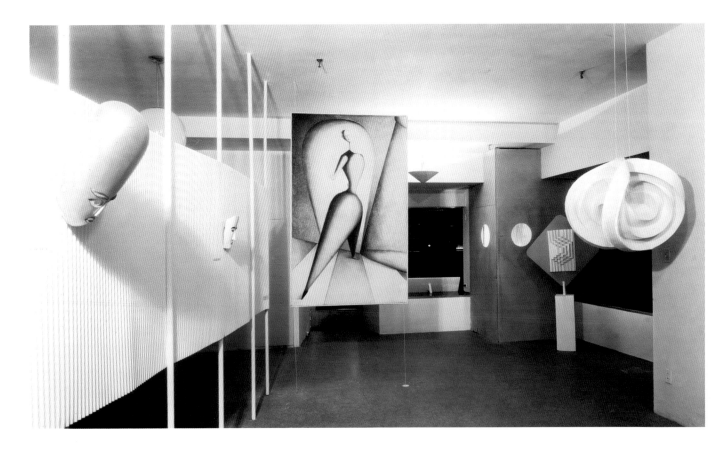

Above In 1938, the Museum of Modern Art in New York held a major exhibition, 'Bauhaus 1919–1928'. The installation was designed by Herbert Bayer who had recently immigrated to the United States. Bayer, in the best Bauhaus tradition, was successful in many fields of art and design, and had previously, in Europe, created numerous museum exhibits using new design techniques. In the first years of his residency in the U.S., Bayer designed a series of outstanding exhibition designs for MoMA. Bayer was an important figure in presenting Modernism to America.

Opposite top Alex Steinweiss was a native New Yorker who adopted a Modernist approach to graphic design and made significant contributions through his work, particularly in the design of album covers. His cleverness as a designer was evident in this cover for *AD* magazine in 1941 in which he gave the triangle a double meaning. This kind of ambiguity was a hallmark of progressive graphic design in that it engages the viewer in the perceptual process.

Opposite bottom Herbert Bayer designed this cover for the December 1939/January 1940 issue of *PM* magazine that featured insert articles on his own work, philosophy, exhibition design and views on typography.

and architect Knut Lonberg-Holm to collaborate on developing a new information system, *Catalog Design*, where a large quantity of complex technical information was organized and made legible and understandable. Architect Richard Neutra referred to Sweet's as a great building-material catalogue. This work was an early model of an important function of graphic design, namely information design. Sutnar, an immigrant designer from Czechoslovakia, expressed his Modernist orientation in defining information design as 'a synthesis of function, flow and form. Function is defined as utilitarian need with a definite purpose: to make information easy to find, read, comprehend and recall. Flow refers to the logical sequence of information. Form means dynamic information patterns and clear rational organization.'[13]

Walter Paepcke, a Chicago businessman, was president of the Container Corporation of America (CCA), the leading producer of paperboard for packaging. He hired Charles Coiner and the Philadelphia-based advertising agency N.W. Ayer to begin a unique and progressive advertising programme. The first ads from the mid-1930s featured A.M. Cassandre's work. Each ad emphasized one functional benefit of using paperboard packaging. Other ads by Cassandre soon followed. Within the CCA corporate organization, designers Egbert Jacobson and Albert Kner, with Herbert Bayer as consultant, supported the goal of making the company appear as modern

as possible. In the 1940s, this corporate philosophy continued with three new advertising campaigns: the first promoting the Allied nations who were fighting together in World War II, the second highlighting each of the then 48 U.S. states, and the third introducing the 'Great Ideas of Western Man' campaign which ran for many years. Coiner and his colleague Leo Lionni worked as art directors on the CCA account and guided these advertising campaigns for many years. The former Bauhaus master Herbert Bayer became a design consultant to CCA and produced numerous ads for the campaigns. In a postwar article, Paepcke expressed his visionary opinion: 'The artist and the businessman should cultivate every opportunity to teach and supplement one another, to cooperate with one another, just as the nations of the world must do. Only in such a fusion of talents, abilities, and philosophies can there be even a modest hope for the future, a partial alleviation of the chaos and misunderstandings of today, and a first small step toward a Golden Age of Tomorrow.'[14]

In one of the later 'Great Ideas of Western Man' advertisements, a quote by Oliver Wendell Holmes received a typographic treatment by contemporary designer Ivan Chermayeff. Holmes's quote read, 'Man's mind, stretched to a new idea, never goes back to its original dimension.'[15] So it was with these new Modernist ideas in American graphic design. Once exposed to these fresh new directions, American designers were no longer interested in looking to the past and preserving the status quo.

MODERNISTS SHOW MODERNISM

The physical manifestation of Modernist form in American graphic design spread through a multitude of posters, brochures, ads, letterheads, books and printed ephemera. For many Americans, their first look at Modernism in art was in 1913, at the Armory Show in New York. This was the first large exhibition of Modern art in America. It was held in the 69th Regiment Armory building in New York. While the show was soundly criticized by the public and press, it impressed many American artists with their first look at avant-garde works by such artists as Picasso, Kandinsky and Duchamp.

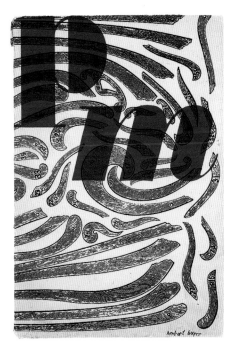

For those in the graphic and commercial arts, exhibits at Dr Robert Leslie's A-D Gallery, extended this new awareness. Other major international exhibits in New York showed progressive works. In 1938, the Museum of Modern Art held a major exhibition of Bauhaus art, design and craft works by both the masters as well as the students. It was entitled 'Bauhaus 1919–1928'. The installation was designed by Herbert Bayer who had arrived in New York that year. In the following year, the Museum of Modern Art (MoMA) showed Lester Beall's posters for the United States Government's Rural Electrification Administration. This was the first presentation of graphic design at MoMA and was an important historic moment of recognition for

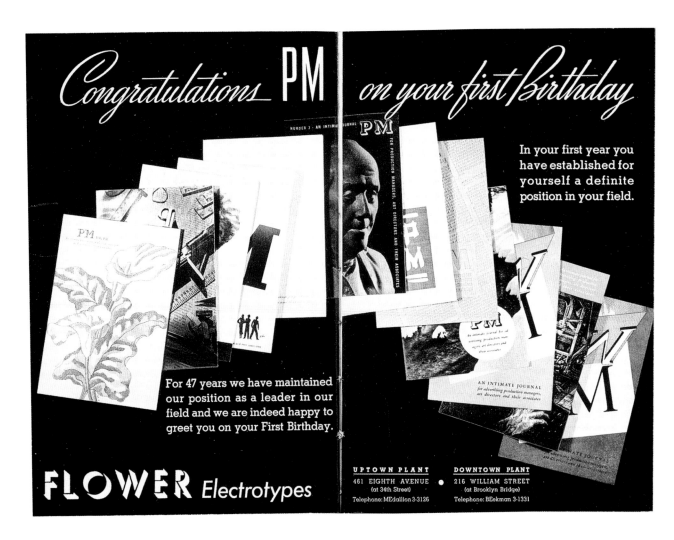

both Beall and the emerging graphic design field. Major and minor galleries continued their advocacy of design during World War II. In 1942, a modest exhibit was mounted at the A-D Gallery entitled, 'Advance Guard of Advertising Artists'. The exhibit featured the work of ten Modernist designers: Frank Barr, Herbert Bayer, Lester Beall, Jean Carlu, György Kepes, E. McKnight Kauffer, Herbert Matter, Laszlo Moholy-Nagy, Paul Rand and Ladislav Sutnar (see page 130). Juried exhibitions were regularly held at the American Institute of Graphic Arts (AIGA) and at the New York Art Directors Club. These competitive events afforded both the immigrant designers and the young Americans opportunities to be judged against their peers, be rewarded for their best accomplishments and gain public recognition. The event also gave these designers an opportunity to meet socially and become acquainted with others in the small design community of New York.

PEOPLE HELPING OTHER PEOPLE
Beyond formal classroom settings, key mentors took special personal interest in helping newly arrived immigrants or emerging American designers.

Dr Robert Leslie was prominent among these. A medical doctor by training, Leslie returned to his love of typography and graphic arts and set up his own typography company in New York called The Composing Room. His company provided typography services for advertising agencies and graphic designers. Between 1927 and the 1942, Leslie welcomed almost every immigrant designer by providing him or her with professional contacts, and featured their work in his intimate graphic arts journal *PM* (changed to *AD* in 1941). The publication was a journal for art directors and production people and, more importantly, was a mirror of what was being produced by the most progressive designers of the time. Usually, Leslie would feature an exhibition at his company's A-D Gallery. The show was accompanied by printed invitations and, concurrently, an insert section which went into the journal. In this way newcomers had a major opportunity for their work to be shown to their peers in New York and, more importantly, to potential business clients. The personal and professional support given by 'Uncle Bob' was substantial and greatly facilitated the introduction of Modernism into American graphic design. Leslie was supported in his interpretive work by editor Percy Seitlin. In a 1941 issue of *A-D*, Seitlin, in typical fashion, commented on how Modernist work should exist side by side with the traditional: 'Things aren't bad just because they are old, nor are they good because they are new. What counts is the harmony, or lack of it, in the relationship between the old and the new.' [16] The issues of *PM* and *AD* as well as the exhibition brochures provide important documentation of this critical early phase of the development of design in the United States. Through his encouraging support of young designers, Leslie played a major role in the development of progressive design in New York.

In Philadelphia, Charles Coiner was a mentor to many immigrants and young designers. At N.W. Ayer, Coiner championed the work of promising young Americans and immigrants. He was able to find a position there for Leo Lionni and worked alongside him on challenging accounts. Coiner hired György Kepes, A.M. Cassandre, Jean Carlu, Fernand Léger, Matthew Liebowitz, Xanti Schawinsky, Herbert Matter and others. Coiner liked to remember that it was he who had welcomed Cassandre at the pier as he arrived from Paris, and that even then he had already lined up a design assignment for Cassandre. For many years, Coiner produced a regular column in *Advertising & Selling* entitled 'Clipping Board', where he showcased what was new in current examples of design, art and typography. Beside the visuals, Coiner added his personal critical commentary. In one issue, he presented an abstract two-page spread from *Junior Bazaar* magazine with the notation: 'Fashion-wise teenagers are evidently more receptive to modern make-up than other magazine readers. Art directors Brodovitch and Liberman point the way for modern-minded editors.' [17]

Opposite *PM* (later renamed *AD*) was a graphic arts journal published by The Composing Room, Inc., a New York-based typography company. The magazine included covers and inserts by many of the accomplished graphic designers of the 1930s and 1940s. This was an advertisement for the Reliance Reproduction Company which produced the photo-engravings for this publication. The photography showed an array of covers from *PM*.

DESIGN LABORATORY
ALEXEY BRODOVITCH

Typographic cover for a brochure promoting classes by Alexey Brodovitch.

Coiner's column soon became an important place for immigrant designers to have their best work shown to peers and prospective clients.

TEACHERS AND STUDENTS

In contrast to schools in Europe, the few American art and design schools that existed were slow to embrace Modernism. Most design, if it was taught at all, was presented in a context of a traditional *beaux-arts* approach. Representational painting and drawing from plaster casts was the norm. However, a few exceptions began to provide hope. Leon Friend was chairman of the progressive art department at Abraham Lincoln High School in New York. Among other activities, he supported an extra-curricular organization that was called the 'Art Squad'. Students were regularly inspired by progressive guest speakers such as designer Joseph Binder, printmaker Lynd Ward and typographer Dr Robert Leslie. They were also assigned creative art and design projects that guided them towards choosing realistic career options for their art. Several important design professionals emerged from this enlightened programme, including Gene Federico and Alex Steinweiss.

On the college or university level, formal education about Modernist design was limited in the United States in the 1930s. Instead, inspired and curious individuals had to seek out the information wherever they could find it. In Philadelphia in 1930, Alexey Brodovitch began teaching design courses at the School of Industrial Design. He would select his most capable students to assist him with work in his professional studio. Later, after his move to New York to work for *Harper's Bazaar* magazine, Brodovitch taught courses in design and photography at the New School. These classes were instrumental in creating a new generation of inspired photographers, designers and art directors.

Later in the 1930s, educational opportunities began to be more widely available with the arrival of key immigrants. Displaced teachers from Europe looked for opportunities in America. Walter Gropius, founder of the Bauhaus, arrived from England in 1937. He made Cambridge, Massachusetts – the home of Harvard University – the Busch-Reisinger Museum and the Massachusetts Institute of Technology (MIT) into the architectural centre of his 'American Bauhaus'. In 1937, Laszlo Moholy-Nagy organized his 'New Bauhaus' in Chicago, supported by businessmen and industrialists. He would engage important progressive designers and artists to teach for him, including György Kepes, Johannes Molzahn, Hin Bredendieck, George Fred Keck, Alexander Archipenko and R. Buckminster Fuller.

What made these courses different was the dramatic move away from teaching design purely from an art perspective to exploring methods for problem solving. At the New Bauhaus, the form-building fundamentals of the Dessau Bauhaus foundation programme was replicated in America.

A student in those early years at the New Bauhaus recalled, 'Moholy outlined his ideas, leaving us bewildered but begging for more … Previous to that we had all been used to designing by looking through books and magazines and getting ideas – that is, taking someone else's. This whole new revolutionary concept of thinking – taking the required elements, the medium, the purpose and arriving at a solution from inside out – was real liberation, and we were just ripe for it … Here was not just a technique … but something that could be applied with no restrictions.'[18] Among the progressive young American designers, another American pioneer, Saul Bass, learned important lessons as a scholarship student of György Kepes at Brooklyn College.

Will Burtin teaching design courses at the Pratt Institute in 1939.

Immigrant designer Herbert Bayer taught a class for the American Advertising Guild in New York from 1939 to 1940. A detailed article in *PM* magazine explained his aesthetic theory and presented student examples. Bayer's course emphasized the importance of a knowledge of psychology and perceptual values in design education. In an introduction to the article, Percy Seitlin wrote: 'Bayer believes in what Sigmund Freud spent a lifetime explaining – that the human mind, like an iceberg, is only partially accounted for by what shows above the surface. The designer's work is important not only to himself but to the larger cause of heightening the imaginative life of the people.'[19] Two students in Bayer's class who would go on to make important contributions as professional designers were Bob Pliskin and Gene Federico.

Paul Rand taught a course at the Laboratory School of Industrial Design and the American Advertising Guild. The Laboratory School, established in 1936, prided itself as being the first school in the nation to devote its entire curriculum to training for the field of industrial design. Every instructor at the school was required to be actively involved in the field while teaching at the school. The Cooper Union also offered courses in design. Several young New York designers who accepted Modernist ideas were Alex Steinweiss, Matthew Leibowitz and Milt Kamens. In Topeka, Kansas, Bradbury Thompson learned of the avant-garde through European magazines in the library at Washburn College. From 1938, New York students were able to take classes from Will Burtin at the Pratt Institute. Burtin, who had recently arrived from Germany, had little knowledge of English. He joked that he taught his students design while they taught him English. These designers, who were busy with maintaining offices at the time, showed their professionalism and commitment to design by passing along their progressive expertise to eager students.

ADVOCACY FOR THE NEW DESIGN

In the late 1930s and 1940s, important supporters of Modernism outside the design professions appeared. In 1931, Gertrude Vanderbilt Whitney

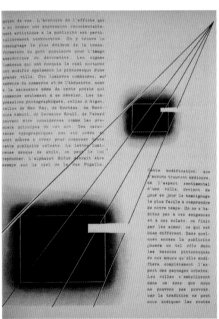

founded the Whitney Museum of American Art in New York, after the Metropolitan Museum of Art had refused the offer to donate her collection in 1929. That same year, the Museum of Modern Art opened and soon led the way towards an awareness and acceptance of Modernism in art. MoMA's founding director was Alfred H. Barr, Jr. More than any other person in the twentieth century, Barr influenced the way we look at the art of our time. His concept of Modernism as an integration of all the arts had evolved during the 1920s. In 1930, MoMA mounted an important exhibition entitled 'Modern Architecture', showcasing most of the world architects who were part of the International Style. In other art exhibits, it presented the works of Pablo Picasso, Paul Klee, Wassily Kandinsky and Max Ernst to New Yorkers. MoMA asked Lester Beall to design fundraising material. Mildred Constantine became a curator of design in the 1940s, and in this capacity championed the cause of graphic design through her connections with designers. Constantine provided space for them to exhibit their work at the museum. Other museums soon joined MoMA in presenting Modernism to America. In 1939, what was to become the Solomon R. Guggenheim Museum opened its doors.

Existing professional organizations and new ones soon responded to the need of this emerging profession. In 1920, the Art Directors Club of New York was formed. This club, which places its focus on advertising, promotional design and media, has long been the sponsor of annual competitive exhibitions, lectures, conferences and social gatherings. Earlier, in New York, the American Institute of Graphic Arts (AIGA), with its roots in printing and graphic arts, evolved into the national organization of choice for professional graphic designers. Since its formation in 1914, AIGA has sustained programming in competitive shows, conferences, publications, projects in the public interest and advocacy initiatives. Also with graphic arts and printing roots, the Society of Typographic Arts (STA) was organized in Chicago in 1927. Attempting to keep pace with the changes in the field, the STA reorganized and changed its name to the American Center for Design (ACD) in 1989. These organizations provided a place for designers to meet their contemporaries in a professional setting. In Chicago in the 1920s, a small group of commercial artists, designers, typographers and book designers organized to meet, share information and advance work collectively. They became known as the 'Chicago 27', and included in the membership were dominant professionals such as R. Hunter Middleton, who designed 92 typefaces for the Ludlow Typography Company, and Egbert G. Jacobson. Lester Beall was involved in the STA during his Chicago years. Contemporary Chicago designer Hayward Blake remembers, 'The "Chicago 27" were real instigators of design. They promoted design and were very open about what they did.' [20] In the 1930s, the design community was a

small one so it was possible in these venues to meet one's peers, compete for awards, have work published, participate in organizational activities, socialize and make important contacts for referrals of new clients and projects.

MODERNISM ARRIVES IN THE MAILBOX

European publicity magazines were the major means by which American designers learned about Modernism in the 1920s and 1930s. American designers such as Paul Rand, Bradbury Thompson and Lester Beall were largely self-educated, and these magazines served as their textbooks. These designers could hardly wait from month to month to receive the latest issue of the magazine in the mailbox or at the library. *Gebrauchsgraphik*, the German design and advertising magazine, regularly featured articles on innovative graphic design and designers in Europe such as Herbert Bayer, Lucien Bernhard or OHW Hadank. From Paris came the magazine *Arts et Metiers Graphiques*. This publication was somewhat more art-oriented but nevertheless featured the work of Alexey Brodovitch, Jean Carlu, Paul Colin and others. Also published in Paris was the magazine *VU*, designed by Alexander Liberman. *VU*, the precursor to *Life* magazine, was a photography and image-dominant tabloid news magazine with photographic essays in bold, striking, full-bleed layouts. From Switzerland, *Graphis* magazine, edited by Walter Herdeg, served as a showcase for emerging and established designers, artists and illustrators around the globe. All of these magazines shared the goal of seeking new and exciting talent in design and art and bringing it to the attention of the world. Later, in the 1950s, Herbert Spencer's journal *Typographica*, produced in England, was a great inspiration to American designers as it featured articles on both traditional and avant-garde typography. Magazines were central to the offices and libraries of Modernist American graphic designers as they provided inspiration and information to a profession in the making.

European books were also important, although they were less available than the magazines. Foreign travellers returned with copies of avant-garde publications such as the *Bauhausbücher* series which documented the masters and teaching at the Bauhaus in Germany. Designers were also naturally curious about many disparate subjects and often added esoteric titles to their libraries. Will Burtin had extensive volumes on nature and science. Several American publications began to feature articles on Modernist design. The issues of *PM* and *AD* produced by Dr Robert Leslie, as previously described, were contributions to the field.

Many young Americans first saw Modernist design in the pages of *Advertising Arts* in their school libraries. Between 1930 and 1935, the journal consistently featured articles profiling progressive designers, elaborated on the roots of Modernism and presented testimonials by

A page from *Vanity Fair* magazine promoting their portfolio of modern French Art.

businessmen on the benefits of this new style. Created as a supplement to the trade publication *Advertising Buying & Selling*, *Advertising Arts* was the first American magazine to publish modern design solely for the benefit of other designers and their potential clients. The journal showcased what the editors thought was important at that time. Industrial designers were also presented in its pages. Work by Norman Bel Geddes, Walter Dorwin Teague, Donald Deskey and Raymond Loewy was included. Of special interest were the articles on layout by Dr Agha in which he translated the artistic ideas of the European avant-garde into practical tools for the American layout artist.

At Condé Nast, Dr Agha regularly provided the American consumer with articles on Modernist art from Europe. Articles, features and even a portfolio of prints of Modernist painters were available though articles and advertisements in *Vanity Fair* magazine. The magazine promoted and marketed a portfolio composed of reproductions of modern paintings. Avant-garde art could now take its place on the walls of American homes.

Circle: the International Survey of Constructivist Art, published in 1931 and edited by Ben Nicholson, was available in America. It interpreted important aspects of this central movement for American designers. This publication contained the first translations of Jan Tschichold's dramatic ideas about new typographic forms. *Commercial Art & Industry*, from England, was also a printed reference in America.

Several books stand out as major sources of Modernist interpretation in graphic design. Douglas C. McMurtrie's book, *Modern Typography & Layout*, was published in 1929. McMurtrie, a printing historian, became an early interpreter of Modernism to American designers. He connected European designers and type founders with the American market as well as showing American designers Modernist models in Europe. He was a contributor to advertising, fine printing, bibliography and the history of printing. His book was the best source of early examples of Modernist typography that was written and published for the American market. Graphic design exemplars by Karel Tiege, Kurt Schwitters, El Lissitzky, Walter Dexel and others were included. In the text the author called for a return to basics as he wrote, 'It is not with mannerisms that we are concerned, but with essentials. And in the bare essentials of the new typography there is substance enough to occupy our thoughtful printers in study and experiment for some time to come.'[21] An influential book from Europe was *Mise en Page (The Theory & Practice of Lay-Out)* by A. Tolmer. This brilliant work, published in 1931, used elements of book design in an avant-garde approach. The pages included mixed-media illustrations such as metallic paper, linoleum printing and embossing. The page layouts of *Mise en Page* predicted the style of many experimental magazines for the next twenty years. Another important book was *DESIGN, The New Grammar of*

Mise en Page, designed by Louis Caillaud in 1931, was an influential avant-garde book that featured free-form and unusual layouts. A. Tolmer, its author, said that in this book the art of layout is free of its bonds but it must carry conviction of its own accord. It was necessary to abandon the strict vertical and horizontal grid of Tschichold. He felt that this reaction to pure geometric form was a new direction for Modernism.

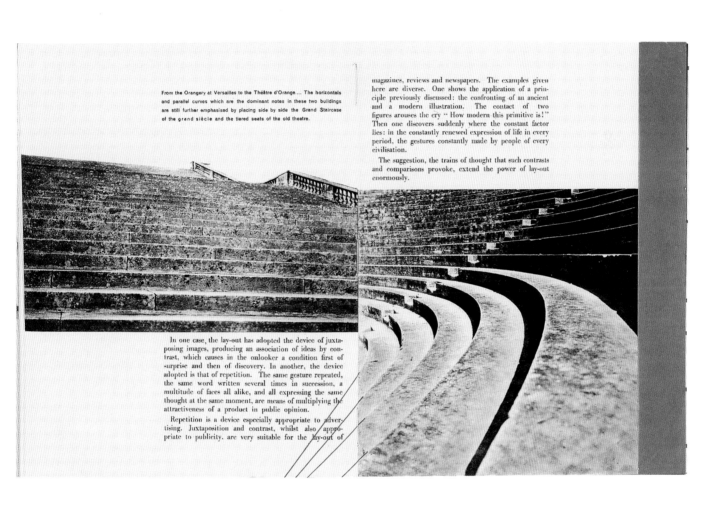

From the Orangery at Versailles to the Théâtre d'Orange... The horizontals and parallel curves which are the dominant notes in these two buildings are still further emphasised by placing side by side the Grand Staircase of the grand siècle and the tiered seats of the old theatre.

magazines, reviews and newspapers. The examples given here are diverse. One shows the application of a principle previously discussed: the confronting of an ancient and a modern illustration. The contact of two figures arouses the cry "How modern this primitive is!" Then one discovers suddenly where the constant factor lies: in the constantly renewed expression of life in every period, the gestures constantly made by people of every civilisation.

The suggestion, the trains of thought that such contrasts and comparisons provoke, extend the power of lay-out enormously.

In one case, the lay-out has adopted the device of juxtaposing images, producing an association of ideas by contrast, which causes in the onlooker a condition first of surprise and then of discovery. In another, the device adopted is that of repetition. The same gesture repeated, the same word written several times in succession, a multitude of faces all alike, and all expressing the same thought at the same moment, are means of multiplying the attractiveness of a product in public opinion.

Repetition is a device especially appropriate to advertising. Juxtaposition and contrast, whilst also appropriate to publicity, are very suitable for the lay-out of

Above In the 1930s, it was common for industrial
designers to also design trademarks, packaging
and advertising. Walter Dorwin Teague, the dean of
1930s' industrial designers, designed this all-plastic
Brownie camera for the Eastman Kodak Company
in 1934. In addition to the product design, he also
created the packaging. The camera and packaging
design reflected the influence of Art Deco style at
the time.

Opposite top The Chrysler Corporation produced
the 'Airflow' car in the 1930s, applying form
suggested by both the aesthetics of the streamline
style and scientific aerodynamic principles. This
car, which did not prove profitable, made a
definite break with previous car designs. It did
influence future automotive design, especially in
the famous Zephr model by Lincoln.

Opposite bottom This unique locomotive
was designed by Henry Dreyfuss in 1938 for the
New York Central System. It was for the 'Twentieth
Century Limited' train. The design exemplified
and symbolized the style of the 1930s in its
streamlined, aerodynamic form. In effect, this
locomotive was the icon of the 1930s' product
design in America.

Advertising, written by James T. Mangan. It presented visual fundamentals
accompanied by many examples of progressive design applied to advertising.

PICTURE POWER IN ADVERTISING

In the 1930s, advertising was in transition between the era of the great
copywriter and of the illustrator who generally was more fine arts oriented.
These illustrators were to provide the first major move towards a visual
emphasis in promotional communications and advertising. The decade was
the heyday of illustrators such as McClennan Barclay, Jimmy Williamson and
René Clark. The role of the art director evolved to one who integrated the
various parts of an ad and determined the right illustrator for the job. This
layout work was passed along to the next person in the production line.
Despite this traditional organization, avant-garde ideas were finding their
way into advertising. Form was regarded as an expression of function. 'How
you said it was as important as what you said.'[22] Beauty as well as utility
became part of function. This was a major way in which the designers' new
responsibility became intensified in marketing communications.

Ernest Caulkins, the progressive American advertising executive, was one
of the few businessmen in advertising who understood Modernism and its
benefits. In his ads he had attempted something different, namely to equalize
the relationship between text and image. He said, 'It offers the opportunity
of expressing the inexpressible … expressing not so much a motor car,
but speed; not so much a gown, but style.'[23] Among American designers,
Bradbury Thompson and Lester Beall led the way in this new direction.
For these three men, there was no distinction between the formal values
brought to advertising or graphic design. It was all the same new language.

INDUSTRIAL DESIGNERS SUPPORT THE CAUSE

A philosophical battle emerged between design disciplines in the 1930s.
It was concerned with determining which field was at the heart of design.
Industrial design was an important discipline which influenced Modernism
and graphic design. Arthur Pulos, designer and teacher, defined industrial
designers as men believed to be in touch with the realities of the machine
yet capable of speaking the public's language.[24] Architects, too, wanted to
feel that they were the chief designers of the times and that any Modernist
design of note came from their offices. There is no question about the
importance of this connection, but the dichotomy of ownership was evident
in these years as industrial design, like graphic design, was seeking its
direction in America.

In New York in 1934, the Metropolitan Museum of Art hosted an exhibition
of industrial art in modern home furnishings. While the museum was still
preoccupied with the idea that all design should derive from architecture,

the show did provide for a showing of new modern products by important American industrial designers. In 1937, Clarence Hornung wrote, 'The industrial designer speaks a complex language, related to advertising design, packaging, stage design, merchandising design and mechanical engineering.'[25] Among others represented were Walter Dorwin Teague, Raymond Loewy, Donald Deskey, Gilbert Rohde, Gustav Jensen and Russel Wright.

THE STYLE OF ART DECO

While artists and the general public embraced the Art Deco style, designers were sceptical of its value. Some referred to the style negatively as 'the modern deprived of its manhood'. The ongoing construction of New York Art Deco skyscrapers in the late 1920s and 1930s helped focus industrial designers and others on streamlined forms in their design. Art Deco became so popular that it was used to market items as diverse as radios and bathroom scales, packaging and railroad engines. In 1938, the magazine *Architectural Forum* wrote that Henry Dreyfuss's design for the New York Central System's Twentieth Century Limited train was 'a new mercury in a much more luxurious form. Its engine remains one of most distinctive type forms of the era.'[26] The 1934 Chrysler Airflow automobile, although not a commercial success, showed the influence of this penchant for speed and streamlining. The sleek lines seemed to be the very essence of the modern machine age.

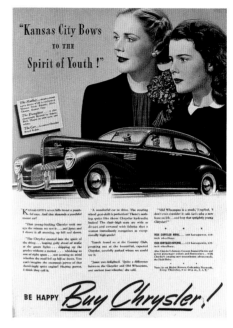

Graphic designers were carried along with this interest in Futuristic-like, streamlined form. Brodovitch, Beall and Carlu produced posters and other graphics in the 1930s which reflected implied motion. The form was also characterized by zig-zag style and a revival of interest in American Indian, Aztec and Egyptian art. It was a look of contrast between dynamism and simplicity. Although popular, it was also a controversial influence in graphic design. One critic referred to Art Deco style as suggesting 'the staccato rhythm of the assembly line'.[27] Another, a prominent industrial designer, wrote that in Art Deco, the clichés of the past were exchanged for an ill-digested present-day formula. Self-styled designers blindly applied ornament to the surface of form – in itself badly planned.'[28]

A LOOK AT THE FUTURE

The Great Depression that had gripped the United States for a decade was beginning to wane by 1939. America and the world needed something that was positive and forward-looking. The time was perfect for an international event, and New York again supplied the magic setting. There could not have been a more exciting opportunity to celebrate Modernism than at the New York World's Fair of 1939–40. The event was conceived as an exposition of technological advances that would emphasize social and historical relevance,

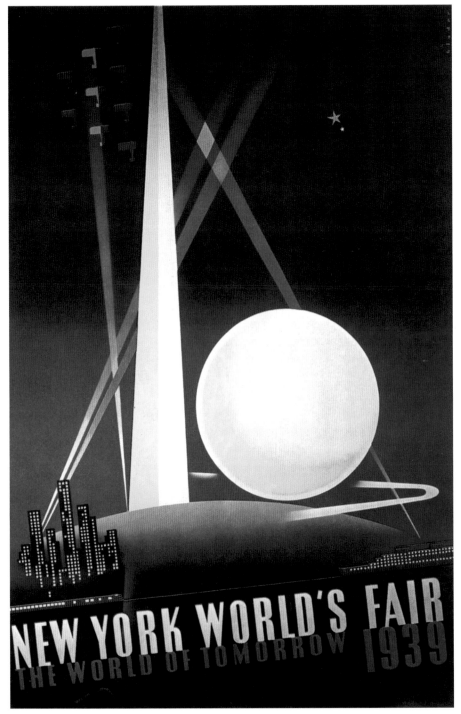

Above left This poster was one of the memorable icons of the 1939 New York World's Fair. It was designed by Joseph Binder and was effective largely because of its directness and simplicity.

Above right, top Alvar Aalto, the distinguished architect from Finland, designed this Finnish Pavilion for the 1939 New York World's Fair. Widely hailed as the outstanding interior design of the Fair, Alto was inspired to create an evocation of the Finnish landscape. All the displayed objects were constructed of wood and integrated in this collage-like organization.

Above right, bottom The New York World's Fair in 1939 provided America with a utopian look into the future. Many Modernist designers were working side by side with American architects and designers to create buildings, exhibits and publications for the fair. One of the highlights of the Fair was the General Motors Futurama's exhibit 'Highways and Horizons', in which scale models of cars moved about in a futurist city. Spectators were seated in a moving platform around the display. This photograph was of a designer putting finishing touches on the exhibit.

as a 'fair of the future'. A unified whole, it represented all the interrelated activities and interests of the American way of life.

Located in Flushing Meadows, the theme of the fair was 'The World of Tomorrow'. The skyline was dominated by two huge geometric objects. The sculptural trylon and perisphere became the symbols of the fair. Industrial designers Walter Dorwin Teague and Gilbert Rohde participated in the original planning, begun in 1935. Modernist designers of all persuasions – architects, interior designers, graphic designers – were represented in the various structures and promotions of the fair. Will Burtin designed a major exhibit for the United States Federal Works Agency. This exhibit featured four free-hanging displays representing education, libraries, recreation and conservation. Twenty-four years later, in 1964, Burtin again was to design for a World's Fair, at the same site, this time for the Eastman Kodak Company. Ladislav Sutnar designed the Czechoslovakian Pavilion, but it was never built due to the outbreak of war in Europe.

The fair provided many designers with exceptional opportunities for work and exposure. Paul Rand designed a booklet, *A Design Student's Guide to the New York World's Fair*, which was published as an insert in *PM* magazine. The Laboratory School of Industrial Design in New York sponsored the section which presented noteworthy buildings and exhibits at the fair and highlighted the designers involved. Attractions recommended were the Communications Focal Exhibit designed by industrial designer Donald Deskey, known for his interior designs at the Radio City Music Hall. Also recommended in the student guide were the Food South Focal Exhibit designed by Russel Wright, the Theme Center, the Perisphere and AT&T building by Henry Dreyfuss, a mural in the Medicine and Public Health building painted by Alexey Brodovitch, the North Carolina exhibit designed by Xanti Schawinsky, the Finnish Pavilion by Alvar Aalto, the Swiss and Glass Industries exhibits by Herbert Matter, and the Eastman Kodak, Ford and US Steel exhibits designed by Walter Dorwin Teague. The General Motors building and Futurama exhibit were designed by Norman Bel Geddes. Lewis Mumford optimistically set the theme for the fair by hoping that it would 'lay the pattern for a way of life which would have an enormous impact in times to come'.[29]

The New York World's Fair showed America and the world the synergy of Modernist expression. The way in which designers, planners, architects and sponsors alike shared the common view of Modernism was impressive. This visionary opportunity was nurtured in a very special creative environment. The event demonstrated how progressive design might reach its full potential in America. Following the fair, the Modernist ethic was extended by highly visible exhibitions, demonstrations and manifestos that were printed in avant-garde publications. Sutnar predicted this evolution of

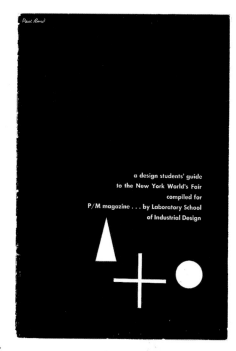

a design students' guide to the New York World's Fair compiled for P/M magazine . . . by Laboratory School of Industrial Design

This is a cover designed by Paul Rand for an insert in *PM* magazine in 1939 which highlighted important buildings and exhibits at the New York World's Fair for the benefit of design students. Rand's use of the geometric shapes on the cover communicated the essence of the symbolism of the Fair. The insert pages and spreads were equally interesting in the use of silhouetted photographs with typography in the layouts.

Donald Deskey designed this introductory page from the souvenir book of the New York World's Fair in 1939. President Franklin Roosevelt expressed his best wishes and vision for the Fair. The book was a dynamic view of many of the important exhibits and buildings at the Fair and was realized with active page layouts composed of photographs and contrasting type elements.

graphic design in America when he wrote, 'We have readily accepted the rapid tempo of advances in science and technology where the inventions of yesterday are today's realities. Similarly, the potential advances of today's new graphic design are building a knowledge of design vocabulary which will be taken for granted tomorrow. And the creative forces at work will find their basic validity in terms of the human values of sincerity, honesty and the belief in the meaningfulness of one's work, in people who disregard material advantages for the sake of new experiments that will make future developments possible.'[30] This statement proved the value that Modernism had for design and how it had taken hold in America.

Martin Greif, in his book *Depression Modern*, summed up the decade as he wrote, 'America in the 1930s, down on its luck, but believing nonetheless in the material benefits of mechanized progress, sought its way out of the Depression not through a nostalgic return to its pre-industrial past, but through the creation of new objects, of needed and necessary things, well-designed and inexpensively mass-produced. While some sang cynically of paper moons on cardboard seas, others dreamed, optimistically, of an American era in which everyone, rich and poor alike, would share in the material riches of the nation – of a time in which all Americans would own a multitude of simple, useful, beautiful objects bought in stores created consciously as a golden mean between the five-and-dime and Tiffany's.'[31]

By the end of the 1930s, Will Burtin saw Modernism starting to become ingrained in American free enterprise. Speaking of the cost benefits of good design, he wrote, 'The vocabulary of visual communication develops rapidly as art and science grow together again. Under the impact of this trend and despite trash and the belief that "advertising is sales promotion only" boys, the value of modern design even on that basis proves itself, and makes the cash register ring more often.'[32]

The diverse designers, clients and customers of New York who embraced Modernism exemplified how progressive ideas, when engaged in a dynamic process, can emerge into a new synthesis. This description is not unlike the very nature of New York City itself. In this unique crucible of creativity, a difficult and demanding decade came to an end. But Modernism would have to wait, gestating a little longer in America, before coming to full maturity at mid-century in America.

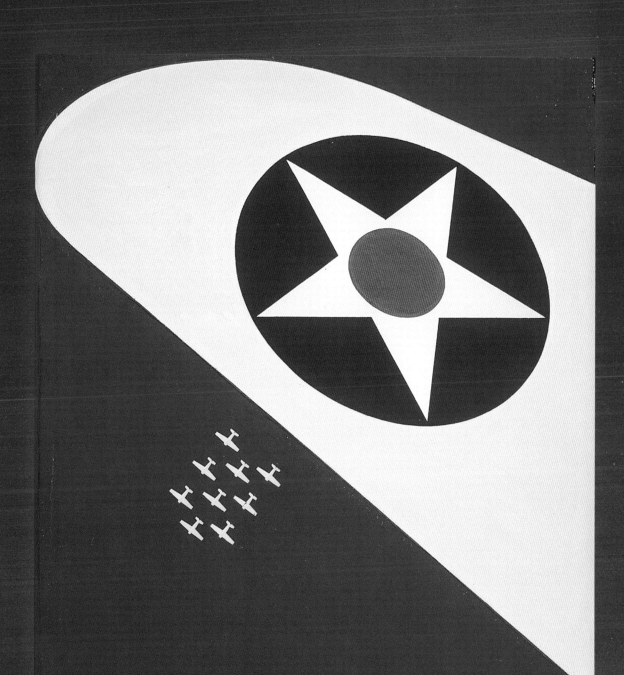

AIR CORPS U.S. ARMY

At War and After:
The Creative Forties in America 1940 – 1949

'In the perspective of fifty years hence, the historian will detect in this decade
a period of tremendous significance. He will see it as a period of criticism,
unrest and dissatisfaction to the point of disillusion when the new aims were
being sought and new beginnings were astir. Doubtless he will ponder that,
in the midst of worldwide melancholy owing to an economic depression,
a new age dawned with invigorating conceptions and the horizon lifted.'

Norman Bel Geddes, *Horizons*

THE WORLD MARCHES TO WAR

In the late 1930s, federal projects and war preparations put Americans back
to work. With events like the New York World's Fair, a feeling of hope for
the future was in the air. The fair showed the world the promise of America's
technological leadership. This feeling conflicted with concerns for the
inevitability of war in Europe. Then World War II began with Hitler's
invasion of Poland in September 1939. In spite of the isolationist majority
in the United States, America was left with no alternative after the surprise
bombing of Pearl Harbor by the Japanese on 7th December 1941. America
had to commit itself to full support of the war effort. The war and the
postwar return to a vital consumer economy were to set the stage for great
changes in graphic design.

GRAPHIC DESIGNERS SUPPORT THE WAR

In 1939, the British magazine *Art and Industry* featured a special issue
entitled 'The Artist's Function in Time of War'. The editor wrote, 'War in
Europe must inevitably affect many of those engaged in Art for Industry
somewhat adversely. There will be much less advertising; much less call
for magazine and newspaper illustration; industrial design and styling must
await the return of peace; and a great many artists, designers, art schools,
teachers and students will be compelled to find some other outlet for their
activities and an alternative source of income.'[1]

While many New York designers such as Will Burtin, William Golden
and Gene Federico went into military service, the few graphic designers
who were not active helped the war effort as best they could. In July 1942,
the U.S. government established the Office of War Information. Bradbury
Thompson, along with Tobias Moss, William Golden and others worked
in this office, producing propaganda material. Later, Golden designed
publications targeted at military personnel in Europe. In 1945, Burtin
worked for the Office of Strategic Services and then the Army Air Corps

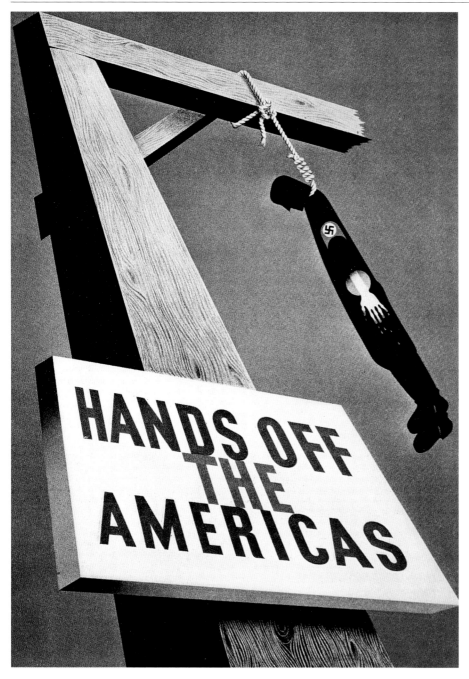

Opposite During World War II, Will Burtin worked as a designer for the Office of War Information. As a part of this effort, he designed, in 1944, a series of instructional books to support training U.S. Air Force personnel in gunnery procedures. Shown here is a page from one of the manuals. This project was noteworthy in that, because of the functional aspects of the information, Burtin shortened the training time for the course from six months to six weeks.

Left New York designer Alex Steinweiss created this poster in 1942. A graphic with high impact, it was very clear in suggesting the consequences of Axis penetration of the Americas.

NATIONAL WAR FUND SYMBOL CUTS

The National War Fund symbol was widely used as the insignia for the 1943 campaigns for war relief agencies. More than 132,000,000 pieces of printed campaign literature were issued carrying the symbol alone or in combination with established local identification.

Its use is recommended as a means of more effectively tying in with the national effort. The symbol has been designed for use in national media, printed promotional material, for state war chests, and for local war chests.

It may be used with or without the following lettering: "National War Fund" and "For Our Own—For Our Allies". It may be combined with local community chest or war fund symbols where this seems desirable.

Electrotypes of the symbol are available as shown herewith. Mats are also available. Reproductions in other sizes may be made from glossy photographs.

Electrotypes, mats and photographs are available through your State director.

FOR OUR OWN.- FOR OUR ALLIES

No. 1
2" x 1⅞"—two color electro with lettering or **without** lettering...**$1.00**

No. 2
2" x 1⅞"—one color electro with lettering or **without** lettering... 50¢

No. 3
1" x 1"—two color electro with lettering or **without** lettering....**$1.00**

No. 4
1" x 1"—**one** color electro with lettering or **without** lettering...... 50¢

No. 5
¾" x ⅝"—two color electro. Available **without** lettering only......... 75¢

No. 6
¾" x ⅝"—**one** color electro. Available **without** lettering only......... 50¢

No. 7
5" x 4⅝" — two color electro with lettering or **without** lettering**$2.00**

No. 8
5" x 4⅝" — **one** color electro with lettering or **without** lettering**$1.00**

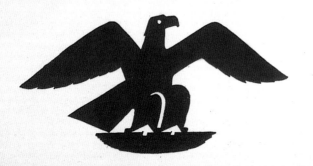

Please enter your order **through your state director.** Ask for NWF Symbol Cut No. (........). Be sure to specify whether with or **without** lettering on top and bottom of symbol.

NATIONAL WAR FUND
46 Cedar St., New York 5, N. Y.

NWF35—1-44

148

developing new instructional manuals. His training manuals on gunnery procedures for the B-25 bomber were noteworthy because they shortened the length of the gunnery course from six months to six weeks. These manuals are among the exemplars in graphic design and especially that facet called information design.

Design activity, like industrial war production, was diversified across the United States. In Philadelphia, Charles Coiner, who had volunteered his services to the government in the 1930s, again offered his professional talents as a consultant. Among his many wartime projects was the design of a graphic symbol system for the Citizens Defense Corps, later called the Office of Civil Defense. This project predicted the corporate design systems of the 1960s. It became well-known in America through the printing of the symbols on armbands for air raid wardens and on many other applications.

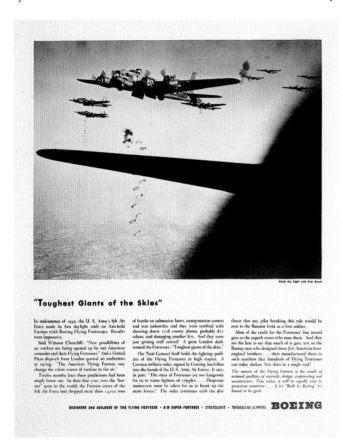

Opposite Charles Coiner designed this mark for the National War Fund in 1943. It was widely used in America during the war as part of the programme to raise donations for the war effort.

Above left The art director for this 1942 Boeing advertisement was Charles Coiner. Coiner used a straight 'news' approach as though the ad were an article. It was direct, informative and appropriate marketing during World War II.

Above right Charles Coiner was asked during World War II to design a system of marks for the Citizens Defense Corps (later known as Civil Defense.) The Civilian Defense Corps was a volunteer organization in the United States to ensure homefront defense in case there was an attack directly in the U.S. mainland. Coiner developed a complicated series of related symbols for bomb squads, nurses, firemen, etc – shown here is the parent mark and other marks from the system.

It was effective because of its Modernist logic, simplicity and geometric construction.

Overleaf Jean Carlu designed this poster in 1941. In retrospect it is generally seen as one of his most effective posters and certainly one of America's greatest propaganda posters of World War II. It was successful because of its impact and the appropriateness of the symbols selected for the illustration element.

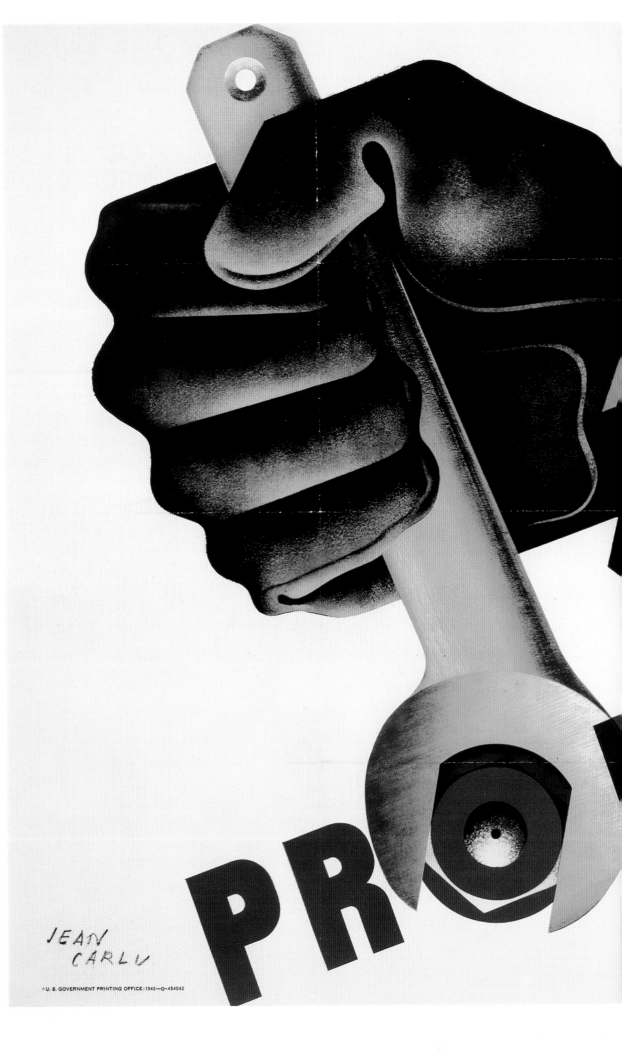

JEAN
CARLU

© U. S. GOVERNMENT PRINTING OFFICE:1942—O—454042

PRO

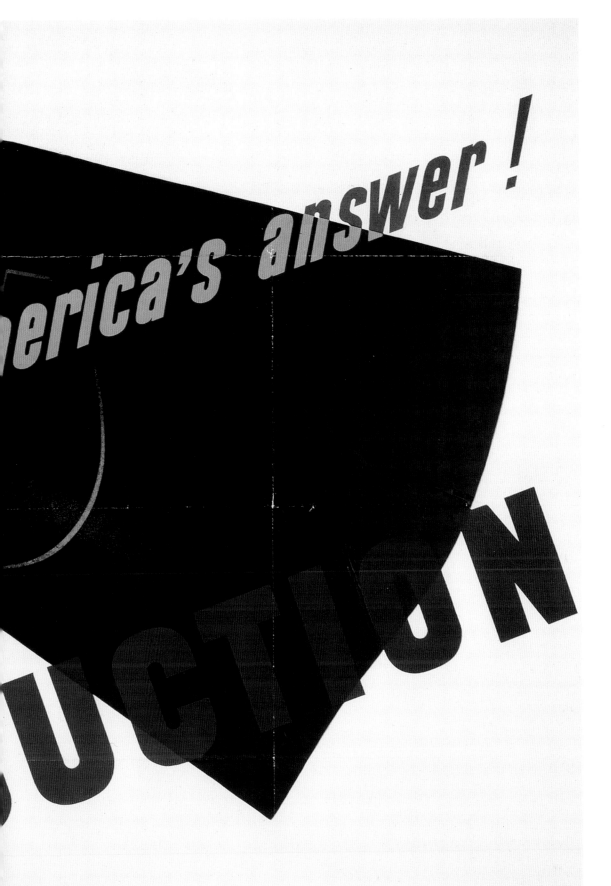

DIVISION OF INFORMATION
OFFICE FOR EMERGENCY MANAGEMENT
WASHINGTON, D.C.

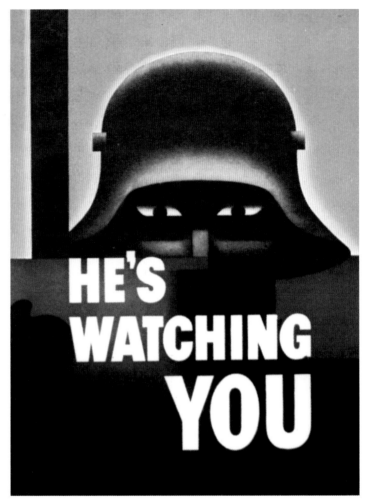

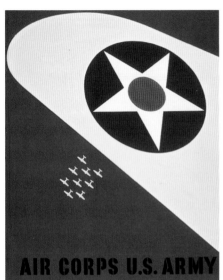

Coiner also assisted the Office for Emergency Management in art directing propaganda posters. As a part of this programme, designers produced dramatic posters to support the war effort on the home front. Coiner was art director for the poster 'Production: America's Answer'. It was designed by Jean Carlu and was widely hung in factories and industrial plants. Glenn Grohe designed an important but controversial poster entitled 'He's Watching You', in which a Nazi soldier is staring over a wall at the viewer. This poster caused confusion for many war plant workers because of its degree of abstraction. This stylistic problem led to a more representational style of imagery such as J. Howard Miller's image of 'Rosie the Riveter' showing off her strong arm in the poster entitled, 'We Can Do It!' Other powerful posters were designed by the immigrants Leo Lionni and Joseph Binder. George Giusti also contributed his considerable talents in support of the war effort by designing posters and collateral print materials.

Lester Beall was ineligible for the draft because of his age. On his war poster 'Don't Let Him Down', Beall used active graphic images in the cause of national patriotism. His trade ads for *Collier's* magazine foreshadowed

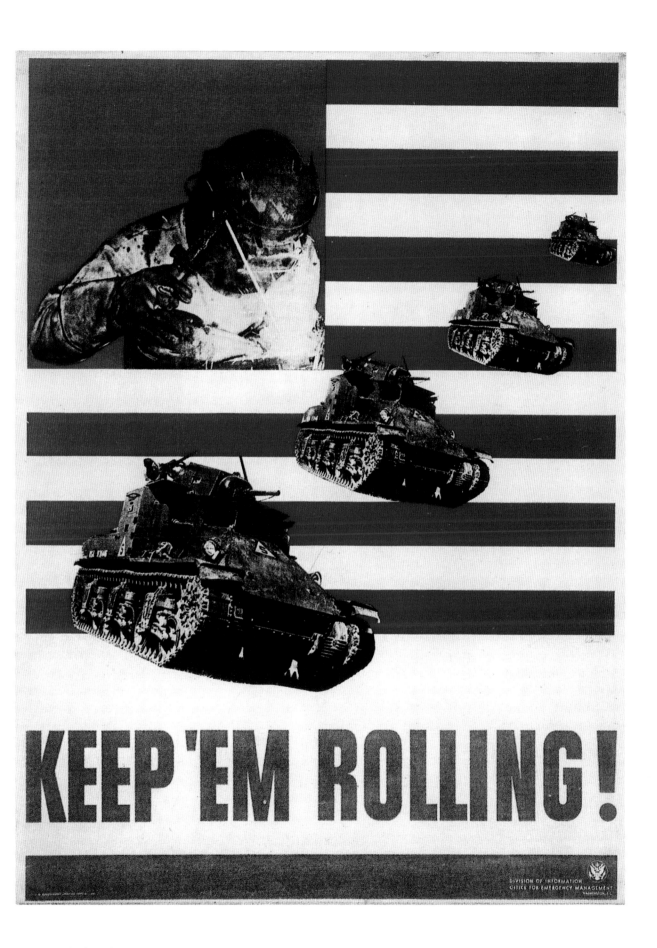

Below George Giusti designed this cover for *Fortune* magazine in August 1942. The simple, bold and dynamic rendition of a Navy airplane was characteristic of Giusti's style. The issue featured an article on the U.S. Navy.

Opposite Lester Beall's 1942 wartime propaganda poster, 'Don't Let Him Down', was forceful in its use of diagonals and arrow forms. The words say 'down' and the arrow points down, which made this poster an example of useful repetition.

America's entrance into the war in Europe through their indirect messages such as in the 'Hitler's Nightmare' advertisement. His ad 'Will There Be War?' captured the dilemma facing America at that time. Beall also designed a publication for the Air Corps in which he translated, through dynamic typography, layout and photomontage, the action of military air engagement. Later, in 1942, he designed a large-format publication, working with Nelson Rockefeller, to promote unity among the South American allies. This brochure, entitled 'Hacia La Victoria' (Towards Victory), featured text in Spanish by Carl Sandburg and photographs by Edward Steichen. These elements combined to create a dramatic series of pages.

Richard Edes Harrison designed many maps for *Fortune* magazine which gave Americans on the home front a better geographic view of the war. Of particular interest were the ways in which Harrison created new and

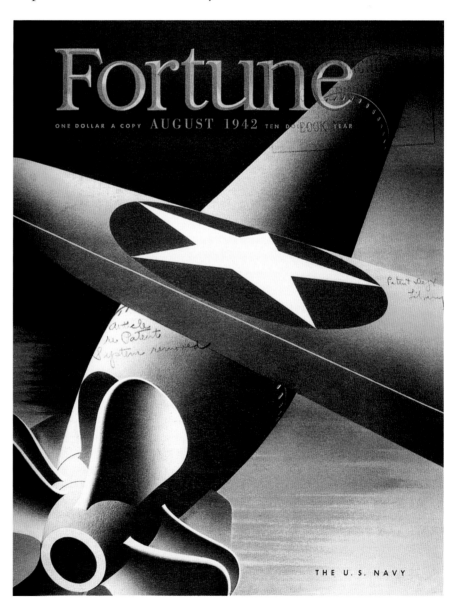

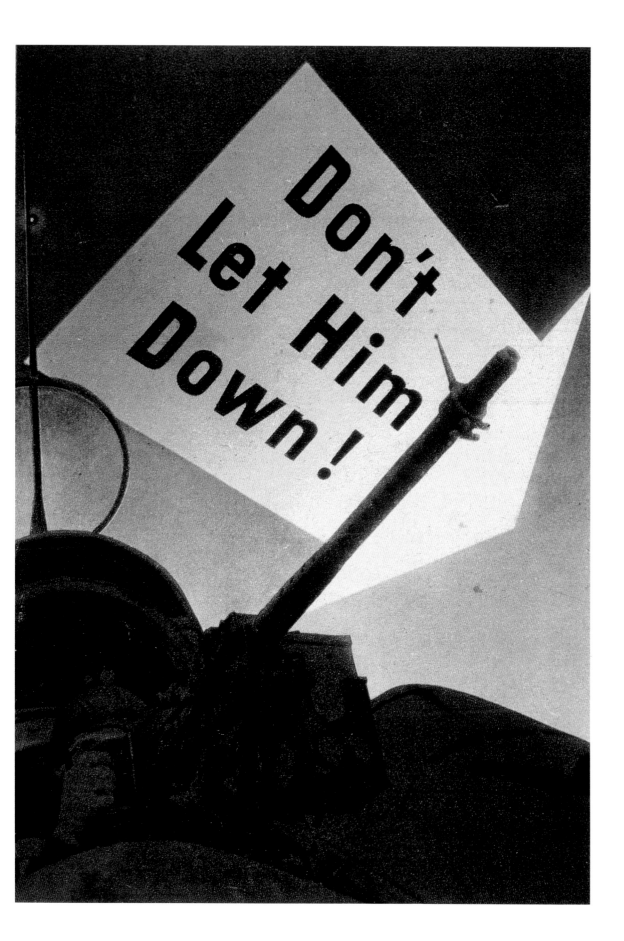

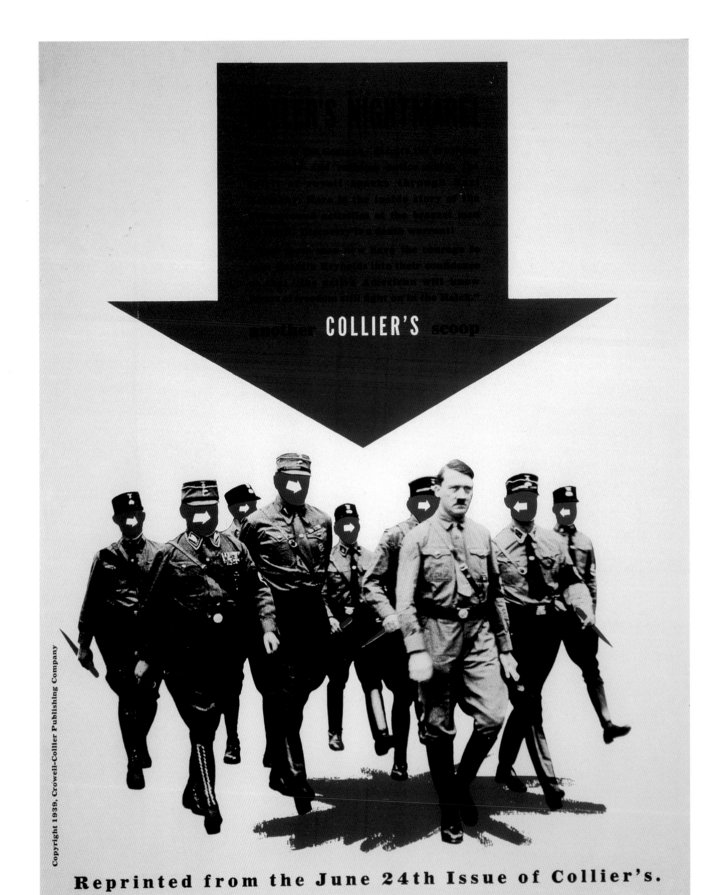

another COLLIER'S scoop

Reprinted from the June 24th Issue of Collier's.

Opposite A trade ad for Crowell Publishing Company, produced by Lester Beall in 1939, predicted America's fear of Hitler and the Nazi tyranny in Europe. Entitled 'Hitler's Nightmare', the advertisement is a piece of powerful communication with the use of the large, blood-red arrow forcing the viewer to this image of the marching Hitler and his soldiers. Beall retouched the background of the photograph and the faces of the storm troopers, replacing the faces with red arrows pointing in towards Hitler.

Below In 1939, there were two opinions as to America's geopolitical direction, namely whether they should continue to practise isolationism or join the Allies in the war against Germany in Europe. This trade ad for Crowell Publishing Company was designed by Lester Beall and it asks the question: 'Will there be war?' The image was powerfully crafted by Beall with the larger-than-life hand print underneath a smaller, silhouetted photograph of Winston Churchill, the prime minister of England. Beall was fond of using ambiguity as a theme in his graphic design and this ad is a prime example of the technique.

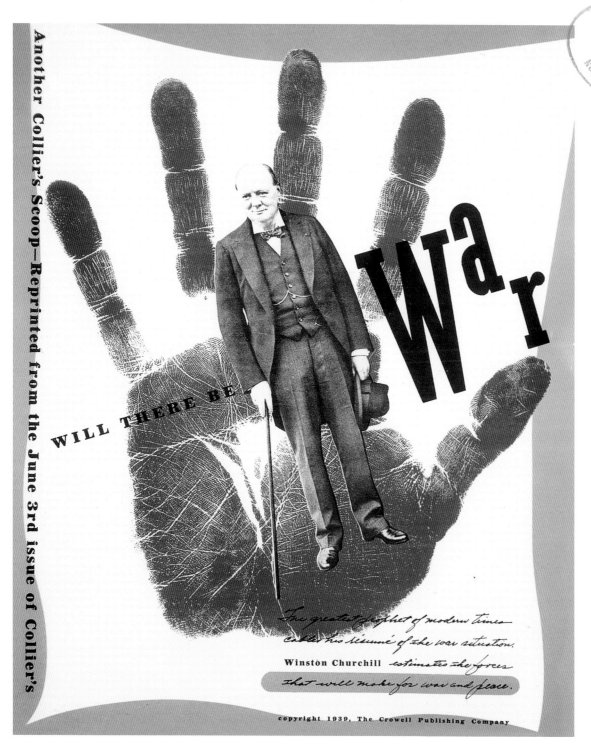

At War and After: The Creative Forties in America 1940–1949

Eight Views *of the World*

THE U.S: *its geographical isolation is more seeming than real*

ICELAND: *kingpin of the North Atlantic*

EUROPE: *more close neighbors than any other continent*

AFRICA: *around this premontory trade must detour*

ARGENTINA: *a dagger pointed at the heart of Antarctica*

AUSTRALIA: *island continent to which distances are great*

ALASKA: *causeway to the World Island*

ASIA: *the cradle of civilization, the grave of conquest*

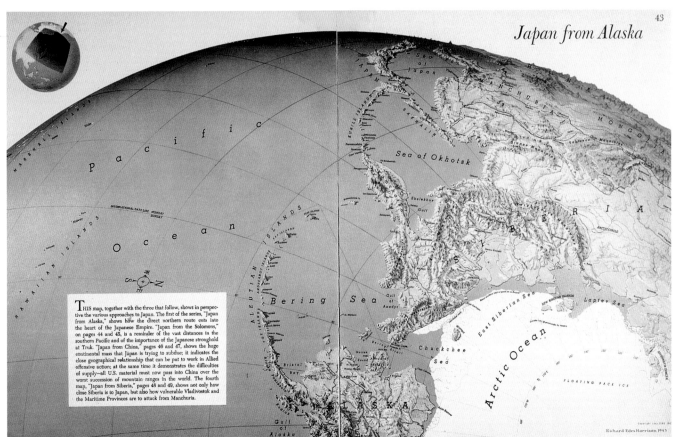

Japan from Alaska

THIS map, together with the three that follow, shows in perspective the various approaches to Japan. The first of the series, "Japan from Alaska," shows how the direct northern route cuts into the heart of the Japanese Empire. "Japan from the Solomons," on pages 44 and 45, is a reminder of the vast distances in the southern Pacific and of the importance of the Japanese stronghold at Truk. "Japan from China," pages 46 and 47, shows the huge continental mass that Japan is trying to subdue; it indicates the close geographical relationship that can be put to work in Allied offensive action; at the same time it demonstrates the difficulties of supply—all U.S. material must now pass into China over the worst succession of mountain ranges in the world. The fourth map, "Japan from Siberia," pages 48 and 49, shows not only how close Siberia is to Japan, but also how vulnerable Vladivostok and the Maritime Provinces are to attack from Manchuria.

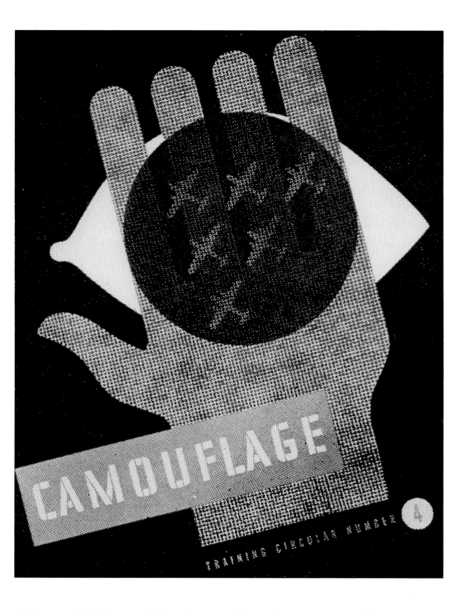

Opposite During World War II, the American public needed clear information about the status of the war. One designer who contributed significantly to this need was the map illustrator Richard Edes Harrison. His colour maps for *Fortune* magazine, this one from 1944, provided unique views of locations around the world where the war was being fought. This page shows eight views of the world and a view of Japan from Alaska.

Left During World War II, Alex Steinweiss designed for the United States War Department. This cover for a periodical on camouflage training was done in 1943. In the layout, Steinweiss showed his skill at integrating symbols and typography into a unified publication cover.

different global views of the theatres of war. Later, in 1944, Harrison published these maps in a book entitled *Look at the World: the Fortune Atlas for World Strategy*. In Chicago, Gyorgy Kepes and Robert J. Wolff supported the war effort by conducting a class in camouflage design at the Institute of Design. Illustrators also used their talents to help the war effort. Norman Rockwell painted a series of dramatic posters on the themes from President Roosevelt's famous 'Four Freedoms' speech and continued to create covers for the popular *Saturday Evening Post* magazine on poignant war topics. The posters extended the impact of the speech and provided important reminders to Americans about their country.

A NEW DEFINITION OF GRAPHIC DESIGN

Although advertising was scaled back during the war, with few new products coming on the market, the layout man, the illustrator and the account

salesman persisted as the principal figures in the advertising business. However, the great age of American illustration was coming to an end. Pictorial artists such as Robert Fawcett, Austin Briggs, Steven Dohanos, Douglas Crockwell and others serviced the needs of traditional print advertising. A close tie still existed between the areas of typography, printing or 'the graphic arts' and graphic design. For example, the American Institute of Graphic Arts (AIGA) to this day carries its original name. Now a graphic design advocacy organization, AIGA remains as a legacy of the unity of these disciplines from the 1920s through the 1950s. The traditional connections between the fields lingered as dramatic changes in the 1940s became the crucible from which modern graphic design emerged. The advertising layout man and the illustrator were being replaced by the graphic designer, whose work was based on Modernist precepts. The influences of the Bauhaus were modified and adapted for the American business scene. 'Given a climate ripe for change, the idea that visual communication could be both powerful and simple was a radical – but fashionably pragmatic – idea.'[2] Graphic designers interpreted beauty as an element of function, and a great debate raged between advocates of maximum typographic legibility and those who were more interested in experimentation. While this philosophical battle raged, the emerging role of the modern graphic designer was that of 'a conceptual problem-solver who engaged in the total design of the space, orchestrating words, signs, symbols and images into a communicative entity'.[3] In 1940, Laszlo Moholy-Nagy wrote that he saw in America 'a new generation was rising with the potentiality and discipline of that America imagined by us in Europe'.[4]

As we have seen, the art world had an important impact on graphic design in the 1940s. Many of Europe's great artists had emigrated to New York and found a community amongst the designers. With the numbers of Modernists from the design, art and architecture worlds in residence in the United States during the 1940s, graphic designers found inspiration and support for their innovations close at hand. Despite the presence of these substantial figures in related fields, in the 1940s the scarcity of great American graphic designers was conspicuous. Herb Lubalin recalled, 'They could be counted on one hand in the 1940s and on both hands in the 1950s.'[5]

Changes in the field were coming, as was apparent in the new directions in magazine design. The progressive magazine designs of Dr M.F. Agha at Condé Nast magazines, Alexey Brodovitch at *Harper's Bazaar*, Alexander Liberman at *Vogue* and Frances Brennan at *Fortune* magazine were obvious proof of the new look in editorial design. Will Burtin became art director of *Fortune* magazine in 1946, bringing with him a new visual sensibility to the magazine. The ideal professional for the position, Burtin was able to connect a new design sensibility to the optimistic postwar economic boom. Burtin

Opposite This 1945 cover for *Vogue* magazine is among the classic designs by art director Alexander Liberman. It is a powerful cover with a poster-like impact.

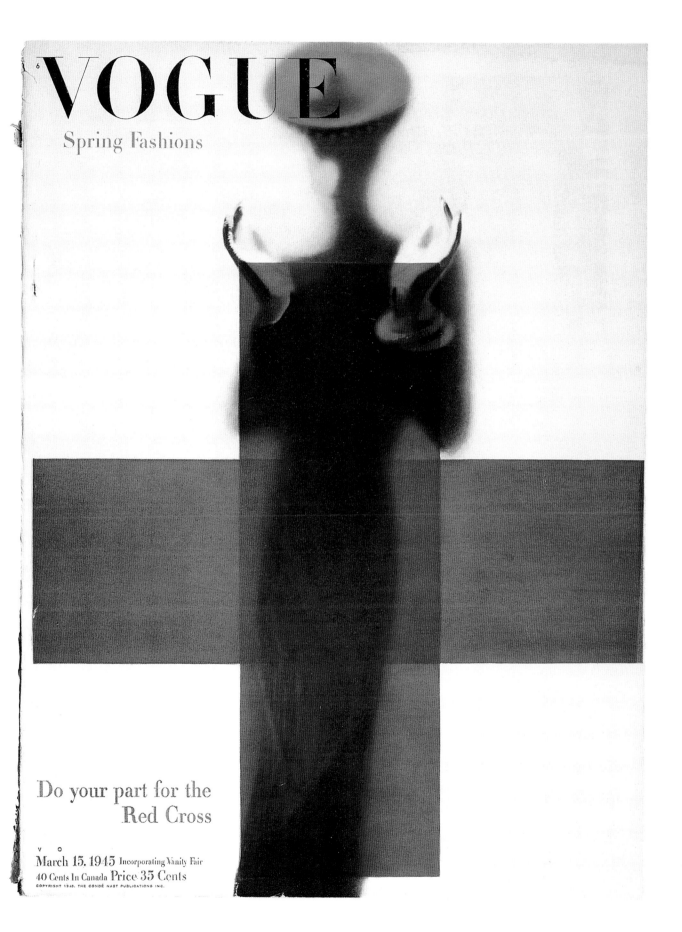

VOGUE

Spring Fashions

Do your part for the
Red Cross

March 15, 1945 Incorporating Vanity Fair
40 Cents In Canada Price 35 Cents
COPYRIGHT 1945. THE CONDÉ NAST PUBLICATIONS INC.

At War and After: The Creative Forties in America 1940 – 1949

Herbert Bayer designed a world geographic atlas for the Container Corporation of America in 1953. This spread is from an introductory section.

produced innovative covers and spreads by hiring the best designers, artists and illustrators. His typography was simple, and with excellent photography and illustration, he was able to hold the interest of businessmen in topics related to economics, science and technology.

Dr Agha had paved the way with a modern look for *Vanity Fair* earlier in the mid-1930s by using the best photographers, illustrators and technological support. On *Vanity Fair* pages, he used Futura types, full-bleed images and dynamic asymmetrical layouts. In addition, his studio was a training ground for young designers such as William Golden, Alberto Gavaschi and Cipe Pineles (see overleaf). The art department was the first to have photostat machines, which produced direct high-quality photographic prints. These art directors and designers, through their dedication to progressive design, truly became the pioneers in editorial design.

Another popular consumer magazine was *Life*. Known for its lavish photographic essays, it became especially important to the American public during World War II as it featured expansive coverage of the war through heroic photographic articles. These iconic images of battle brought home the reality of war to the people on the home front, helping to bridge a gap that was often unimaginably wide.

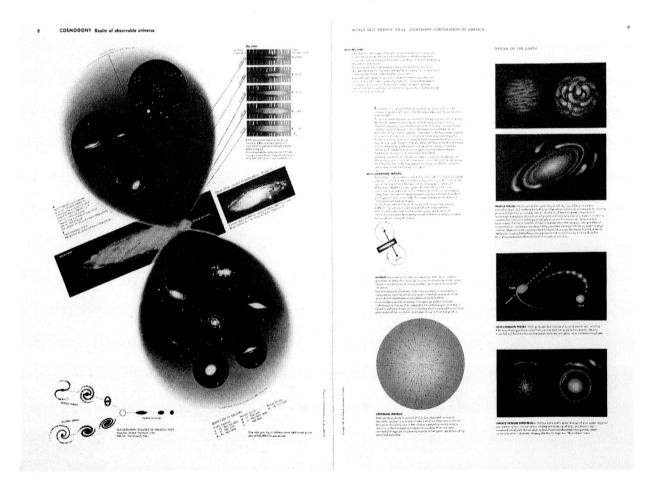

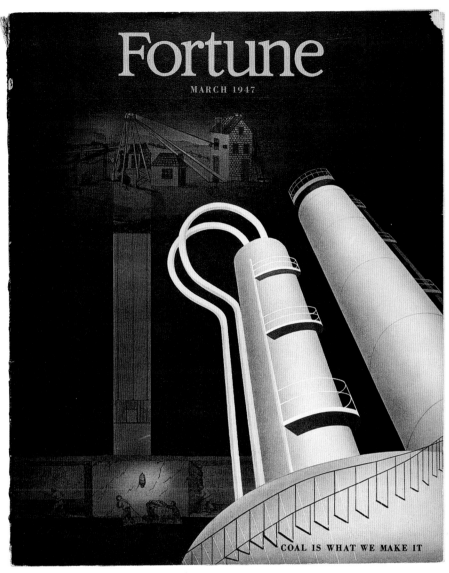

COAL IS WHAT WE MAKE IT

Fortune magazine, under Will Burtin's art direction, was at its best in the variety of high-quality art and design that appeared on its covers. Designers, artists and illustrators such as Arthur Lidov and Herbert Matter (whose work is shown here), contributed their special vision to the façade of this progressive business magazine. At *Fortune* Burtin demonstrated his consummate skills at editorial design – namely layout, visualization and information design – as well as his ability to hire new design talent to represent technical subjects.

At War and After: The Creative Forties in America 1940 – 1949

Below *Seventeen* magazine was among the first to see the marketing potential in America's teenagers. Art director Cipe Pineles frequently contributed her own layouts to the pages of *Seventeen*. This spread from 1948 features illustrations by Pineles.

Opposite Editor Helen Valentine, marketing expert Estelle Ellis and Cipe Pineles teamed up to produce *Seventeen* magazine issues which met with much success. This was one of Pineles's most well-known covers from July 1949. The mirror-image theme was eye-catching and memorable.

MADISON AVENUE IN THE 1940S

In 1949, Lester Rondell, president of the New York Art Directors Club, wrote, 'It is the art director's responsibility to be wary and wise in his use of an extreme point of view. There are as many ways of solving an art problem as there are artists.'[6] The world of advertising in the 1940s showed a division between the traditional marketing-oriented business side of advertising and those few enlightened graphic designers who had a more progressive orientation. Of this group, Paul Rand and Herbert Matter in New York and Charles Coiner at N.W. Ayer in Philadelphia stood out as leaders. Coiner continued in his role as art director of the Container Corporation of America account, infusing America's consumer magazines with unique ads by leading artists. In 1949, Coiner was a judge for the annual New York Art Directors Club exhibition. In the printed exhibit annual he wrote, 'The secret of a good advertisement, creatively, seems to be having every link in the production chain equally strong; plus a designer who has – aside from

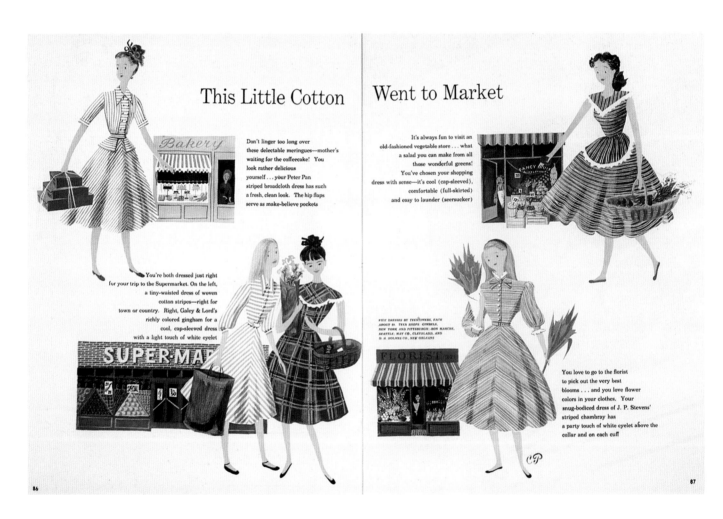

This Little Cotton

Went to Market

Don't linger too long over these delectable meringues—mother's waiting for the coffeecake! You look rather delicious yourself . . . your Peter Pan striped broadcloth dress has such a fresh, clean look. The hip flaps serve as make-believe pockets

It's always fun to visit an old-fashioned vegetable store . . . what a salad you can make from all those wonderful greens! You've chosen your shopping dress with sense—it's cool (cap-sleeved), comfortable (full-skirted) and easy to launder (seersucker)

You're both dressed just right for your trip to the Supermarket. On the left, a tiny-waisted dress of woven cotton stripes—right for town or country. Right, Galey & Lord's richly colored gingham for a cool, cap-sleeved dress with a light touch of white eyelet

FIVE DRESSES BY TEENTIMERS, EACH ABOUT 10. TEEN SHOPS: GIMBELS, NEW YORK AND PITTSBURGH; BON MARCHE, SEATTLE; MAY CO., CLEVELAND; AND D. H. HOLMES CO., NEW ORLEANS

You love to go to the florist to pick out the very best blooms . . . and you love flower colors in your clothes. Your snug-bodiced dress of J. P. Stevens' striped chambray has a party touch of white eyelet above the collar and on each cuff

86

87

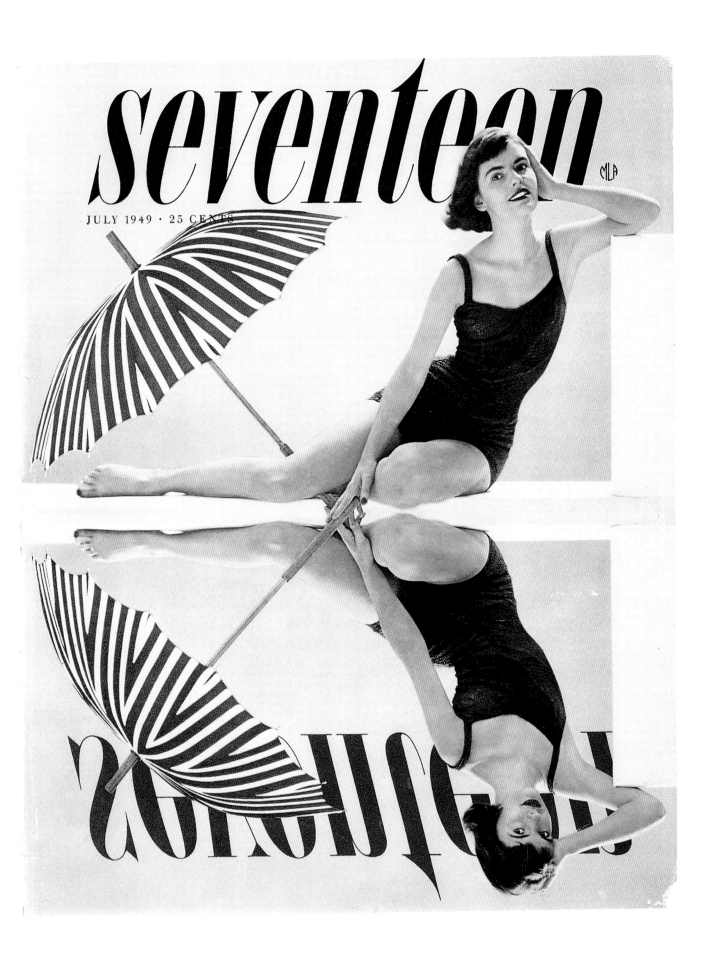

seventeen

JULY 1949 · 25 CENTS

talent – tenacity, diplomacy and salesmanship. It is no good to create a beautiful layout if disintegration sets in at any one of the important points of production.'[7] In the postwar period, with the economy moving again, more and more Modernist designers were active in producing imaginative advertisements and receiving recognition for bringing fresh, design-oriented solutions to the world of marketing.

GRAPHIC DESIGN ACROSS AMERICA

Two prominent designers, Paul Rand and Bradbury Thompson, emerged during the war and made major contributions to the new direction in American graphic design. They shared an interest in bringing the formal ideas of the European avant-garde into their work at the same time as being firmly grounded in the realities of the American business scene.

Rand, a native New Yorker, worked through the 1940s at the Weintraub Advertising Agency, designing outstanding campaigns for Orbachs, Stafford Fabrics, Disney Hats and others. His covers for *Direction* magazine afforded the opportunity to explore new approaches in form and content interpretation. The covers show Rand's unique understanding of perceptual values, his

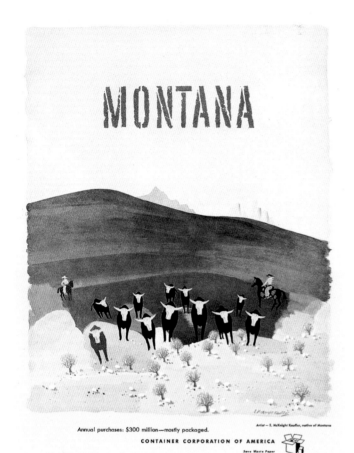

Annual purchases: $300 million—mostly packaged.

Artist — E. McKnight Kauffer, native of Montana

CONTAINER CORPORATION OF AMERICA

Save Waste Paper

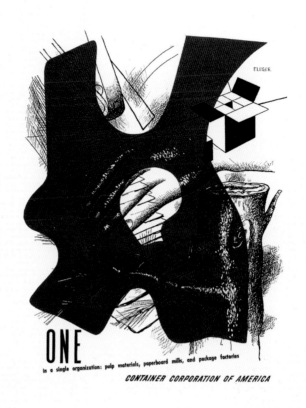

ONE

In a single organization: pulp materials, paperboard mills, and package factories

CONTAINER CORPORATION OF AMERICA

Above left Montana was the birth state of
E. McKnight Kauffer. He had spent most of his
career in England but participated in the Container
Corporation of America's 48 States campaign
with this ad for his home state in 1944. The CCA
ad campaign featured a prominent artist or
illustrator from each of the 48 states.

Above right Fernand Léger was a famous
French artist who waited out World War II in New
York. While he was in the U.S., art directors such
as Charles Coiner asked Léger to produce work
for Container Corporation of America's ad
campaigns. This ad, from 1941, emphasized the
fact that the CCA organization was a full-service
packaging business. Léger also designed covers
for *Fortune* magazine.

Overleaf Between 1947 and 1949, Paul Rand
designed a series of ads for Disney Hats. In the
campaign, each ad was different but was
composed of similar elements, namely a hat, the
outline of a figure, the company seal and the copy.
This series showed Rand's ingenuity at presenting
a visually uninteresting product line with creativity
and visual interest.

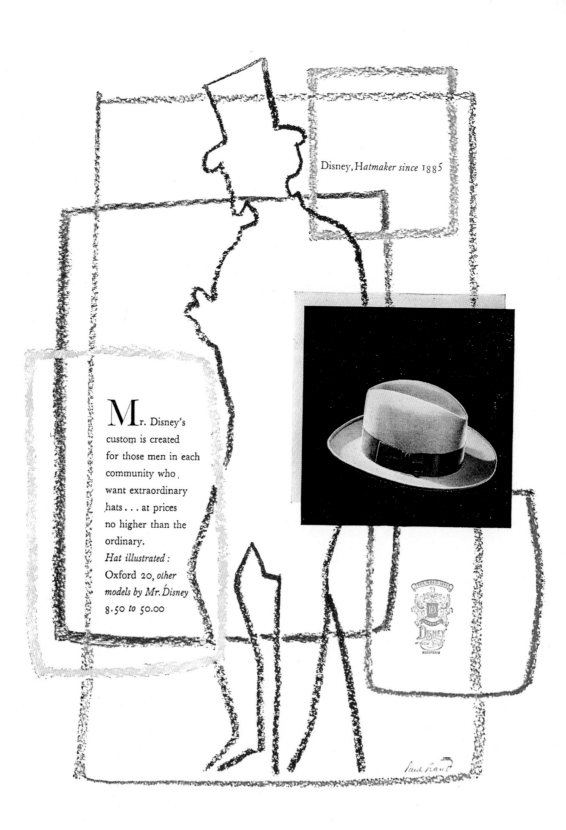

Disney, H*atmaker since* 1885

M**r. Disney's
custom is created
for those men in each
community who .
want extraordinary
hats . . . at prices
no higher than the
ordinary.
Hat illustrated :
Oxford 20, *other
models by Mr. Disney*
8.50 *to* 50.00

need to explore symbols and imagery widely and his confident, creative curiosity, which was an important aspect of his approach throughout his career. His book, *Thoughts on Design*, published in 1947, was a visionary look at the emerging role of the contemporary designer. Of Rand's work, Moholy-Nagy wrote in 1940 that he was impressed by its 'refreshing optimism in these confusing days'.[8] Rand became the inspiration for many young designers of the 1950s and 1960s. In Rand's classes at Yale, the doctrines of Modernism offered structure, discipline and a certain fundamental reasoning. His later assignments were, in a sense, intellectual explorations of the study of limited means – in other words 'a pedagogical celebration of the Modernist ideal'.[9] Louis Danziger felt that Rand largely made it possible for graphic designers to work. More than anyone else, he made the profession reputable. He paved the way from commercial art to graphic design. A contemporary, Herb Lubalin, called Paul Rand 'the Picasso of Graphics'.

Below left Design historians have called Paul Rand the 'the history of graphic design in America'. This testimonial underscores his importance in fully realizing Modernism in America. This design from 1954 was created in the quest for the RCA account. Rand cleverly used the Morse Code symbols for RCA as the dominant elements.

Below right, top Paul Rand created this pattern for a fabric design by making a photogram of an abacus. He then used the image on the jacket of his book, *Thoughts on Design*, in 1947.

Below right, bottom Paul Rand designed many ads for Stafford Fabrics, a company which, during the war, provided the material for soldier's uniforms. There is a powerful poignancy in the integration of the symbol of the rifle and the neckties.

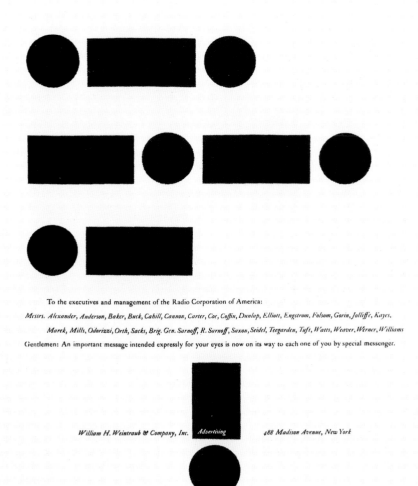

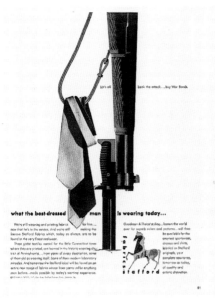

Above left Paul Rand designed a series of covers for the magazine *Direction* between 1938 and 1945. *Direction* was a cultural arts publication which occasionally dealt with world events. Rand demanded freedom in these designs and they exemplify the power of Rand's visual ingenuity at its best. This cover, from 1942, uses two powerful symbols to communicate a powerful message in wartime America, namely that the eagle (the U.S.) was claiming the rat (the Axis powers). The sketchy drawing technique used by Rand enhances the strength of the image.

Above right This cover, from March 1939, features an American Indian theme. Rand provided the reader with dramatic scale contrast in the imagery of the totem. This formal imagery is contrasted with the informality of the magazine masthead letters, seemingly scattered across the top of the cover.

Opposite The Christmas 1940 cover of *Direction* is among Rand's most powerful works. It is effective due to the ambiguous symbolism of the barbed wire/Christmas gift. The meaning was extended by the presence of blood spots over the surface.

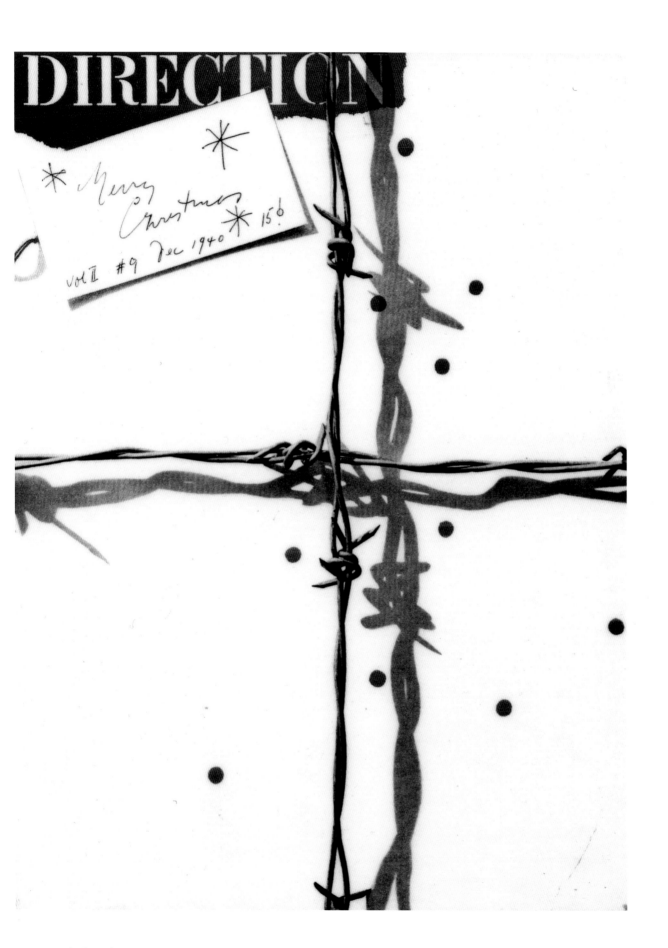

W

a

b

c

w is for war,
buy war bonds and lend
all aid that you can
to bring war to an end.

artist: ben stahl
advertiser: bell aircraft corporation
agency: addison vars company
engraving: 4 color process, 120 line screen

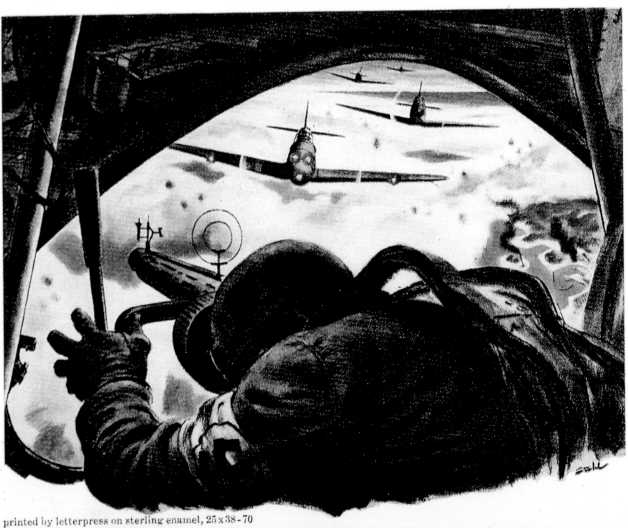

 printed by letterpress on sterling enamel, 25 x 38-70

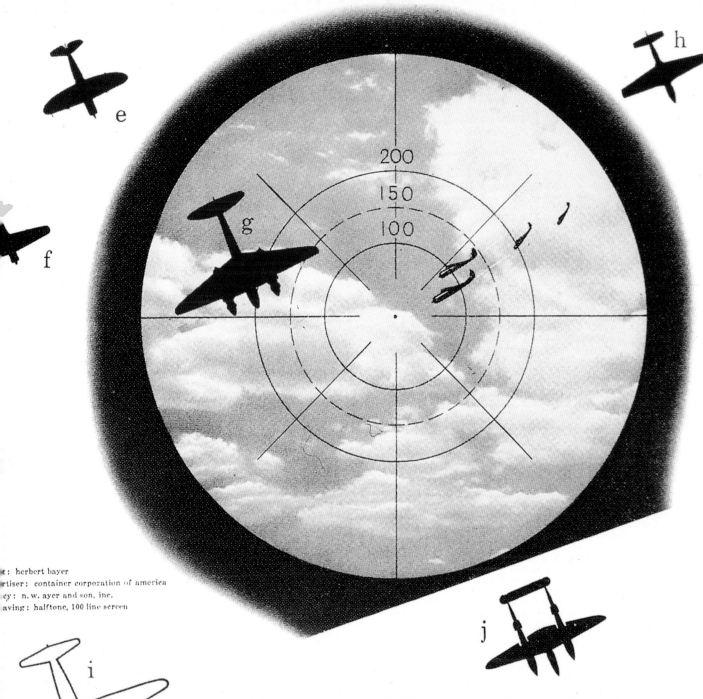

e

h

f

g

200
150
100

t : herbert bayer
rtiser : container corporation of america
cy : n. w. ayer and son, inc.
aving : halftone, 100 line screen

j

i

from now on the war news will thrill you more and more. the nazis are
almost ready to collapse and japan is on the brink of ruin.
neither hitler hirohito knew what america could do with high
speed production. nor did the axis know the lay hidden in what
they called our soft decadent race. nor know the willingness
of those on the home front to oversubscribe five r loan
drives and still be ready, if the time comes, to p he next one over.

you identify these?

liberator, b-24, u.s.
hamp, type 0, japan
hellcat, f6f, u.s.
wildcat, f4f, u.s.
thunderbolt, p-47, u.s.
zero, type 0, japan
mosquito, great britain
mustang, p-51, u.s.
commando, c-46, u.s.
lightning, p-38, u.s.
messerschmitt, me.109e., germany
superfortress, b-29, u.s.

k

l

printed by letterpress on sterling ena india tint, 25 x 38 - 70 2945

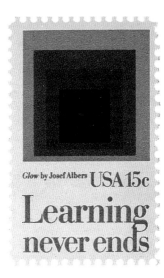

Westvāco

Bradbury Thompson was a contemporary of Rand but had a very different background and visual sensibility. Born in Topeka, Kansas, Thompson became interested in graphic design while studying and working on publications at Washburn College. He moved to New York in the late 1930s and began working for West Virginia Pulp and Paper Company (Westvaco), designing and editing its publication, *Westvaco Inspirations for Printers*. Thompson had great creative freedom in this work and was able to develop a style which reflected his great love for graphic and experimental typography. *Westvaco Inspirations* was targeted at a printing audience and was produced on a minimal budget. Thompson used flat, transparent, overlapping process colours, illustrations from antique encyclopedias and very expressive page spreads on topical themes. He continued his consultant projects for Westvaco throughout his career. After World War II, he was art director for several magazines, including *Mademoiselle*, *Art News* and *Smithsonian*. Later, Thompson's book design for the Westvaco Library of American Classics, the *Washburn College Bible* project and his numerous postage stamp designs for the United States Postal Service became important career accomplishments.

A formal element of the International Style was the use of geometric shapes. In contrast to this, the art movement of Surrealism brought, in the 1940s, a new quality of form to Modernism. The shape was biomorphic and organic. Inspired by the forms in the paintings of Surrealists such as De Chirico and in the sculpture of Alexander Calder and Isamu Noguchi, the 'porkchop' shape became common in graphic and product design. Charles Eames adopted the shape for his plywood furniture, Russel Wright used it in his kitchenware products and Alvin Lustig applied the shape in his book-jacket designs. For example, his dust-jacket layout for *Anatomy for Interior Designers*, done in 1948, was a typical example of the biomorphic form applied in graphic design.

A transitional figure, Lustig's career alternated between California and New York. For an emerging designer such as Lustig, the architect Frank Lloyd Wright was an important influence. Although Lustig eventually studied briefly with Frank Lloyd Wright, he was largely self-taught. His graphic design in the late 1930s, created with the forms from the printer's type case, reflected the impact of Wright's style. Lustig designed books for the publisher Ward Ritchie and went on to become known for his innovative approach to paperback jacket design. He was a designer who had broad interests in problem-solving. During his career he accomplished design in many forms, including book design, exhibit design, packaging, interior

Previous pages War imagery was naturally ubiquitous in printed publications during World War II, even in business publications such as *Westvaco Inspirations for Printers*. These issues, which promoted Westvaco papers to designers and printers, were designed from 1938 to 1962 by Bradbury Thompson. This spread, from 1944, indicated Thompson's style of contrasting typography carefully integrated with symbols, illustration and photography.

Above left Bradbury Thompson was a prominent member of the Citizens Stamp Advisory Committee for the U.S. Postal Service from 1969 until his death. This involvement meant that Thompson was able to upgrade the quality of U.S. postage stamps through his own participation as a designer and as a consultant for other designers. In 1980, he designed this stamp, 'Learning never ends', which featured the artwork 'Glow' by his colleague at Yale University, Josef Albers. Thompson designed over ninety stamps during his career.

Above right Bradbury Thompson designed this simple corporate logotype in 1968, using the macron mark over the letter 'a' to bring distinction to the graphic way the corporate name appears. In this case it also doubles as a way of telling the viewer how to properly pronounce the name. It was an excellent example of a basic Modernist idea, namely that a simple concept can be a functional and appropriate solution.

Opposite This book jacket by Alvin Lustig, *Anatomy for Interior Designers* by Francis de Neufville Schroeder, was created in 1948. These organic shapes were used by Lustig on many of his book jacket designs.

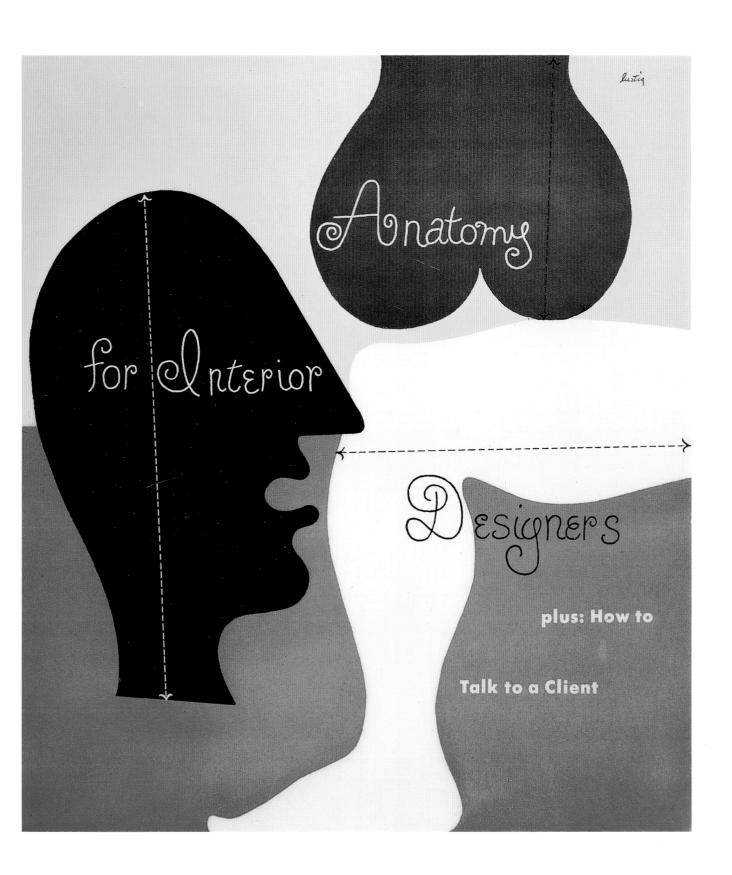

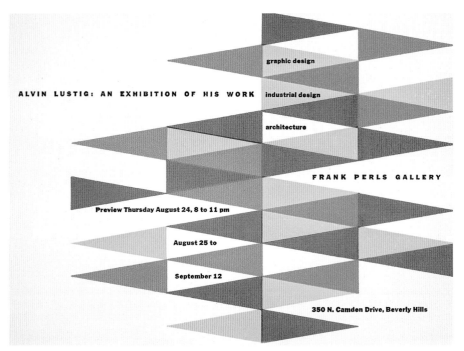

Graphic shapes with text:
graphic design
ALVIN LUSTIG: AN EXHIBITION OF HIS WORK
industrial design
architecture
FRANK PERLS GALLERY
Preview Thursday August 24, 8 to 11 pm
August 25 to
September 12
350 N. Camden Drive, Beverly Hills

Left Lustig was the consummate Modernist designer. This colourful exhibition announcement was designed in 1949 for a one-man exhibit of Lustig's work at the Frank Perls Gallery in Beverly Hills, California. It was a bright, eye-catching design in which the simple geometric shapes are complemented by the carefully integrated typography.

Below Lustig created this self-promotion piece in the late 1930s using two colours plus a printed metallic gold. The design represented Lustig's impeccably clean typography style. He used long lines of Futura capital letters which created bands of tone across the sheet. Legibility was enhanced by increasing the letter spacing. The monumental central design element represented the influence of Frank Lloyd Wright's style in this phase of Lustig's development.

ALVIN GEORGE LUSTIG

THE CENTER DESIGN HAS BEEN CONSTRUCTED OF TYPOGRAPHIC GEOMETRIC SHAPES, EACH COLOR BEING A SEPARATE LOCKUP OF ALREADY EXISTING SQUARES, CIRCLES AND THEIR DIVISIONS. THERE ARE NO PLATES OR ENGRAVINGS. SUCH RESULTS WITH NO EXPENSE OTHER THAN ACTUAL PRINTING COSTS, SHOULD BE ATTRACTIVE TO THOSE WHO, WITH LIMITED BUDGETS, SEEK FINE DESIGN AND TYPOGRAPHY. THERE ARE ABOUT TWENTY DIFFERENT CHARACTERS RANGING FROM SIX TO ONE HUNDRED AND FORTY-FOUR POINTS, WITH QUANTITIES SUFFICIENT TO PRODUCE DESIGNS MANY TIMES THIS SIZE, IN AS MANY COLORS

AS DESIRED, OR THE SIMPLEST OF SPOTS OR SIGNETS. ASIDE FROM THE ORNAMENT, LETTER FORMS OF A WIDE RANGE OF DESIGN AND SIZE CAN BE CONSTRUCTED FROM THIS MATERIAL. THE LETTERING ON THE ENVELOPE IS AN EXAMPLE. MAY I CALL AND SHOW YOU OTHER USES TO WHICH THIS MATERIAL HAS BEEN PUT IN THE PRODUCTION OF STATIONARY, BOOK-PLATES, MAILING PIECES, PATTERN PAPERS, POSTERS AND THE LIKE, AND DISCUSS WITH YOU YOUR SPECIFIC PROBLEM? MY PHONE NUMBER IS CRESTVIEW 14827 AND THE ADDRESS IS 431 SOUTH REXFORD DRIVE, BEVERLY HILLS, CALIFORNIA.

Left Knoll Associates has always been associated with modern products, advertising and design. This ad, designed by Alvin Lustig in 1949, promoted Knoll's Rapson chair. Based on the formal design qualities of the chair itself, the ad was a very elegant combination of line, shape, image and type.

Below left Alvin Lustig's interests in design were many. He designed graphics, advertising, furniture, fabrics, book jackets, identities, interior design, architectural graphics, environmental design, architecture, exhibits, products and even a one-man helicopter for the Roteron Company in 1949.

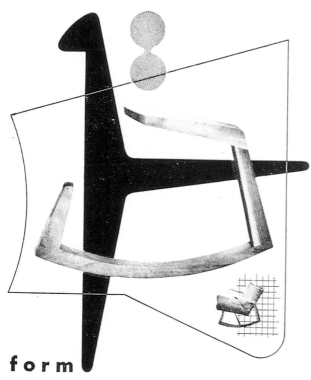

form

Clarity of form is a basic element of good contemporary furniture.
The rocker, designed by Ralph Rapson, exemplifies
the honest design characteristic of all H. G. Knoll products.

H. G. KNOLL associates
601 MADISON AVENUE, NEW YORK 22, NEW YORK

Of this novel H. G. Wells wrote: *"I do not know how to express the admiration I feel for this wonderful book without seeming to be extravagant. I am not usually lavish with my praise, but indeed the book impresses me as among the very greatest novels I have ever read. It is wholly beautiful; it is saturated with wisdom and humor and tenderness."*

Growth of the Soil

KNUT HAMSUN *winner of the Nobel Prize for Literature, 1920*

Opposite & below These book-jacket designs by Alvin Lustig were produced in the 1940s and early 1950s. Because he designed so many jackets in this period, Lustig experimented widely with style and technique. Some were illustrative, such as *Growth of the Soil* by Knut Hamsun, and others were strictly typographic, such as *The Mind and Heart of Love* by M.C. D'Arcy, *History as the Story of Liberty* by Benedetto Croce and *Five Stories* by Willa Cather. Even within his typographic jackets, Lustig showed a range of appropriate form and font selection.

Overleaf left Alvin Lustig always wanted to be an architect. He did design several buildings but his career was devoted to many other forms of design as well. He created this cover for *Arts & Architecture* magazine in 1942.

Overleaf right This cover for *Fortune* magazine was designed by Alvin Lustig in 1946. Lustig's use of colour has been attributed to his years in California. This design was interesting because Lustig integrated both flat and dimensional objects on the colour surface.

CALIFORNIA

arts & architecture

FEBRUARY 1942 · PRICE 25 CENTS

ERIKA MANN

DOROTHY LIEBES

WILLIAM WURSTER

GENE FLEURY

RICHARD NEUTRA

LUSTIG

Fortune

DECEMBER 1946

lustig

At War and After: The Creative Forties in America 1940 – 1949

Ladislav Sutnar designed this information poster in 1943 as part of a series entitled 'The Story of Oil' for Standard Oil of New Jersey. The poster, number eight in the set, presented 'Transportation of Oil' and showed Sutnar's abilities at translating a section of the complex oil-refining process into an understandable and meaningful poster.

8. Transportation of Oil

To supply people's needs for oil worldwide, more than 3 billion barrels of crude and refined products move yearly from wells to refineries to users. To achieve this vast and steady flow, the petroleum industry has developed one of the world's great low-cost distribution systems. Fleets of modern tankers ply oceans and coastal waters, carrying crude oil from producing fields and oil products from refineries. In rivers, canals, and harbors, thousands of barges transport millions of barrels of refined products. Streams of oil flow constantly through pipe lines, whose total length would encircle the earth several times. In addition, hundreds of thousands of tank cars and thousands of tank trucks carry oil to service stations and homes.

Presented by Esso Standard Oil Company

design, environmental design, architectural signage, fabrics, furniture, advertising and magazine design. In 1946, Lustig even designed a one-person helicopter for the Roteron Company. Although he maintained a productive design office which did the highest-quality work, Lustig, like Moholy-Nagy, was a visionary who saw design as a curative for society's ills. This attitude was represented in his interest in educating both his clients and, eventually, his students at Yale.

Aside from the design supporting the war effort, in New York there were now the beginnings of corporate design and innovations in information design. With roots in the progressive typography of Jan Tschichold's work from the 1920s and 1930s, information design placed emphasis on the functional

Left Sweet's Catalogs was a major client of Ladislav Sutnar's from the early 1940s. It produced a library of technical information for architects and engineers. Sutnar was the logical designer to create an information system for them, including the trademark circled 'S' (for Sweet's). Sutnar designed extensively for Sweet's Catalogs in the 1940s and 1950s.

Below Sutnar, throughout his career, practised a rational and objective approach to graphic design. His priority was legibility and comprehension of information. Sutnar produced several publications for Sweet's Catalogs in which he proposed graphic standards for the design of technical catalogues information. In this spread from the book *Catalog Design Progress*, produced in 1950, Sutnar indicated proposed format standards for catalogue pages.

The structural organization of this 20-page service catalog on electrical wires and cables shows an extension of the preceding catalog's symmetrical pattern. The catalog is designed in two sections of four visual units each—the first section on production, the second on finished products. The two sections are preceded by an introductory unit containing information on product features, range of applications, and index to sections. The catalog's front cover identifies manufacturer and product in boldly visualized trademark (red circle). A large photograph identifies the sub-ject of each section (visual units shown in black). Primarily on activities, the first section is treated pictorially throughout. In the second, detailed information on specific products is arranged in chart form for easy finding, while general information is organized in vertical panels for quick reference. The integration of two dissimilar sections, each with its own characteristic pattern, has here been achieved through use of color, similar opening units, and repetition of a simple rhythmic sequence (1-3, 1-3) in the catalog's organization.

mark and stationery designed for Paul Theobald & Company,
publishers of contemporary art books

folders and catalog designed for
The Society of Typographic Arts
exhibition of 1948

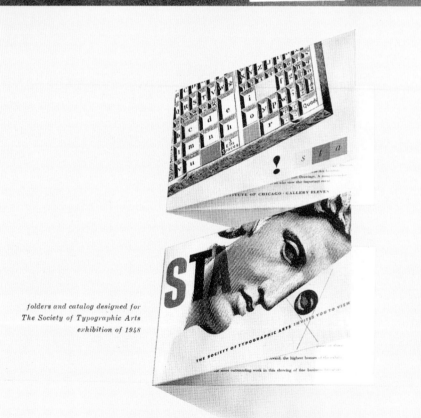

and legible role of graphic design through typography, symbols, maps and photography. It is a synthesis of function, flow and form. The Czech immigrant designer Ladislav Sutnar was a pioneer of information design. He and architect Knut-Lonberg-Holm 'developed a systematic approach as an integral part of their work for Sweet's Catalog Service'.[10] This work for Sweet's stands as an early exemplar of information design.

In addition to New York and Philadelphia, Chicago was also an important centre for Modernist design in the late 1930s and 1940s. Morton Goldsholl, a student of Moholy-Nagy's, began his business in Chicago and put into practice many of the principles he had learned from his teacher about light, sequence and formalism in design. Goldsholl remembered Moholy-Nagy's utopian challenge that 'artists and designers must change the world'.[11] In the early 1950s, Goldsholl became fascinated with the potential of animation and motion graphics. He produced an important short animated film on corporate identity for the Kimberly Clark Corporation entitled 'Faces and Fortunes'. Also, he designed a new graphic symbol which was intended to help customers recognize 'good design' in the marketplace. Based in Chicago, the Container Corporation of America featured work by many European immigrants such as Herbert Bayer. Its corporate designer, Egbert Jacobson, was already on staff. In 1940, he hired Albert Kner to begin an in-house design department. This department, which evolved later into CCA's Center for Advanced Research in Design, was an important model of how the design function can serve within a large corporate structure.

In California, two transplanted New Yorkers, Saul Bass and Louis Danziger, established businesses which, in time, took on a very West Coast character. Bass studied at the Art Students League and Brooklyn College in New York. He worked in the advertising business there until, in 1946, he was transferred by Buchanan & Co. to its Los Angeles office. In 1950, he joined Foote, Cone & Belding Advertising and worked there until setting up his own office, Saul Bass Associates, in 1952. Known for his versatility, Bass's projects included creating films and film titles, designing advertising, posters, packaging, print and environmental design. He created the storyboards for the famous shower scene from the film *Psycho*, and there is a heated debate to this day over whether he actually directed the scene as well. Bass was also an articulate spokesman for design. Of his film title work, he wrote, 'A graphic and industrial designer heretofore, I now found myself confronted with a flickering, moving, elusive series of images that somehow had to add up to communication.'[12] Bass is most widely known for his extensive corporate-identity programmes, including United Airlines, AT&T, Quaker Oats and Warner Communications.

The other native New Yorker, Louis Danziger, had been a student of Lustig and Brodovitch. In California, his clients included the Container Corporation

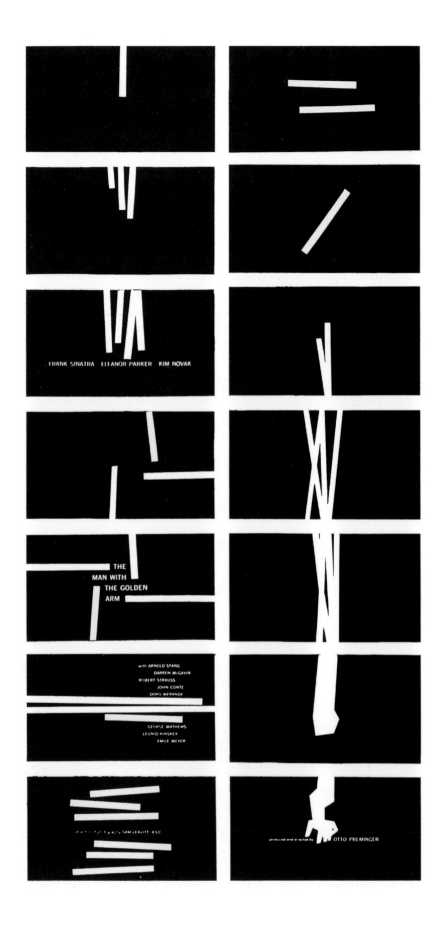

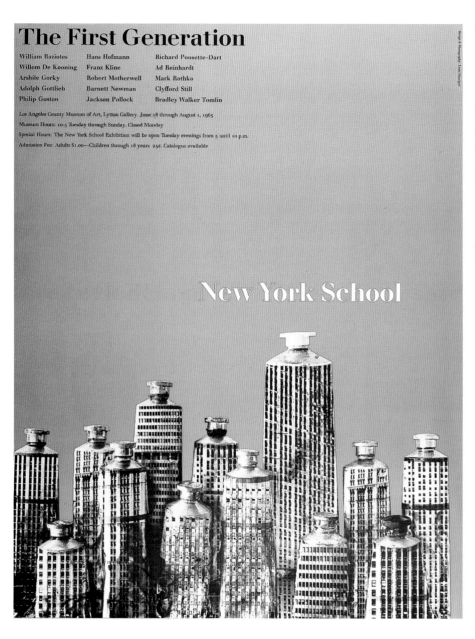

The First Generation

William Baziotes	Hans Hofmann	Richard Pousette-Dart
Willem De Kooning	Franz Kline	Ad Reinhardt
Arshile Gorky	Robert Motherwell	Mark Rothko
Adolph Gottlieb	Barnett Newman	Clyfford Still
Philip Guston	Jackson Pollock	Bradley Walker Tomlin

Los Angeles County Museum of Art, Lytton Gallery. June 18 through August 1, 1965

Museum Hours: 10-5 Tuesday through Sunday. Closed Monday

Special Hours: The New York School Exhibition will be open Tuesday evenings from 5 until 10 p.m.

Admission Fee: Adults $1.00—Children through 18 years 25¢. Catalogue available

New York School

Opposite Saul Bass designed this film title sequence in 1955 to promote the film *The Man With the Golden Arm*. Not since Jan Tschichold and the Stenberg Brothers had a designer devoted himself to an innovative approach to film promotion. Bass's method was to develop the graphic form of the film identity and then apply it to posters, ads, and many other applications. The simple, dramatic use of framing shape for the tortured arm quickly became a recognized symbol. Bass carefully integrated the custom letterforms of the title to the inner space of the graphic.

Left In 1965 the Californian designer Lou Danziger designed this poster for 'The First Generation', a major exhibition of painting at the Los Angeles County Art Museum. The poster is Modernist in style through its clarity of information, simplicity, asymmetry and expansive use of negative space. Danziger's clever use of the paint tubes to suggest New York skyscrapers, brought an ambiguity to the poster which made it memorable.

Below Louis Danziger designed this trademark for Flax Art Supplies in 1949. The 'F' is simply constructed, bold in weight and adaptable to many applications.

Overleaf Alexey Brodovitch was art director at *Harper's Bazaar* magazine for twenty-five years. During this time he revolutionized editorial design, especially influencing fashion magazines. Brodovitch often used repetition as a visual theme in his covers for the magazine. In this cover from 1940, he established a strong unity between with butterfly and the model by repeating the circular eye form. Not only was it an effective visual device but it showed the influence of Surrealism. The photography is by Herbert Matter.

of America, the Atlantic Richfield Company, and the 1984 Los Angeles Olympic Games. For many years he was a teacher at the California Institute of the Arts. Danziger was one of the few practicing designers who saw the importance of design history as an integral part of a professional design curriculum; he had lived through much of this history; he knew the principle Modernist designers and therefore was able to bring intimate knowledge to his teaching. During the 1970s and 1980s, his courses at the California Institute of the Arts and Harvard were important models for other educators.

Alexey Brodovitch continued his pioneering editorial design work during the war years at *Harper's Bazaar*. His covers and page layouts showed a maturity not evident in the 1930s. More and more, he hired the best photographers from Europe and the United States to illustrate articles.

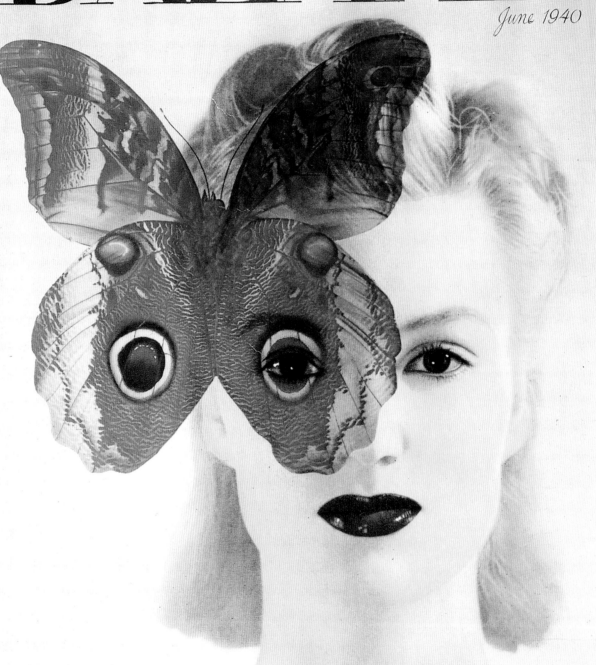

Harper's BAZAAR

June 1940

SUMMER FASHIONS

25 fr. in Paris · 50 cents · 2/6 in London

He championed work by Henri Cartier-Bresson, Robert Frank, Martin Munkasci, Lisette Model and many others. Interested in the rhythm and visual flow of the pages through the magazine, Brodovitch was influenced in this by his fellow Russian, the film-maker Eisenstein, who concentrated on the relationships of frame to frame, scene to scene, etc. When producing an issue of *Harper's Bazaar*, Brodovitch would make running dummy paste-ups of the page layouts and place them in continuous sequences on the floor of the office. This was the way that his editors Carmel Snow and (eventually) Diana Vreeland and assistants would see them in presentation. In addition to photographers, Brodovitch hired many prominent creative artists and illustrators. For many years in his work at *Harper's Bazaar* magazine, Lillian Bassman assisted him, although she was not recognized adequately for the innovative layout and photography to which she contributed. In 1945, Brodovitch produced a photographic book entitled *Ballet* which featured his own documentation of many years of visits to various ballet performances. The imagery in this book intended to communicate the motion of the ballet, not present it realistically. This application of fuzzy, out-of-focus photography influenced a whole generation of photographers and art directors.

DESIGN ADVOCACY OF THE 1940S

In the 1940s, graphic design work was exhibited at the Museum of Modern Art in New York. In 1941, an exhibit of award-winning posters on defense subjects was mounted. This exhibit hoped to bring attention to the government's role in promoting what *Time* magazine called 'the propaganda of patriotism'. The next year, MoMA sponsored an exhibit, 'Useful Objects in Wartime', which was divided into a display of household objects made

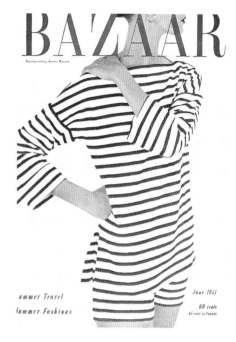

Above This bold cover by Brodovitch from 1951 is the essence of summer in the way in which the art director has selected the photograph and cropped in closely to bring attention to the casual outfit and the relaxed stance of the woman.

Below Brodovitch photographed ballet performances for a number of years. In 1945, he produced a book, *Ballet*, in which he presented imagery from eleven of these performances. In the case of this spread, there were two separate images which appeared to move and flow together when the reader viewed them together in the book. This book was one of Brodovitch's finest career projects and is one of the great exemplars in the history of graphic design.

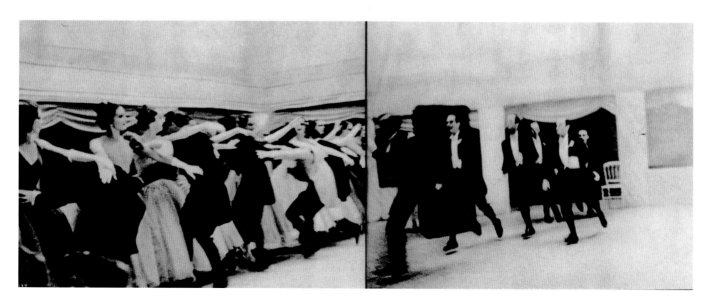

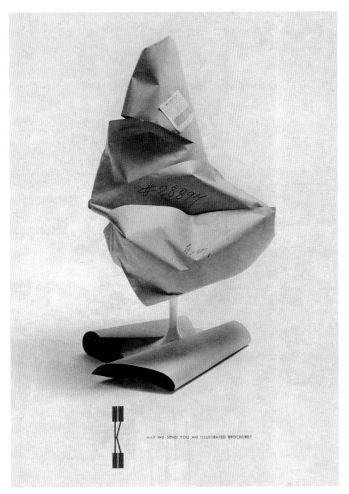

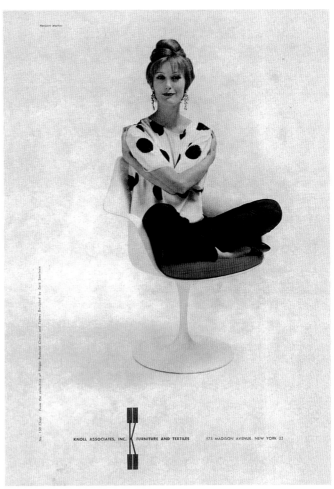

Above Herbert Matter was a designer of many talents, who worked in graphic design, identity, photography and advertising. In this classic set of Knoll Furniture ads from 1956, Matter wrapped the Saarinen Chair in paper, leaving only a few clues to its real form. Then, in the next ad, he presented the same chair with a female model in the same shape as the wrapped version. He made the perception of the ads a surprise, and one that the viewer was certain to remember.

Opposite Many of Matter's design solutions, such as this cover of *Fortune* magazine from 1943, were derived from photographic processes. The image, a photogram, was eye-catching and dynamic in its tonality and colour combination.

from materials not used in the war effort, a display of products that had been asked for by men and women in the military, and a display of equipment essential for civilian defence. MoMA's curator, Mildred Constantine, sponsored a poster competition to raise awareness and funds for polio research. Many important designers participated, with Herbert Matter's dynamic poster being awarded first prize. Matter was as accomplished a photographer as he was a graphic designer. His innovative advertisements for Knoll Furniture and the Container Corporation of America were truly dynamic and free in organization.

At MoMA, Edgar Kaufmann Jr, head of the Department of Industrial Design, championed the cause of quality design with exhibits and award programmes and heralded the cause that 'form should be determined by function, structure and materials'.[13] Dr Robert Leslie continued to support immigrants and young American designers through the early 1940s with exhibits and publications at The Composing Room, Inc. These exhibits, in retrospect, are like a 'who's who' of the pioneers of American Modernist graphic design.

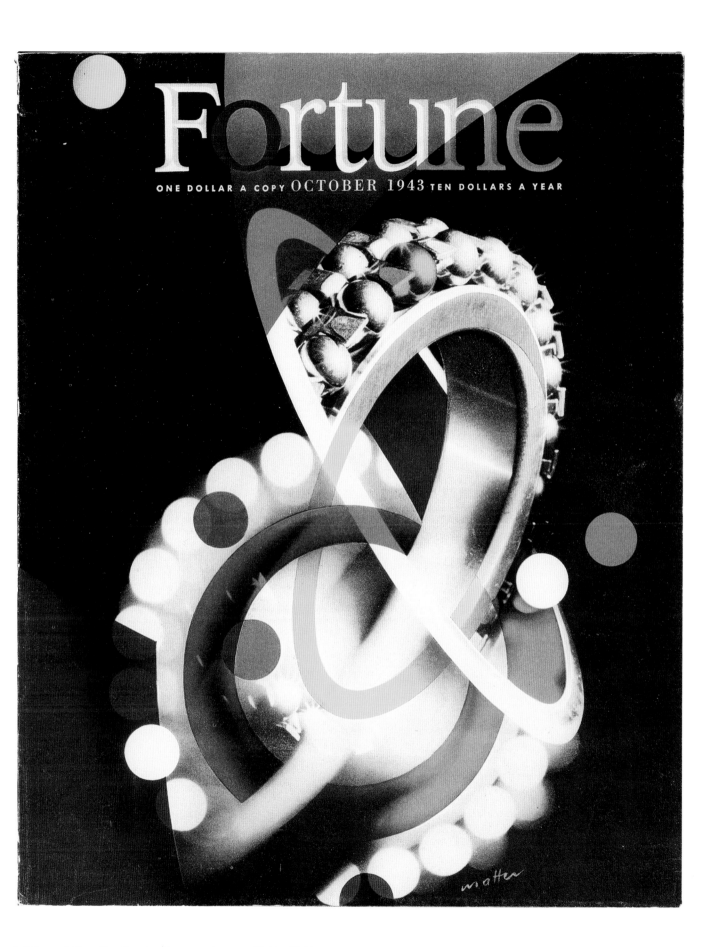

At War and After: The Creative Forties in America 1940–1949

Below right This exhibit, sponsored by Dr Robert Leslie at New York's A-D Gallery in 1942, consisted of works by ten prominent designers: Frank Barr, Herbert Bayer, Lester Beall, Jean Carlu, György Kepes, E. McKnight Kauffer, Herbert Matter, Laszlo Moholy-Nagy, Paul Rand and Ladislav Sutnar. The printed announcement cover was simple in showing the signatures of these ten men. The exhibit was important in that it brought together, for the first time, the central group of Modernists composed of both immigrants and American designers.

In 1941, Herbert Bayer's exhibit at the A-D Gallery featured student work from his class at the American Advertising Guild. The presentation showed not only Bayer's great talent as a designer but also his special skills as a teacher of design. The works from his classes emphasized the visualization of perceptual and psychological effects. Percy Seitlin, writing in *A-D* magazine, commented about the exhibit, 'These studies are progressive and modern because they try to utilize a body of knowledge about psychology as it relates to design. They are not art for art's sake, laissez-faire or mystical.'[14] Bayer believed that progressive graphic design 'was the most appropriate expression of progress, and that it would help people understand the rapid advancements in science and technology that were bound to affect them'.[15]

In 1949, the A-D Gallery gave Will Burtin an exhibition entitled 'Integration – The New Discipline in Design'. The show presented Burtin's latest work in the context of his philosophy of design. In the exhibit announcement, Burtin called for the designer to be a communicator, link, interpreter and inspirer. Continuing, he wrote, 'To enlarge and define this vocabulary of visual language, and thereby contribute toward integration of

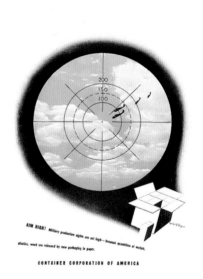

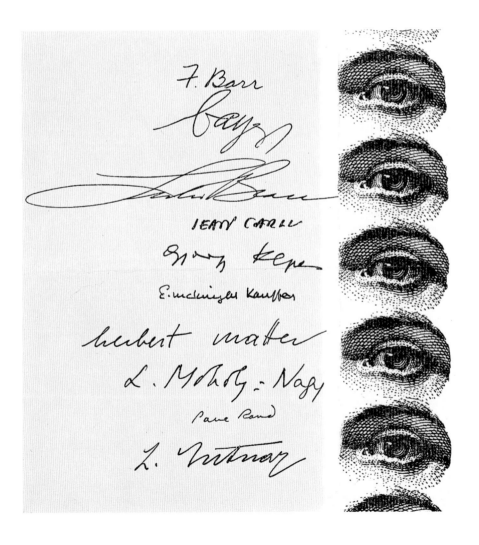

our culture, is his social responsibility as a man, his job as a designer.'[16] Alvin Lustig also had his turn at an A-D Gallery exhibit in 1949. In the brochure he stated his visionary attitudes:

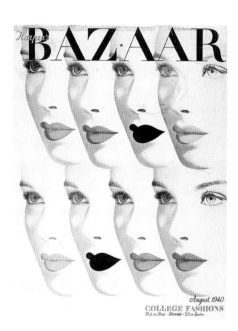

'In our fragmented times we must seek for wholeness. Faced on all sides by violently contradicting ideas demanding our exclusive allegiance, we can only seek for some truth between and beyond these extremes. Our most creative act at the moment is synthesis. Already we can see the dim outlines of a universality that will satisfy our deepest needs. For the artist, the primary problem is to find some balance between his own personal creative integrity and the still undefined wants of society. Approached with dignity and discipline, these apparently conflicting demands can be made mutually to react upon each other to produce both definition for society and freedom for the individual. Then we will begin to see that those sharp divisions that seem to cleave our lives can be held in delicate tension and by their very polarity promise us a profounder reality than the past has ever offered.'[17]

Herbert Bayer's work appeared in museum exhibits, posters, print matter, advertising and on magazine covers. This cover, done for *Harper's Bazaar* magazine in August 1940, showed Bayer's continuing interest in photomontage, pattern and emphasis achieved through colour.

It was through progressive exhibits and publications of this type that designers began, in the 1940s, to see their mission as something very different and much greater than just 'the layout man in the bullpen of the art department'.

RECOVERY AND PEACETIME

The postwar years were, as Will Burtin remembered, a period marked by deep conflicts between ideas, social theories, and people and their interests. It was a period that underwent a technological progress which would have been inconceivable only two decades before, a period of falling idols and new heroes, and an epoch when a new communication medium took a powerful hold on people's consciousness of the world around them. America was ready to return to a normal life after the end of hostilities in 1945. Many of the material sacrifices, so present during the war, were over. Now the great American industrial infrastructure was redirected towards producing consumer goods. Americans were hungry to buy new cars, new home appliances and all the other necessities of modern life. Young married couples were called the 'baby boomers' as birth rates rose dramatically. New homes in the suburbs were in great demand. These were optimistic years in America.

Graphic designers were busy in the postwar years. Vast numbers of new products were being manufactured and they all needed to be designed and advertised. In an article in *Print* magazine entitled, 'Postwar Graphic Arts

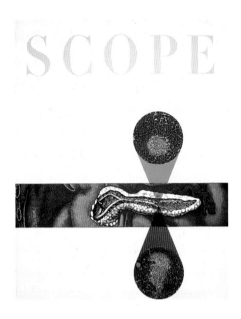

SCOPE

Upjohn, the American pharmaceutical company, was a major client of Will Burtin's. He was art director of its magazine, *Scope*, which was sent out to doctors, pharmacists and other health professionals. This was the cover of the very first issue of *Scope* in 1948, in which Burtin, by his cover visualization, predicts by many years the possibility of test-tube babies.

Education', Edward Frey looked ahead to what changes were necessary in design education. He wrote, 'A new dynamic creative order must of necessity supplant one that has been based largely on tradition and imitation. There will be a demand for creative thinking, creative planning and creative craftsmanship in all the industrial and graphic arts.'[18] The postwar period was an expansive time for education. The United States government had instituted a 'G.I. Bill', legislation by which returning veterans were given a free education. This meant that after 1945, colleges, universities and art schools were overflowing with a new influx of students. The student population was older and wiser, many having matured greatly in the military. They were serious about their studies and committed to 'getting on with it' so they could enter the workforce, buy a home, start a family and make a good income.

Veterans were looking for educational programmes that would prepare them for a career. The only major curriculum integrated in design was at the Institute of Design in Chicago. This programme, begun in 1937 by Laszlo Moholy-Nagy as the 'New Bauhaus' and supported by his fellow Hungarian immigrant György Kepes, stressed the formal values of design (line, shape, texture) in contrast to the representational drawing approach of most *beaux-arts* schools of the period. In the 1940s, Bauhaus master Josef Albers was active at Black Mountain College in North Carolina in gathering a group of important visionaries to offer courses in the creative arts and design. Among others, he brought designer Alvin Lustig there to teach a summer class. The faculty included R. Buckminster Fuller, photographer Beaumont Newhall and composer John Cage. Black Mountain College, opened in 1933, was a gathering place where European immigrants met the American avant-garde around intellectual issues. Active until 1957, Black Mountain eventually provided impetus for the new graduate graphic design programme at the Yale University School of Art in the early 1950s. Yale was recognized as the first educational programme in graphic design at the post-secondary level. In 1951, Alvin Lustig was consultant to the curriculum, which featured a formal design core complemented by real-world design assignments.

Yale was also unique because many of the faculty were practicing designers. Lustig's philosophy was that education should lead industry, not follow it. Prestigious guest faculty members such as Lester Beall, Alexey Brodovitch and the photographer Walker Evans brought vitality and reality to the coursework. As regular teachers, the programme featured Josef Albers, Paul Rand, Bradbury Thompson, Norman Ives, Herbert Matter and the typographer Alvin Eisenman. James Fogleman was a student at Yale during those formative years. He was one who agitated for a change in the Yale curriculum away from tradition towards a more modern programme. Fogleman would later become design director at CIBA and initiate a progressive corporate design programme.

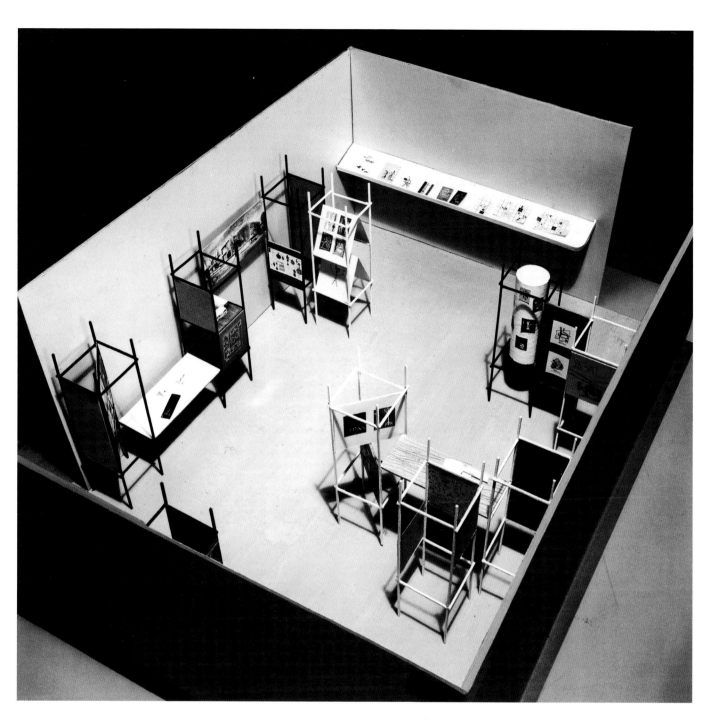

Students in the Yale programme did not view themselves as preparing for careers in commercial art or advertising design. Instead, they saw graphic design as dealing more with communication issues and problem-solving. This difference was key in the process of transforming graphic design from a service function into a professional status. The Yale programme was to become a major source for the next generation of important designers in America, especially among those who went into teaching careers. Its alumni list reads like a who's who of second-generation Modernist designers.

This scale model was designed for a one-man exhibit of work by Alvin Lustig in 1949. The exhibit was shown at the A-D Gallery in New York, the Walker Art Center in Minneapolis, Minnesota, and the Frank Perls Gallery in Beverly Hills, California. Lustig designed the exhibit system itself so that it was modular and would all fit in one box for shipping.

Above left Following World War II there was a great deal of optimism in the United States. War veterans were returning, buying homes and starting families. This cover for *The New Yorker* magazine, illustrated by Constantin Alajalov, appeared in 1946. It efffectively documented the positive postwar mentality in America.

Above right Automobiles were in great demand in the years following World War II. This ad for Frazer automobiles was designed by Paul Rand in 1949. Its bold, expressive and unique approach to advertising cars was typical of Rand's Modernist orientation. The typography and photograph were carefully crafted in the negative space around the indexical arrow symbol.

Among its distinguished line-up were Sam Antupit, Ivan Chermayeff, Alan Fletcher, Thomas Geismar, Rob Roy Kelly and Arnold Saks.

A NEW GENERATION TAKES HOLD

The American graphic designers of the 'creative forties' (a term coined by Hans Barschel) were critical in assimilating the new avant-garde approaches of the 1930s and making them appropriate for business and industry as they rode the crest of the postwar economic surge. Chicago designer Bruce Beck remembered, 'We believed we were part of an era that was creating design. It was a terribly exciting time.'[19] There was a feeling of openness to the design of this decade and a common feeling among designers that design really did make a difference. The world was better for its contributions. 'It was the expansion of the designer's task from a craft to a method of thought that represents the professionalization of graphic design.'[20] The challenge was clear: a new profession was taking shape. Through education and the pioneering achievements of this first generation of both immigrants and American designers, in the form and content of graphic design, the scaffolding for the dynamic and continued evolution of the field for the next sixty years was secured.

CORNER OF A PERFECT KITCHEN

Representing the latest developments in kitchen fitments, Hygena Units are a clever combination of contemporary design and practical utility. Beautifully made from selected woods, they are finished in gleaming, wipe-clean enamel and Formica. With cabinets covering every kitchen need, Hygena is designed as a Unit System in which selected Units can be combined in any desired arrangement and added to as required. You can build your ideal kitchen piece-by-matching-piece, starting with as little as one Unit.

Hygena Units are much less expensive than they look. The roomy Broom Unit on the left of the picture, is £13.7.6. Base Units with fitted cupboards, drawers and Formica work surfaces are priced from £8.15.0 and the Wall Units, with sliding glass doors, £7.10.0 each. Notice the polystyrene 'Minibins' for cereals, dried fruits, etc. Easily fixed beneath cabinets or shelves, they cost only 7/- each, complete. A full colour catalogue of the complete Hygena range will gladly be sent on request.

 MAKES THE PERFECT KITCHEN

 HYGENA CABINETS (LIVERPOOL) LTD., KIRKBY TRADING ESTATE, KIRKBY, LIVERPOOL

A New Style:
American Design at Mid-Century 1950–1959

'Modern businessmen have come to recognize that design can and should be used to express the character and identity of business organizations. Design is a function of management, both within an industry and the world outside it. Industry is the institution that reaches further into our civilization than government and therefore has a greater opportunity and responsibility to influence the quality of life.'

Herbert Bayer quoted in *A Tribute to Herbert Bayer*, 1979

THE AMERICAN SCENE

The American economy continued to boom in the 1950s. Despite the 'police action' in Korea, Americans generally knew peace, prosperity and conformity in this decade. The nation had a certain naivety, a simple and optimistic approach to life which preceded the turbulent changes to come in the 1960s. It was the calm before the storm. Improved mass-market technology made television sets affordable for many more people and brought advertising for a vast range of products straight into people's homes. Strikingly different product forms became available. The critic Thomas Hine referred to the 1950s as a time when 'everything from a T-bird to a toaster took on a shape that seemed to lean forward, ready to surge ahead'. It was as if the streamlined Art Deco style of the 1930s had been updated for a new audience. Detroit produced cars with exaggerated tail fins and gleaming chrome.

But despite the bright and shining optimism, the early 1950s were also the era of the McCarthy Communist witch hunts, the beginning of a deep dissent in the land – a conflict between liberalism and xenophobic conservatism. Jack Kerouac's book *On The Road* (1957) and Allen Ginsberg's poetry gave voice to the underground counterculture of the Beat Generation. Music lost its squeaky-clean image and became dissonant and more subversive. Art became more expressive and abstract. The definition of art was even challenged by Claes Oldenberg's soft sculptures and Allan Kaprow's 'Happenings'. The art of New York finally eclipsed that of Paris – the Americans had arrived on the scene with a vengeance. The 1950s was the decade that saw the emergence of the painter Jackson Pollock. His work grew out of a dynamic, improvisational Zeitgeist that characterized both the progressive jazz of the time and the writings of the Beat Generation. Socially, the beginnings of the civil rights movement happened in 1950 as Rosa Parks sparked the bus boycott in Montgomery, Alabama. Signs of deep change were on the horizon as Americans basked in the postwar optimism while they cruised around the new suburbs in their gas-guzzling cars with huge fins on each rear fender.

Opposite top *Portfolio* magazine was a major professional achievement for Alexey Brodovitch. In this experimental arts publication he was able to combine optimum editorial and design quality. This two-page spread from 1951 presented an article on the painter Jackson Pollock. Scale contrast in the photography plus the understated typography combines to create a layout of great elegance.

Opposite bottom Advertising designer Robert Gage worked for Doyle Dane Bernbach, Inc. He produced this ad for the New York rye bread company, Levy's. A whole series of similar ads followed, appearing even as late as 1967. These ads represented the simple, direct, humorous and sometimes controversial approach to print advertising that was common in the 1950s.

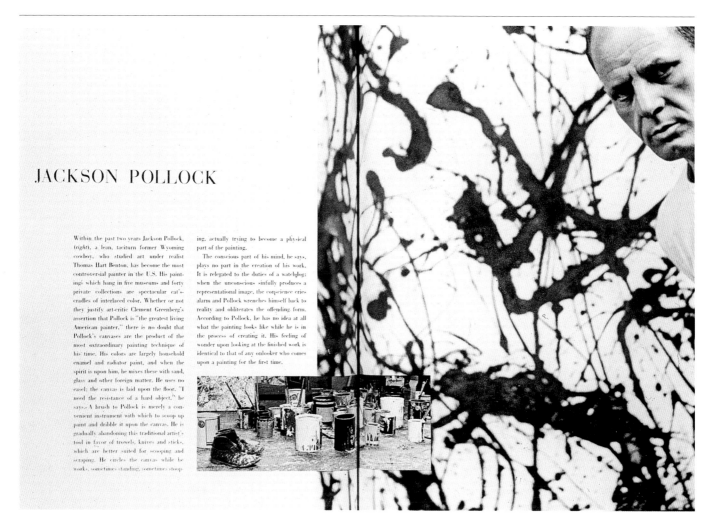

JACKSON POLLOCK

Within the past two years Jackson Pollock, (*right*), a lean, taciturn former Wyoming cowboy, who studied art under realist Thomas Hart Benton, has become the most controversial painter in the U.S. His paintings which hang in five museums and forty private collections are spectacular cat's-cradles of interlaced color. Whether or not they justify art-critic Clement Greenberg's assertion that Pollock is "the greatest living American painter," there is no doubt that Pollock's canvases are the product of the most extraordinary painting technique of his time. His colors are largely household enamel and radiator paint, and when the spirit is upon him, he mixes these with sand, glass and other foreign matter. He uses no easel; the canvas is laid upon the floor. "I need the resistance of a hard object," he says. A brush to Pollock is merely a convenient instrument with which to scoop up paint and dribble it upon the canvas. He is gradually abandoning this traditional artist's tool in favor of trowels, knives and sticks, which are better suited for scooping and scraping. He circles the canvas while he works, sometimes standing, sometimes stoop-

ing, actually trying to become a physical part of the painting.

The conscious part of his mind, he says, plays no part in the creation of his work. It is relegated to the duties of a watchdog; when the unconscious sinfully produces a representational image, the conscience cries alarm and Pollock wrenches himself back to reality and obliterates the offending form. According to Pollock, he has no idea at all what the painting looks like while he is in the process of creating it. His feeling of wonder upon looking at the finished work is identical to that of any onlooker who comes upon a painting for the first time.

ADVERTISING IN THE 1950S

By the late 1940s and early 1950s, an increasing consciousness about graphic design and designers was evident because Modernism became more visible on the creative scene. Design became a more dominant force in the corporations and in the advertising business. An important debate occurred between typographic purists and those who believed in excitement and experimentation. The most effective examples of design in the 1950s were able to mediate these differences, excite their readers and be legible. In advertisements, copy was shorter, headlines more brief, and text functioned to support the illustration. Photography, both colour and black-and-white, was the dominant medium of advertising illustration. Creativity was the big word in this decade, especially in advertising. Towards the end of the 1950s, at a New York Art Directors Club conference, keynote speakers stated that designers were now moving away from being just layout men to assuming creative responsibility for the whole job. Many designers opened their own businesses; companies specializing just in graphic design. In corporations, the title 'graphic design' finally meant something. Those who practised this

You don't have to be Jewish

to love Levy's
real Jewish Rye

A New Style: American Design at Mid-Century 1950–1959

Below Gene Federico was a New York designer who worked both in graphic design and in advertising. This print advertisement for *Woman's Day* magazine comes from 1953. It exemplifies Federico's love for expressive typography that is carefully crafted and integrated with photography. The word and the image are well-balanced on behalf of the message and the client.

Opposite The Container Corporation of America produced a memorable series of ads in consumer magazines through the 1950s and 1960s. Entitled the 'Great Ideas of Western Man', each ad was centred around a quote from a famous politician, philosopher or artist. This ad, designed by Gene Federico, comes from the 1960s and features a quote by Benjamin Disraeli. Federico gave the ad power through a clever hierarchy of elements. Every piece of image or type has a proper size and location, thus ensuring a unity to the overall layout.

work could have a sense of formal visual values, understand production and technical information, marketing and communications approaches, budgets, and be able to talk knowledgeably with businessmen and executives. The graphic designers were now welcomed at the conference table, in the boardroom, with marketing people, accountants, copywriters, behaviourists and company presidents. They had moved from the bullpen to the front office.

Marketing research began in the 1950s and became a major control on the process of creative advertising. This meant that advertising had to be measured and that new ideas and business decisions must be based on solid statistical data. This approach led to a further divide between the traditional creators of advertising and the more creative, conceptual wing of the business. Aloof from this dichotomy, the Container Corporation of America continued its innovative advertising campaign 'Great Ideas of Western Man' through the early 1950s. This programme bridged the world of art and design and proved the value of an 'extendable' design that is so well-conceived that it can endure indefinitely.

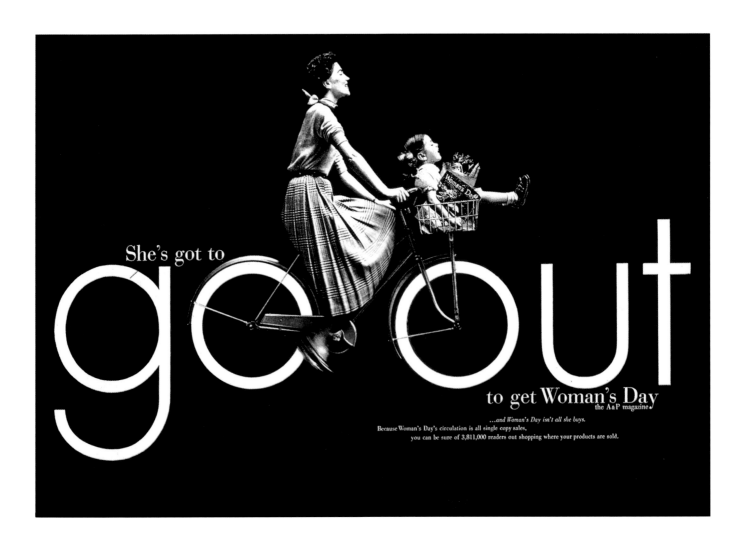

On Education and the Future .Speech, House of Commons, June 15, 1874

DISRAELI

Upon
The
Education
Of
The
People
Of
This
Country

The
Fate
Of
This
Country
Depends

Great Ideas of Western Man—one of a series Container Corporation of America

PROMOTING MODERNISM IN THE 1950S

By the 1950s, more and more corporations were aware of the benefits of effective design and having designers on staff who could guide the design and promotional needs of the company. This awareness was the dawning of the golden age of Modernist graphic design. Architects have always been a source of inspiration for enlightened graphic designers. This was especially true in the postwar period. New materials and technologies were developed during the war and were available for commercial application. Harnessing these possibilities enabled America to manufacture an affordable Modernism. For example, from the technology that produced bent plywood for wartime leg splints came the chairs of Charles and Ray Eames. Design historian Lorraine Wild referred to the design of the 1950s as either 'consumer modern', targeted aggressively to the general public, or 'high modern', directed at

artist: herbert bayer

every	at	is	a minority
new	its	precisely	of
opinion,	starting,	in	one.

THOMAS CARLYLE (HEROES AND HERO WORSHIP, II, 1840, LECTURE IN LONDON, MAY 8.)

GREAT IDEAS OF WESTERN MAN...ONE OF A SERIES CONTAINER CORPORATION OF AMERICA [CCA]

© CCA 1961

Herbert Bayer designed this ad for the Container Corporation of America's continuing 'Great Ideas of Western Man' series begun in 1950. This ad featured a quote by Thomas Carlyle from 1840. Bayer used a series of random sticks in disarray with one in particular that was straight. This arrangement was a perfect visual metaphor to extend and symbolize the meaning of the quote. The Great Ideas ads were a unique way of indirectly suggesting corporate progressiveness and excellence through consumer advertising.

selling design itself to corporations and potential clients. She felt that the unresolved issue of whether design practice should be an art or a business caused a confusion that remains to the present day. The high style meant that form was inextricably linked to conceptual content. This was the message of the Modernists, and by the 1950s a body of work had been accomplished by designers such as Paul Rand, Lester Beall, William Golden and Gene Federico. This work signalled that something new was apparent on the graphic landscape.

But this new approach still had to be sold. Designers were now able to say what it was that they were doing and how they saw its future. In his book, *Thoughts on Design*, Paul Rand described design as having three necessary parts: the client materials, the formal visual material and the designer's concept. Magazines such as *Print*, *American Artist* and *Graphis* took on a

Charm called itself 'The magazine for women who work', and in this it was unique in its marketing focus. Cipe Pineles, the first female art director of a major magazine, made the visual appearance of the magazine balance and extend the content. This cover, from 1952, exemplifies Pineles's sensitivities to the integration of photography and typography.

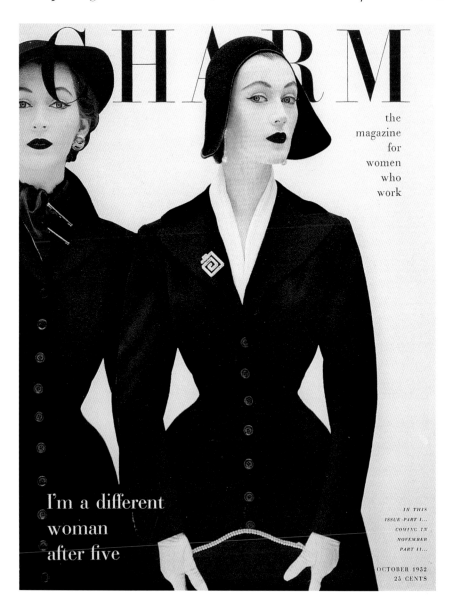

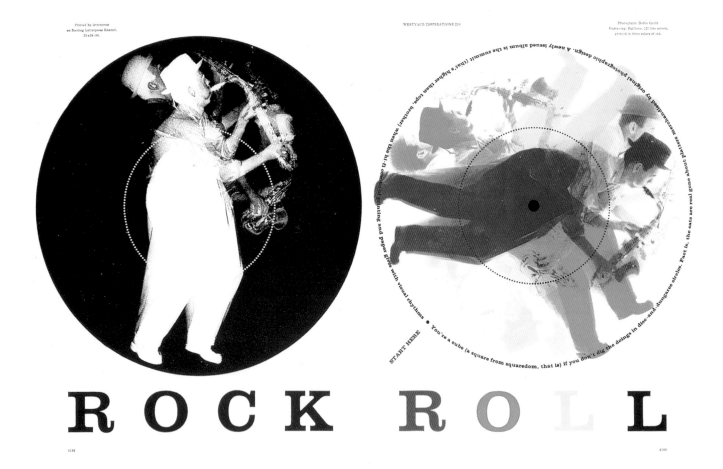

Printed by letterpress
on Sterling Letterpress Enamel.
25x38-50.

Photograph: Bodie Guild.
Engraving: Halftone, 120 line screen,
printed in three colors of ink.

ROCK ROLL

Above Bradbury Thompson designed many issues of *Westvaco Inspirations for Printers* between 1939 and 1962. Thompson consistently was experimental in his visual design approach to these pages. This spread from 1958, on a timely 'rock-and-roll' theme, exemplified Thompson's abilities at translating type and image into a powerful unity that communicates a clear message.

Opposite right Otto Storch was art director at *McCall's* magazine in the 1950s and 1960s. He brought a new look to the magazine with his expressive typography as shown in these pages from 1959. He was a master at the careful integration of type and photographic imagery. The words became important kinetic elements on the page, extending the message by the manner in which they were presented. The photographer for these pages was Allen Arbus.

new importance as they showed the landscape through the work of designers like Cipe Pineles, Bradbury Thompson, Henry Wolf, Allen Hurlburt, Leo Lionni, George Giusti and Will Burtin. CA magazine, introduced in 1959 as the *Journal of Commercial Art*, became a showplace for the 'high modern' works. Later it would change its name to *Communication Arts*.

Advocacy groups such as the American Institute of Graphic Arts (AIGA) in New York and the Society of Typographic Arts (STA) in Chicago contributed to the development of design by sponsoring competitive exhibits and catalogues. Founded in 1951 by Walter Paepcke, chairman of the Container Corporation of America, the International Design Conference in Aspen became a major forum in which design could be seen as an integral part of good business. Critic Reyner Banham in his anthology of the Aspen speeches noted, 'It was the intention of conference planners to lure skeptical businessmen into listening to argument posed by well-respected brethren who supported design.'[1] Conference themes were different each year. In the 1950s, the conferences were targeted at businessmen and corporate executives. By the 1960s, speakers included architects Louis Kahn and Paul Rudolph, designers Saul Bass and Charles Eames, and visionaries

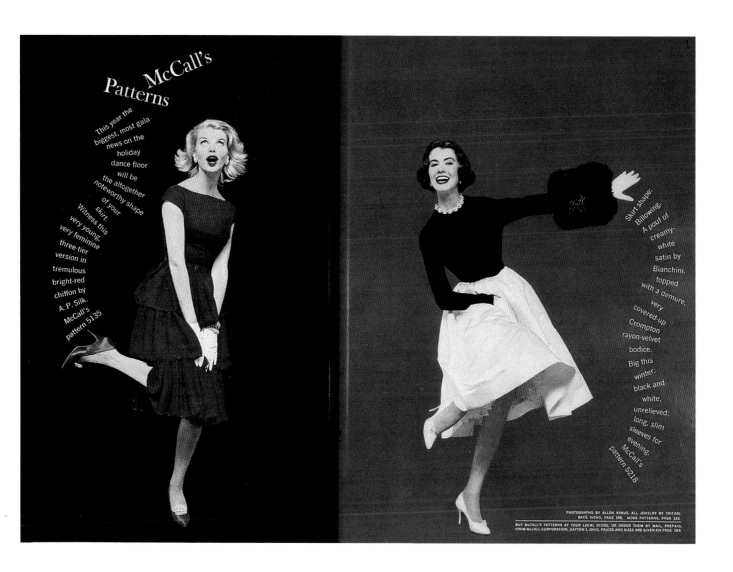

McCall's Patterns

This year the biggest, most gala news on the holiday dance floor will be the altogether noteworthy shape of your skirt. Witness this very young, very feminine three-tier version in tremulous bright-red chiffon by A. P. Silk. McCall's pattern 5135

Skirt shape: Billowing. A pouf of creamy-white satin by Bianchini, topped with a demure, very covered-up Crompton rayon-velvet bodice. Big this winter: black and white, unrelieved; long, slim sleeves for evening. McCall's pattern 5218

PHOTOGRAPHS BY ALLEN ARBUS. ALL JEWELRY BY TRIFARI.
BACK VIEWS, PAGE 188. MORE PATTERNS, PAGE 102

BUY McCALL'S PATTERNS AT YOUR LOCAL STORE, OR ORDER THEM BY MAIL, PREPAID,
FROM McCALL CORPORATION, DAYTON 1, OHIO. PRICES AND SIZES ARE GIVEN ON PAGE 184

A New Style: American Design at Mid-Century 1950–1959

FORTUNE

February 1960

NEW YORK

NEW YORK

NEW YORK

NEW YORK

NEW YORK

NEW YORK

NEW YORK

NEW YORK

NEW YORK

NEW YORK

Opposite Leo Lionni designed this cover for *Fortune* magazine in 1960. Lionni became art director of the magazine following Will Burtin's tenure. On this cover, the pattern of Venus letterforms creates variety, while at the same time the overall effect is one of unity. Typographically, the cover design suggests the blinking lights of Times Square. It is also an excellent Modernist example of how a magazine cover can be designed using type alone.

Above left From 1948 until 1971, Will Burtin designed the magazine *Scope* for the Upjohn Pharmaceutical Company. *Scope* was a journal targeted at health professionals and those in the pharmaceutical business. It featured articles on medical matters and new drugs as well as subjects that were more esoteric. This cover, from 1955, was typical of Burtin's objective approach to the design of the magazine. The classic Bodoni type for the masthead is contrasted by the Modernist geometry of the elements below in the layout.

Above right *CA, The Journal of Commercial Art*, first appeared in 1959. It was an advocacy magazine for graphic and advertising designers, even though it still made reference to the trade-oriented label of 'commercial art'. This first cover, created by type designer Freeman Craw, was a bold and colourful introduction for the magazine. It featured profile articles on designers, technical information and articles of interest to those in the visual design world.

R. Buckminster Fuller and S.I. Hayakawa. William Golden was an eloquent speaker who bridged the creative and the business worlds with his pragmatism. At the ninth conference in 1959, Golden brought the conference back to earth with his comment, 'I happen to believe that the visual environment of advertising improves each time a designer produces a good design – and in no other way. The obvious function of a designer is to design. His principal talent is to make a simple order out of many elements. The very act of designing exposes elements that are inconsistent and must obviously be rejected. When he is in control of these elements, he can usually produce an acceptable design.'[2] At the 1955 Aspen conference, Golden's friend, Will Burtin, took a different tack: 'As designers and artists we are daily and intimately connected with business activities, whose character in terms of social and economic ramification we must understand and appreciate. Yet in our lives we are also moved – and perhaps more profoundly – by broader issues of philosophy and an awareness of a need or experiment, for investigating directions of thought in which business as a commercial activity cannot assist, yet stands to benefit from. To use business language: before we sell something to business, we should know what we are selling.'[3]

THE ERA OF CORPORATE IDENTITY

Competition among corporations was becoming keen in the 1950s as the postwar economic boom continued. This meant that many companies looked critically at their trademarks, logotypes and brand identities. Pierre Martineau argued, in an article in the *Harvard Business Review* in 1958, that every company elicits broad, subjective attitudes from the public that cannot be addressed in a single communication; only a complete examination of all artefacts connected to a given company will enable its managers to control the public's general impression of that company and its enterprises. Models for identity graphics had existed in America with systems of symbols and, from Europe, with corporate-identity programmes. The symbol system, designed by Charles Coiner for the United States Citizens Defense Corps during World War II, was an outstanding home-grown example (see page 87). The Olivetti programme, designed in 1947 by Giovanni Pintori, was exemplary and had been widely publicized in *Graphis* and other design journals.

The showcase identity programme that set the pace for others was William Golden's work for the Columbia Broadcasting System (CBS). Begun in 1951, the success of Golden's programme was due largely to the support he established with top CBS management persons such as William Paley and Frank Stanton. Golden had learned design and Modernist ideas from Dr Agha at Condé Nast magazines in the late 1930s. After the war, he created a vigorous design department composed of talented young American designers, including George Lois, Lou Dorfsman and Kurt Weihs.

Olivetti Elettrosumma 22

THE
BIG
PUSH

THIS SUMMER America's consumers will fill their shopping baskets fuller than any summer in their history. And they will fill them with the products they know best – the brands they see on television.

Last summer they spent nearly 10 per cent more than they did the previous winter – 7 per cent more for food; 12 per cent more for household appliances; 15 per cent more in department stores and nearly 8 per cent more on installment purchases.

For the television advertiser, each summer becomes more inviting than the last.

Each summer the average family spends more time watching television.

Each day 8,000 new families join the vast television audience, and by July the number of television homes in the country will total 40,300,000 – nearly 3½ million more than last July.

And each summer CBS Television brings to its advertisers bigger audiences than the summer before and larger than any other network.

CBS Television advertisers are better prepared for the big summer sales push than ever – in fact, this summer 14 per cent more of our winter advertisers will be on the air than a year ago.

These are compelling facts for an advertiser who is debating when or where to launch his new advertising campaign.

Clearly the time to start is now; the place

CBS TELEVISION

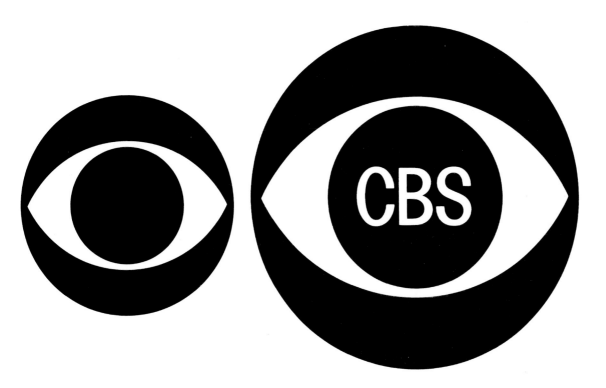

The identity programme for CBS was developed by first modifying by hand the Didot Bodoni typeface. This new font became the centrepiece of the CBS corporate identity. For the television division, Golden created a new identity mark: the 'eye' symbol. This symbol and accompanying typography was then tastefully adapted to thousands of print and video applications. The first on-air view of the eye symbol was on 16th November 1951. The programme was documented in the book *The Visual Craft of William Golden*, which was published by Cipe Pineles following Golden's untimely death in 1959. The CBS programme was a beacon for many corporations; Pineles remembered that after Golden designed the eye for CBS, everyone had to have their own symbol. Golden was the first art director/designer to think verbally as well as visually. Golden showed designers that they needed to view their roles as responsible decision-makers on a par with financial people, marketing people and other policy-makers within the organization. The CBS eye mark, still in use after fifty years, is a testimonial to timelessness in the form of graphic design.

Another major designer who was instrumental in corporate design in the 1950s was Paul Rand. He filtered the best of the European avant-garde influences into his work. In 1956, from his home studio in Connecticut and with a small staff of assistants, he began working on the identity programme for IBM. The distinctive logotype was based on the City typeface, designed by George Trump. The contact for this project had come from architect Eliot Noyes, who had convinced the founder of IBM, Thomas Watson, of the benefits of impressive corporate presentation. Rand, over the next

Opposite, top The corporate identity for CBS was among the first of its kind, appearing in the 1950s. Under the direction of William Golden, the identity programme was applied in all parts of CBS Television across America, from on-air graphics in New York to its Television City facility in California.

Opposite, bottom As creative director of CBS, William Golden frequently hired well-known artists, illustrators and photographers to promote CBS advertising. This classic trade ad from 1957 was illustrated by Golden's good friend, American artist Ben Shahn. In addition to the arresting pattern of Shahn's illustration, the ad showed the unique relationship between text and image.

Above Designed in 1950, the CBS eye symbol quickly became a household image in American living rooms, illustrated here in its two original forms: with and without the accompanying CBS letters. Because of its classic design, the mark has endured and is still being used fifty years later.

Below left & right The corporate identity design boom in the 1950s and 1960s was a manifestation of Modernism reaching its zenith in American graphic design. Paul Rand was a pioneer in this movement towards contemporary identity programmes for major American corporations. Beginning with the IBM programme in 1956, Rand would innovate many integrated design systems in which he made recommendations for every facet of the corporate identity, from water towers to business cards. For IBM and Westinghouse, Rand created new symbols that evolved from previously existing corporate marks, thus providing continuity and a fresh, modern look.

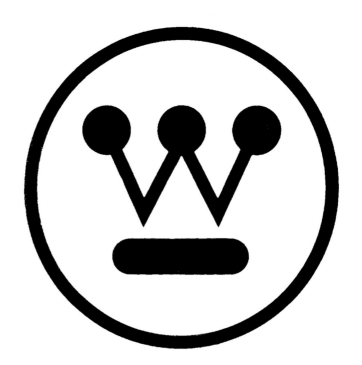

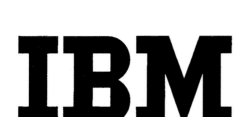

forty years, created new identity programmes for major American companies, businesses and products. In 1960, he gave Westinghouse a new corporate face. Later, other identities were designed for the ABC Television network, Cummins Engine and NeXT Computers. Rand loved to joke that he did the identity for the United Parcel Service (UPS) when starting out as 'a little boy in the business' and that thirty years later he was still working on it.

Lester Beall also saw the potential of corporate identity work in the 1950s and became a major innovator in the field. He developed his capability at corporate identity work from designing packaging systems. He said, 'An effective company or corporate symbol must represent and accomplish many things. It is a company's identifying mark … indicating the company's field of business or its products; reflecting its attitude; signifying the character of its management; and intimating its command of the future.'[4] Beall's work in the 1950s in corporate print design and particularly in packaging became the foundation for his specialization in identity design. In the 1960s, he designed

Below The corporate identity programme for the Westinghouse Electric Company was designed by Paul Rand in 1960. In the graphics standards guide, Rand proposed this sequential design for the development of the corporate mark, the 'circle w'. The Westinghouse design had a prominent presence in Pittsburgh as well as in the larger design community. For example, an expanded version of this symbol was adapted for a large animated, computerized electric sign which graced the skyline of Pittsburgh for many years. In the daytime one would see nine 'circle w's' spanning a 200-foot aluminium background. After dark, random patterns of the mark would appear, in an infinite number of combinations.

several major identity programmes for Caterpillar Tractor, Titeflex and the New York Hilton hotel. His identity for the International Paper Company was extensive and provided him with the opportunity of developing a graphic identity standards manual which became a model for many other corporations and designers in the 1960s.

The era of corporate identity was the beginning of the period in which Modernism reached its height in American graphic design. Among corporations with a commitment to design excellence came the need for in-house corporate design departments. Companies such as Xerox, the Container Corporation of America, Carborundum, IBM and CIBA hired formally trained designers, steeped in the Modernist tradition, to facilitate the design programmes. As managers and staff designers, they monitored the corporate-identity programme, designed collateral materials and corporate propaganda. They also policed the corporate design standards. Westinghouse Electric Company in Pittsburgh had one of the most advanced corporate design groups which, working with Paul Rand as consultant, produced a number of design demonstration projects which were important for the company and served as models for others in the design field. Of special

importance was the publication, *A Modular Grid System in Graphic Design*, which was conceived and designed by Kenneth Hiebert. This guide, compiled in 1969, explained the basics of a typographic grid system and its benefits to corporate design. It was used to standardize many Westinghouse publications, especially those produced outside the corporate design unit. Corporate identity design became a major function of graphic designers in this decade. Specialized design firms sprang up with this service as their main function. Elaborate rationales were developed to justify the corporate need for identity. Rand's *Westinghouse Corporate Identity Manual* included an almost poetic statement titled 'The Look of Excellence'. This statement connects the corporate goal of excellence with the new identity programme: 'Everything we are undertaking in this design program, therefore, is based on the existence of certain standards of excellence and performance. We must elevate our objectives in the fields of architecture, graphics, product design, packaging and advertising. The standards we are introducing, and will maintain through the years ahead, are recognized by able designers and businessmen as the only logical approach to our responsibilities.'[5] These systems and manuals became templates and tools to ensure consistency in Westinghouse graphics and the resultant corporate identity. Concurrently, they also became important artefacts of the rational design of the 1960s.

INFLUENCES FROM EUROPE AND JAPAN

Designers in Europe in the 1950s began to practice a more systematic approach to design, a response to the scientific objectivity that was present in this postwar nuclear age. Yale University's graduate programme in graphic design, guided by Alvin Eisenman, had connected with the Basel School of Arts and Crafts in Switzerland. Armin Hofmann, its director, visited Yale on a regular basis. In Switzerland, designers such as Hofmann, Emil Ruder, Josef Müller-Brockmann, Richard Lohse, Otl Aicher and Carlo Vivarelli practised a rational, objective methodology in their work. This systematic approach appealed to American students, and soon they were studying at

Opposite above During the golden age of corporate identity in the 1960s, Lester Beall designed marks for many different American companies. Shown here is a series of his well-known symbols and logotypes. Shown top left is the logotype for the New York Hilton Hotel. The Hilton mark project was noteworthy for Beall in that it presented opportunities to do many different applications of the new identity, ranging from menus to bathmats for the chain's new flagship hotel. Next is the mark for the Caterpillar Tractor Company; the mark for the investment company Merrill, Lynch, Fenner, Pierce & Smith; the mark for the Connecticut General Life Insurance Company, the mark for the Railway Express Agency (an early

courier company) and the mark for Titeflex, a company that produced industrial springs.

Opposite below Lester Beall designed this identity mark for the International Paper Company in 1960. His best known mark, it is still in use today. Beall began working with IP on their paper packaging; this led to package branding which then allowed him to develop a complete visual identity programme, including one of the first graphics standards manuals. Within the circle of the IP mark, Beall created an element which can either be read as a tree or as the letters IP. This visual ambiguity involves the viewer in the perception process, therefore increasing the ease of recollection.

Top Immigrant designer Ladislav Sutnar designed this promotional piece for addo-x, a Swedish business machine company, in the early 1950s. Centred in the layout was the new addo-x trademark. It exemplified Modernist graphic design in its total geometric construction.

Above Sutnar designed this personal identity mark in 1955. It appeared on his personal papers, on the cover of his book *Visual Design in Action* and on a travelling exhibition of his design work. It represented his great love of Modernist geometry in visual expression.

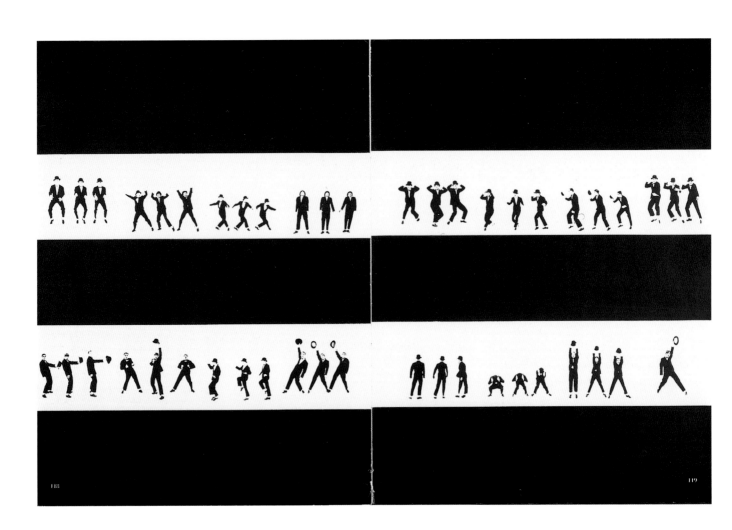

the Hochschule für Gestaltung (College of Design) in Ulm, Germany and at the Kunstgewerbeschule (School of Arts and Crafts) in Basel, Switzerland. Designers in America such as Kenneth Hiebert, Ivan Chermayeff, Tom Geismar and Rudolf de Harak adopted these structural means, especially in their corporate design work. Rob Roy Kelly, a Yale graduate and progressive teacher at Kansas City Art Institute, was the first American educator to bring young Swiss designers to the United States to teach.

Graphic design took on a more global look in the 1950s. Japan took its place on the world design scene with the appearance of a design journal, *IDEA*, which was first published in 1953. This magazine maintained its international view from the beginning and featured, in its premiere issue, works by Raymond Savignac from France and Paul Rand from the United States. Periodically, *IDEA* would publish important history issues which documented Modernist designers as well as emerging designers. An early issue featured 'A Generation of Graphic Art' in which a comprehensive array of contemporary design was collected and shown. The magazine editor wrote, 'The review of top-notch designers in the past through this exhibit would enable the origin of the contemporary graphic design world to be traced and its future development envisioned.'[6] The article was produced in cooperation with Dr Robert Leslie and documented the exhibit of the same title at his Gallery 303 in New York. In 1984, *IDEA* magazine produced a book, *30 Influential Designers of the Century*, intending it to serve as a reference for the history of world design.

BRODOVITCH MOVES ON

Important changes occurred in the magazine field. Brodovitch left *Harper's Bazaar* in 1958 after twenty-five years as art director. However, he went on to produce a number of significant projects, such as the book *Observations* in 1959. Working with Richard Avedon's photographic portraits of celebrities and with text by Truman Capote, Brodovitch used the same cinematic layout technique that had served him so well in his years at *Harper's Bazaar*. Sadly, personal and physical problems beset Brodovitch in the 1960s and led to his decline and eventual death in 1971.

Opposite This two-page spread is from the photography book *Observations*, published in 1959. Designed by Alexey Brodovitch, the book was composed of celebrity photographs by Richard Avedon with text by the novelist Truman Capote. The image selected was an action view of dancers. Brodovitch was influenced by the cinema and loved to create sequential, animated layouts.

Above At the back of the book *Observations* is a photograph of Brodovitch working on the book, moving around the layouts and arranging pages on the floor. The photograph is revealing in that it provides a glimpse into the process that Brodovitch used in designing magazines and books. He was concerned with sequence and proper page flow, and this working methodology accomplished that.

MODERNISM AT FULL MATURITY

The decade of the 1950s and 1960s was the golden age of Modernism in American graphic design. Both critics and historians suggest that Modernism ended with the emergence of a post-Modernist style in the mid-1970s. But when one talks of 'the end of Modernism', there is not a distinct historical end date. 'Histories do not break off clean, like a glass rod; they fray, stretch and come undone; and some strands never part. The reflexes of Modernism still work, its limbs move, the parts are mostly there, but they no longer seem to function as a live organic, whole. The Modern achievement will continue to affect culture for decades to come, because it was so large, so imposing, and so irrefutably convincing.'[7]

7

1960 – 1999

Design Since Mid-Century: Diversity and Contradiction 1960–1999

'We are at a time of explosion of our profession. More and more young designers are reaching the market. For all of them, as for all of us, a detailed knowledge of the past is the only guarantee of a brilliant future. The new technologies have opened unimaginable possibilities for all of us, but the real task is not the education of the machine but that of its operator.'

Massimo Vignelli

THE AGE OF AQUARIUS

While the postwar middle class still held on to an optimistic view of prosperity and peace, the 1960s brought with it the proliferation of dissent in America. The war in Vietnam, as well as the stresses of the ongoing civil rights movement, were dominant forces in this unrest in the land. At this time of transition, change was reflected in many ways. It was the time of anti-war demonstrations on college campuses and the age of psychedelia. The rallying call was for 'sex, drugs and rock and roll'. The West Coast author Ken Kesey became a focal point. After writing his novel *One Flew Over the Cuckoo's Nest* in 1962, he became a hero as he rode cross-country in 1964 in an old school bus with his buddies, the Merry Pranksters. Artists were experimenting with radically new approaches. The Pop Art style emerged with Roy Lichtenstein's comic strip paintings and Andy Warhol's 'Campbell's Soup Cans', while the Op Art of Bridget Riley made viewing paintings a kinetic trip. By 1963, Fluxus artists such as Nam June Paik and Joseph Beuys were doing their thing with performance art, taking art into the realm of the conceptual. The 1960s ended with Woodstock, the grand musical happening in which thousands of young people flocked to a farm in upstate New York.

CONCEPT BECOMES KING

If one agrees with the Marshall McLuhan statement that 'historians and archaeologists will one day discover that the ads of our time are the richest and most faithful daily reflections any society ever made of its entire range of activities', then the advertising and magazine work of George Lois is a useful mirror of the Fifties, Sixties and Seventies. He was called 'America's most resourceful art director and surely its most prolific'.[1] After gaining practical experience on this job, Lois was hired by legendary ad man Bill Bernbach at Doyle, Dayne and Bernbach, where he promptly won three Art Directors Club medals. In 1960, he left to found Papert, Koenig & Lois. This agency quickly grew to a forty-million dollar business in seven years, and in 1967, Lois left to start a new agency again. His classic covers for *Esquire* magazine

In the United States, the 1960s and 1970s were a time of unrest, dissatisfaction and radical change. For many, especially the anti-Vietnam war protesters, the 'peace symbol' became a popular icon. The mark originally was designed by Gerald Holton in 1958 for the Campaign for Nuclear Disarmament (CND), but it came to mean much more in the following two decades.

Esquire

MAY 1969
PRICE $1

THE MAGAZINE FOR MEN

**The final decline and total collapse
of the American avant-garde.**

Campbell's CONDENSED TOMATO SOUP

Esquire magazine is a men's magazine that includes content on politics, men's fashion, celebrities and the arts. In the 1960s, it featured provocative articles and covers. George Lois designed a classic set of covers during this period, including this one from 1969 showing Andy Warhol drowning in his own can of Campbell's Soup. Lois's *Esquire* covers were powerful in that each had wit, irony and ambiguity that made it memorable.

were done in 1972. The key word in understanding Lois's approach is simplification. His work over the years, whether in advertising, identity, magazine design, packaging or television, shows a creative directness with a powerful sense of impact gained through humour and ambiguity.

The popularity of television began to create a more visual culture, and it spawned many new consumer products. Mass-marketing via television revived the advertising business. Graphically, the 1960s brought a new emphasis on the concept, message and the means by which the message could be best communicated. In the N.W. Ayer Advertising Agency in Philadelphia, art director Mike Eakin said, 'The idea should be conveyed as simply as possible, so that nothing comes between it and the reader.'[2] The effective collaboration between the copywriters and art directors made the

The designer Herb Lubalin was a pivotal figure in the typographic expressionism movement in New York during the 1950s and 1960s. This trade advertisement from 1959 celebrated Lubalin's promotion to partner at Sudler & Hennessey, creating a new firm: Sudler, Henessey & Lubalin. The ad showed Lubalin's consummate ability at arranging and nesting classic letterforms in a grouping that became almost sculptural on the printed page in its negative and positive shapes.

1960s a great decade for print advertising. The 1959 'Think Small' advertising campaign for Volkswagen, with art direction by Helmut Krone, showed a new direction for Madison Avenue. It was the minimalism of the art world transferred into the advertising business. General Motors used the advertising slogan 'See the U.S.A. in your Chevrolet' in its national television spots. Art Director Jerry Della Femina wrote, 'It was the first time that anyone really took a realistic approach to advertising.'[3] This realism was a mirror to the freedom in the culture of the times.

The 1970s brought changes to advertising. Agencies grieved over the supposed death of the 'creative revolution'. The business was predominantly conservative, with tight budgets, a strong focus on market research and increased use of celebrity promotion. Shorter television ads were common. William Bernbach, the guru of the creative revolution in advertising, wrote in 1977, 'With the government limiting so much of what you can say, and with hundreds of millions of messages going out daily to the consumer … how you say what you can say is becoming more important. Because with fewer things to say, the only difference lies in how you say it.'[4]

SH&L Expanded - redesign of a familiar face. A more flexible version of S&H, long a favorite of people who work with fine design. You can specify SH&L for a wide range of uses from small space campaigns to large corporate image projects. We offer a Bold Face (for impact), Oblique (new ways of viewing old problems), and Casual (no straining for more effect). For a full showing, call Herb Lubalin at Plaza 1-1250, or write him c/o SH&L, 130 E. 59th Street, New York 20, N.Y.

THE RISE OF TYPOGRAPHIC EXPRESSIONISM

The creative emphasis in the 1950s included the emergence of typography as the dominant approach. Two extreme and opposite approaches were evident. Typographic expressionism was at its peak as it became an exciting and emotional element in itself as well as a means of bringing together other elements in a layout. 'Words and pictures reinforced each other and typography reinforced both. Expressive typography was big.'[5] An important figure in the typography world in the 1960s was Aaron Burns. He sold fonts through his company, the International Typeface Corporation. In addition he produced a tabloid-sized publication, *Upper & Lower Case*, which showcased his fonts with practical articles on typography and history. His 1961 book, *Typography*, presented exemplars of typographic design. In the tempestuous 1960s, Burns joined those pleading for 'less typographic indigestion, more contemporary classicism, less noise, more restraint'. European designers, especially those from Switzerland, were exerting a different typographic sensibility, that is, one of suggesting that type should be read but not necessarily noticed. The message and content were important,

Below left The Swiss typographer Wolfgang Weingart was an instrumental European force in post-Modernism. Through his design and teaching at Basel, Switzerland, he would challenge traditional values. In 1974 he was invited to design several covers for *Visible Language*, an American journal on typography. This cover is an excellent example of his experimental direction, namely in the use of many type sizes, the application of all capital letters, the integration of abstract shapes and the random way of varying letter weight.

Below right The Helvetica typeface was designed by Max Miedinger and Edouard Hofmann and issued by the Swiss type foundry Haas in 1957. Based on the font Akzidenz Grotesque, Helvetica (because of its increased 'x' height and legibility) became very popular in America. In its way it was the icon of Modernist graphic design, seen on just about every piece of graphics in the 1960s. It was clearly the font of choice. Its wide adoption was enhanced through the work of designers such as Will Burtin, Rudolph de Harak and Massimo Vignelli. This illustration is a specimen of the Helvetica type family from 1960.

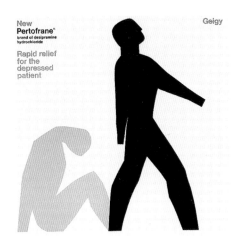

New
Pertofrane®
brand of desipramine
hydrochloride

Rapid relief
for the
depressed
patient

Geigy

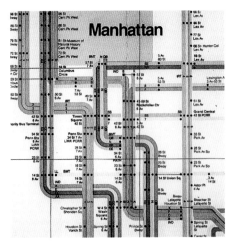

Manhattan

Top The European pharmaceutical company Geigy was a progressive firm that placed a high priority on design excellence. In its United States office, there was a staff of Swiss designers which created Modernist graphic design and advertising in the 1950s and 1960s. Geigy became a conduit for young designers from Europe into the United States. This ad exemplifies their style, with the use of bold Helvetica type in a logical, ordered layout. One of the chief designers, Steff Geissbuhler, eventually became a principal in the New York design firm Chermayeff & Geismar.

Above Massimo Vignelli designed this map in 1966 for the New York Subway System while he was still a principal at Unimark International. Inspired by the style of Henry Beck's classic 1931 map for the London Underground, Vignelli used a strict geometric simplification of the subway lines. The map immediately became controversial because critical New Yorkers claimed that they could not easily understand the graphic abstraction. Soon Vignelli's beautiful map was replaced by a traditional subway map which followed a more conventional cartographic style.

and graphic treatments were means, not ends. Fonts such as Helvetica, News, Folio and Univers became 'a sort of beardless, undistinguished but very functional royalty'.[6] The imagery carried the emotional component as typography and design elements provided the surround.

In the early 1960s, Allen Hurlburt, art director of *Look* magazine, characterized the typography of the 1950s: 'Like the rise and fall of hemlines, typography in our time has moved from the Swiss cheese to the sardine look. Not too many years ago, type designers were vying to see who could get the most letter spacing between the letters and the most leading between the lines. Then we moved to the age of tightly stacked letters and compressed copy. The scissors and the camera made it possible to compress and interlock letters in a manner beyond the measure of mere type metal. If there is a single alarming weakness in the typography we see today, it is its ultimate similarity.'[7] This critical view was to become even more true in the 1960s with the dominance of Helvetica types and Swiss styling. Cynically, Arthur Cohen labelled it 'Swiss sanitation'.

LESS IS MORE

The 1960s was a decade of contradiction. In stark contrast to what was happening around them, the graphic designers of this period were in a very different place. The decade of the select 1960s became the time of the full flowering of Modernism. A second generation now adopted and extended Modernist ideas in their work. Many designers were concerned with everlasting values such as permanence, structure, timelessness and the quest for the purest form possible. The Helvetica typeface gave young designers an important means to further emphasize the message and functional values. It became so popular that, to many, it seemed the only type necessary.

Helvetica and page-grid systems were the tools of the day. A rational design approach had cost benefits for the corporations in that it systematized variables in the process, which naturally led to more effectiveness and consistency in the corporate image. An important designer who adopted this approach in America was Massimo Vignelli who had moved to the U.S. in 1965 to work for Unimark International. Vignelli's projects for Knoll Furniture, the New York City Subway System, American Airlines, Bloomingdale's and others soon became known. In 1971, with his architect wife Lella, Vignelli established Vignelli Associates in New York. He became a spokesman for rational design, speaking at schools and writing extensively for the cause of Modernism. Making his position clear, at one point he preached that design which is void of any structure is anarchy. Designers in the 1970s adopted Modernism not for social change, but 'as an aesthetically and economically attractive technique. Corporations employed Modernists to represent the seemingly flawless consistency of their own structures

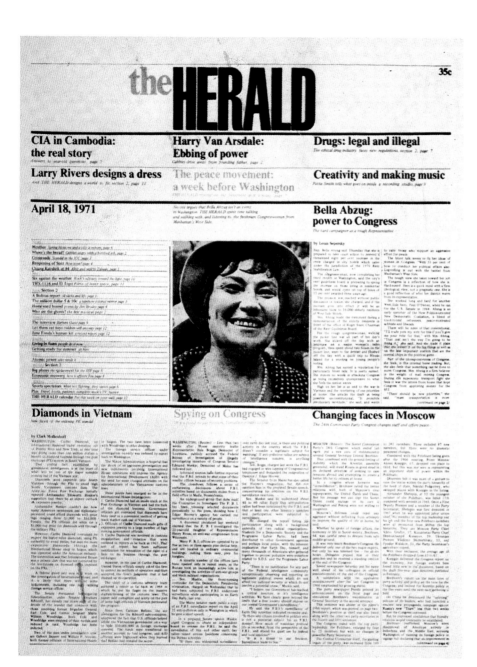

Above left Massimo Vignelli has been a champion of Modernism in all his many design pursuits. He designed this format for *The Herald*, a newspaper in the New York City area, in 1971. The design was based on an obvious underlying organizational grid structure to ensure order and alignment in the layout. The typography was made interesting in his integration of several classic fonts in contrasting relationships.

Above right Rudolph de Harak was a New York designer whose graphics and exhibition design were functional, informational and creative. This book jacket from the early 1960s is one of a series designed by De Harak for McGraw-Hill, memorable for their bold asymmetry and use of Helvetica type. The designer selected a simple image form to symbolize McLuhan's message.

Below left The 1960s were the golden years of corporate identity in America. Chermayeff & Geismar were among the leaders of this movement, designing many effective programmes. The 1964 corporate identity programme for Mobil was exemplary in that it employed a logotype: that is a unique configuration of the company name. In order to bring distinction to the logo, they printed the 'o' in a bright red colour. The programme is still in use, nearly forty years after its inception.

Below right The corporate identity programme for the Bell Telephone System, designed by Saul Bass in the 1970s, was one of the most comprehensive of its time. Bass evolved the design of the mark from previous versions of the 'bell'. He simplified it and integrated it into a system with logos, standard typography, colour, etc. The programme was so large that Bass developed an integrated series of printed booklets outlining the standards.

Opposite Chermayeff & Geismar created this identity mark for Chase Manhattan Bank in 1960. Many others would follow by different designers. The liability of an abstract identity mark is that it requires the company to educate its customers and clients to the connection and meaning of the symbol.

and power to reduplicate themselves across new regions and industries.'[8] In 1960, New York design firm Chermayeff & Geismar created the abstract mark for Chase Manhattan Bank and, in 1964, a logotype for Mobil Oil Corporation. Saul Bass designed a new mark for Bell Telephone and Paul Rand created a mark for the American Broadcasting Company (ABC).

Designers were in two camps: the pure Modernist and those who practised a less strict, more playful and personal approach. The work of Push Pin Studio in New York, led by Milton Glaser and Seymour Chwast, was based on nostalgia and eclecticism. In Kansas City, Rob Roy Kelly led a revival of interest in antique wood type fonts from the late 1800s with his articles, specimen portfolio and book. In San Francisco, where the Age of Aquarius began, rock concert posters by Victor Moscoso, Stanley Mouse, Milton Glaser and Wes Wilson epitomized the psychedelic attitudes toward graphics in the 1960s. In New York, Herb Lubalin embraced the new photographic type composition process to create ads, magazines and print applications in which he based his approach around customized typographic combinations. When leaving advertising design at Sudler, Hennessey & Lubalin to set up his own firm, Herb Lubalin & Associates, Lubalin had a predisposition towards innovative and expressive typography. In this capacity he was clearly the

central force in what editor Harold Hayes called, 'The American School of Graphic Expressionism'. His friend Lou Dorfsman applied similar approaches in the print and on-air graphics at CBS Television. George Lois, too, was part of this expressive typographic venture in his advertising design. In 1962, Lois began designing a classic series of covers for *Esquire* magazine. They reflected controversial issues of the times such as the war in Vietnam, the assassinations in America, politics, race relations, the women's movement and 'America's obsessions with sex, dope and doom. Lois created covers that were statements that force-fed an irresistible taste of the great magazine's content.'[9]

Eclectic typographic forms also appeared in consumer magazines. The designer Otto Storch brought alive the pages of *McCall's*, a women's magazine, with his expressive typographic spreads. Designer Art Paul broke many cultural and social barriers with *Playboy* magazine. Herb Lubalin also treated provocative 1960s' issues of sexuality in his magazines, *Avant Garde* and *Eros*. Henry Wolf gave *Esquire* magazine a new vitality with covers and spreads that were very much in tune with the political and social change of the times. The taboos that the 'flower children' flaunted were reflected in topics and styles of the publishing world.

In an article in *Typographica* 5, Paul Rand summed up the changes in graphic design in the 1960s. He wrote, 'We have inherited from the great aesthetic revolution of the twentieth century the task of bringing to fruition the new ideas and forms which it introduced. This task is not only arduous but

BILL GRAHAM PRESENTS IN SAN FRANCISCO

TICKETS

Opposite, left & right The artists and designers of Push Pin Studios rejected Modernism in favour of nostalgia and a general return to the forms and styles of the past. This reactionary style was popular in the 1960s. The Push Pin logo on the left represents that style well. On the right is their packaging design for Artone Studio india ink.

Left Posters from California in the late 1960s were often done in a 'psychedelic' style, reflecting the influence of the age of 'sex, drugs and rock and roll'. This alternative graphic style harked back to Art Nouveau in its organic forms and was a departure from Modernism. Wes Wilson designed this poster in 1967 for a concert by Buffalo Springfield and the Steve Miller Blues Band.

less rewardingly glamorous than was participation in the original dramatic and dynamic insurgence. Consequently, many designers and typographers have shirked this task. Some have contracted the revolutionary habit of novelty-making: neglecting other aspects of design and indulging in a sort of perpetual juvenilism. Other designers, unable to escape the academic habit, have too soon crystallized the theories of the aesthetic revolution into a set of rules and dogma.'[10] Although the 1960s represented contrasting approaches to graphic design, many of the design traditions started then have endured to the present.

LESS IS A BORE

A special culture and set of circumstances created Modernism in the 1930s, and by the 1970s, that culture was gone. Yet a re-examination of Modernism and all that it entailed was underway. The Modernist goal of rational communication was a remaining ideal in corporations and among many established professionals. With all the breaking down of established traditions, younger designers questioned the need for functionality in graphic design. They preferred solutions that most often were personal expressions involving complexity, subjectivity and ambiguity. A new descriptor – post-Modernism – came into use. What had been in the 1950s and 1960s an international Modernist influence became transformed into 'New Wave', the first phase of post-Modernism.

The term 'post-Modern' was first used in reference to graphic design in the 1977 exhibit 'Postmodern Typography: Recent American Developments', curated by the designer Bill Bonnell and held at the Ryder Gallery in Chicago. In a 1981 article in *Print* magazine entitled 'Blips, Slits, Zits and Dots: Some (Sour) Notes on Recent Graphic Design', author Marc Treib observed that 'The avant-garde of 1980 is today's corporate style for companies from J.P.

Opposite Milton Glaser is a New York artist and designer who, for many years, has used a unique style of graphic design often based on art and nostalgia. He designed this famous 1967 poster for a concert by folk-rock singer Bob Dylan. The poster, which originally was sold with a record, became an icon of the revolutionary 1960s in America. It was effective because of its powerful communicative power. The profile said Dylan, the type said Dylan and the swirling, colourful hair reminds us of the popularity of long hair at this time.

Below Herb Lubalin's great love for typographic expression led him to many effective solutions. The use of the Slinky toy to replace the letter 'S' in this pharmaceutical ad for the William S. Merrell Company was a clever visual device which enhanced the impact and meaning in the ad. Lubalin would later leave this firm because of ethical problems promoting drugs which proved harmful.

Morgan to Pacific Telesis.'[11] In this changing context, it was clear then that corporations, which had embraced Modernism, did it because of practical marketing reasons and not because they believed in it philosophically.

The concept of Modernism faced challenges to its integrity by various critics. Author Alexander Dorner was specific with his concerns about Modernism. He wrote, 'As the diversity of the available material makes clear, it is time to replace the false picture of a Bauhaus style represented by a red square, right angles and a one-sided functionalism ranging from lower-case Dessau typography to sober architecture, with what is in reality a consistently colourful, pluralistic world and, in many cases, a wellspring of outstanding innovations in technology and art.'[12] Dorner's writings reflected precisely the sensibilities of the post-Modernists.

What Ellen Lupton has called 'the clarifying ethos of Modernism' was put to work in 1972, when President Nixon requested the National Endowment for the Arts to launch a 'Federal Design Improvement Program'. The overarching purpose of the initiative was to upgrade the quality and effectiveness of visual communications, interior and industrial design, landscaped environment and architecture in the United States Government. In 1974, the first assembly was entitled, 'The Design Necessity'. The conference emphasized design performance in response to human needs. Its organization was guided by a blue-ribbon group of design professionals: Ivan Chermayeff, Richard Saul Wurman, Ralph Caplan and Peter Bradford. Eventually, large-scale projects were parcelled out to design firms. John Massey of the Container Corporation of America designed a new visual identity programme for the Department of Labor, and Bruce Blackburn

Opposite Herb Lubalin designed this cutting-edge magazine, *Avant Garde*, in 1968. The magazine was provocative and controversial, perfectly characterizing the climate in America at this time. It was 'The Age of Aquarius' and the sexual revolution was in full swing. There was great opposition among the young and others to the war in Vietnam. *Avant Garde* magazine was the perfect match for its time and provided Lubalin with a powerful outlet for his experimentation. It featured articles on avant-garde art and design, politics, sexual expression and more. Its covers and page layouts were pure New York typographic expressionism, Herb Lubalin-style. Later, in 1970, Lubalin designed the full type font *Avant Garde* from the letters used on the masthead of the magazine.

Above left Chicago designer Art Paul created this identity mark for *Playboy* magazine in 1953. It still appears in the magazine after fifty years of use. It is powerful and memorable because of its simplicity.

Above right In 1974, as a part of the Federal Design Improvement Program, John Massey designed this identity mark for the United States Department of Labor. It was one of several projects that were contracted out to private design firms.

Above *Eros* magazine arrived on the scene in the early 1960s. It was designed by Herb Lubalin and contributed to the 'sexual revolution' underway at that time. It was a cutting-edge, provocative and risqué magazine. This issue from 1962 featured a cover and major photographic article on Hollywood actress Marilyn Monroe, with photographs by Bert Stern. Although very controversial, *Eros* was one of Herb Lubalin's great career accomplishments.

Opposite *Show* magazine appeared in the late 1950s, calling itself, 'The Magazine of the Arts'. Its art director was Henry Wolf, who had previously worked at *Harper's Bazaar*. Wolf created dynamic yet sensitive covers and layouts for *Show*. The magazine was short-lived, but nevertheless blended fresh, Modernist approaches to presentation with relevant content on the arts. This cover is from 1964.

SHOW

THE MAGAZINE OF THE ARTS

ONE DOLLAR
NOVEMBER 1964

IAN FLEMING'S LAST INTERVIEW

THE NEW HUMOR

THE WHITE HOUSE
Palace or Prison?

THEIR OWN STORIES:
Truman Capote, Morris West

BALLOT FOR BEST, WORST IN TV

UNDERGROUND MOVIES
How They're Made
(Our cover girl, one of their stars)

GLORIA VANDERBILT'S
First SHOW Story

GUIDE FOR PRO-FOOTBALL "TV WIDOWS"

Above left Willi Kunz was born in Switzerland and arrived in the United States in 1970. He played a major role in introducing new typography from the Basel School to the United States. This approach eventually became known as the 'New Wave' style. Kunz designed this identity and exterior sign for Merit gas stations in 1971. Distinctive in the American sales environment, the Merit signs are memorable in their unusual shape, truncated letterform and overall minimalist asymmetry.

Above right The American designer Dan Friedman was influenced by his schooling in Basel, Switzerland, and at the Ulm School in Germany. By 1970, he was teaching graphic design for Yale University's graduate programme. He created a typography project establishing a set of criteria by which students were required to design a series of square formats using text taken from weather reports. This project was documented in an article in *Visible Language* magazine in 1973. It was an historic project because it gave formal structure to an experimental typographic approach, thus indicating a move away from pure Modernist graphics.

Opposite Friedman designed this poster for the Yale Symphony Orchestra in 1973. The poster, while quite traditional in its aesthetic qualities, gives evidence of the beginnings of Friedman's move away from Modernist design toward a less formally structured approach. The influence of Armin Hofmann and Wolfgang Weingart was obvious. Friedman later would abandon graphic design and traditional Modernism for what he called 'Radical Modernism'.

created a new identity mark for the National Aeronautics and Space Administration (NASA). Other major federal assemblies and projects followed. This enlightened design programme, which began with such promise, lasted until 1980. With new political leadership came new priorities. The programme dramatically lost support, as did its sponsor, the National Endowment for the Arts.

THE MORE THE BETTER

The industrial use of design, public relations, advertising and media forms in the 1980s assumed an increasingly important role. More and more designers were open to trying anything new. The 'scales' of Modernism were being totally rejected in this decade of romance and subjectivity. How things looked was more important than knowing their essence. For young designers the ideal was that quality was perceived as obtainable through plurality and diversity.

In Basel, Switzerland, typographer Wolfgang Weingart was an important influence on American graphic design. Later, two of his students, Willi Kunz and April Greiman, used an approach to typography that was instrumental in the New Wave style. Although Weingart's roots were in Modernism, he taught that design is, above all, a matter of formal expression. American designer Dan Friedman had studied at Basel, but later, when teaching at Yale, he developed a formal process and structure with which to support expressive typography.

Beethoven
Piano Concerto No. 5
(,,Emperor'')
Michael Tusa,
Soloist

Brahms
Symphony No. 3

John Mauceri,
Director

Wagner

Prelude and Transfiguration
from Tristan und Isolde
Carolyne James,
Soprano

The
Yale
Symphony
Orchestra

Saturday
December 1,1973
8:30 in Woolsey Hall
Admission is free

Architects, especially from Europe, were also important influences on graphic designers. In Italy, the Memphis group, led by Ettore Sottsass, placed form before function and dwelled on exploring surface pattern, texture and colour. Designers were using many different colours; for example, the palette of the architect Michael Graves led to 'associations of poached salmon with puréed asparagus, best described as "gourmet graphics".[13] The most consistent criticism of the design of the 1980s was that it 'had become overly stylistic and fashion-oriented, that style is a gratuitous cosmetic applied without regard to content or purpose'.[14] There was an interest in an eclectic style. With the Push Pin artists as a model, three female designers – Paula Scher, Louise Fili and Carin Goldberg – led a 'retro' movement. Constructivist forms were unearthed and applied at will to contemporary commercial projects. The eclecticism of the 1980s looked to all styles as having meaning and relevance, while Modernism, in contrast, had tried to identify a unified and universal formal visual language of geometry which had been validated long before by the rational theories of psychology and communication.

For graphic designers, the digital revolution began in 1984 with the introduction of the Apple Macintosh computer. The technology quickly gained supporters as it bridged the creative design, typography and graphic arts/printing functions. Graphic design, which had been predominantly a hand-generated and photomechanical process, suddenly could be carried out in the virtual world of the computer. Everything about the field was different and there was no turning back. Design schools were forced to change courses and curricula. The design business itself saw major adjustments as typography and other graphic arts functions became the responsibility of the designer. A few designers quickly capitalized on this new tool. April Greiman produced complex, layered graphics, and Rudy VanderLans and Zuzana Licko at Émigré launched a company which produced experimental digital type fonts. David Carson brought a new freedom of personal typography to magazine design in the 1980s. His issues of *Ray Gun* and *Beach Culture* magazines represented a new typographic expressionism, rejecting soundly any remaining formal values of Modernism.

Increasingly, in the 1980s, women established important reputations in graphic design. Valerie Pettis and Deborah Sussman made important contributions. April Greiman's issue of *Design Quarterly* in 1986 'signaled the importance of the Macintosh for graphic design as well as recognizing the influence of a woman designer'.[15] An important influence in design education was Katherine McCoy, who taught at Cranbrook Academy of Art in Michigan between 1971 and 1995. Her philosophy, which began with Modernist roots, evolved over the years to the flexibility of post-Modernism. By the mid-1970s, McCoy was asking whether the idea of a long-range,

permanent aesthetic to design was inconsistent with America's preference for 'free choice'. The vernacular, rather than imported Swiss design, was indeed the indigenous American style. This increasing influence of female designers, begun in the 1980s, has continued to the present and has added dramatic vitality to the profession.

There was, in the 1980s, an increasing interest in the history of graphic design. Design magazines ran articles on the topic, and books were also beginning to appear on the shelf of popular bookstores. In 1983, Professor Philip B. Meggs published his *History of Graphic Design* which still, in its third printing, endures as the definitive survey of the field. At New York State's Rochester Institute of Technology in 1983, the first symposium on the history of graphic design was held. The keynote speaker, Massimo Vignelli, pleaded that without a serious study of history, theory and criticism, design would never achieve full recognition as a profession. In 1989, Dr Barbara Hodik and I published *Nine Pioneers in American Graphic Design*, a book which presents nine designers who otherwise have not been recognized for their Modernist accomplishments.

ANYTHING GOES

Post-Modern interest in the complexity of form, theoretical concerns and computer manipulation were well-entrenched in the mainstream of graphic design. Extended by the emergence of the digital revolution, graphic designers had powerful new tools with which they could create endless

Opposite Symbols and icons play an important role in effective information design. These pictograms were designed by Susan Kare in 1984 for the Apple Computer interface. They have stood the test of time. Still in use, the system has been expanded over the years as new software and functions have emerged. These marks are effective primarily because they are simple and easy to understand and use.

Below left William Longhauser designed this poster for an architectural exhibit, 'The Language of Michael Graves', in 1983. Longhauser, a designer and teacher at the Philadelphia University of the Arts, applied, in an appropriate manner, the visual vocabulary and emerging style of post-Modernism. The poster was visually active with dominant foreground letters in a shallow space atop a pattern of small letterforms in the background.

Below right Paula Scher is a designer at Pentagram in New York. In the 1980s, Scher's graphic design was often unabashedly eclectic and a mixture of earlier avant-garde and Modernist styles. She created this promotional poster for Swatch watches in 1985. The ad is clearly inspired by Herbert Matter's famous Swiss Travel poster from 1935.

April Greiman is a Californian designer, who was a leader in the move to a 'New Wave', post-Modern style and one who was innovative in the potential of digital media. She designed this digital self-portrait in 1987 for the Walker Art Center's magazine *Design Quarterly 133*. The poster included Greiman along with a personal collection of imagery and symbols.

visual effects. Many students and teachers saw the computer as the end rather than the means. Graphic design curricula at many schools were transformed from providing a formal visual education to a training course in using computer software. Formal values were gone from visual design.

A few believers in Modernist ideas were holding their own, often emerging among like-minded functionalists. Under the banner 'Long Live Modernism', Massimo Vignelli's position became stronger. He wrote, 'With the availability and capability of computers, we're now able to do the very best design and the very worst design.'[16] New Wave designers blamed Modernists such as Vignelli for putting them in 'the prison of the grid', while old-guard Modernists fretted about 'the chaos of the new aesthetic'. Paul Rand, always the Modernist at heart, clarified the situation in 1993: 'The language of the computer is the language of technology, not the language of design.' By then, the venerable sage of design believed, 'The tangibles of computer technology are obviously easier to cope with than the intangibles of design. Concepts and ideas spring from the mind and not from the machine.'[17]

Despite all the tensions in the field and the differences of philosophy over graphic design, positive signs of progress were present. Hypertext brought new opportunities for designers to apply their talents to interactive media applications. The user was able to move freely in a digital information environment, selecting linked pathways of layered data. Designed by Bill Hill, Terry Irwin and Jeff Zwerner in 1995, VizAbility was proof of this promise. It is an interactive CD-ROM programme designed to enhance creativity. The World Wide Web, or internet, was operational in 1986 and, by 2000, was available to over a third of North American households. This graphic environment has revolutionized communications as the user is connected virtually to anywhere in the world. Its multimedia capacities allow for sound, text, video and animation. The internet has grown so quickly that its design potential has not yet been realized, even though it offers great opportunities for the designer through its organization, reliability and complex networking functions.

A vestige of Modernist functionalism remains in those designers who specialize in information design. Statistician and writer Edward Tufte has brought new emphasis to this practical aspect of graphic design. He continues a tradition which was built in the 1940s upon the progressive works of Jan Tschichold, Otto Neurath, Will Burtin and Ladislav Sutnar. Since the 1970s, Richard Saul Wurman has added considerably through his books, conferences and businesses. Design firms such as Joel Katz and Associates in Philadelphia, and Agnew, Moyer and Smith in Pittsburgh specialize in making the information in a communication piece its priority.

Many contemporary designers have assumed a more socially responsible role for their design products. In effect they are replying to author and social

hanging at carmine st.

The year is 1979. And 1942. At a small neighborhood pool in Greenwich Village, a movie crew is time-tripping 30-odd years into the past to film "Raging Bull," the story of boxer Jake LaMotta. A gang of skinny, shirtless kids holler from a rooftop as the cameras follow Robert DeNiro (playing LaMotta). He buys a soda at the concession stand, and sits at a picnic table with the actor playing LaMotta's brother. Around the pool, women in one piece bathing suits relax in chaise lounges, and local Mafia heads in tropical shirts play cards. DeNiro has eyes for only one: the platinum blonde who sits at pool's edge, luxuriantly paddling her long legs in the cool water. The camera moves in for a close-up of her legs...and director Martin Scorsese calls.

scientist Lewis Mumford when he asked, while evaluating a building, 'What does it *do* to people?' Just as there has emerged a 'green party' in politics, there are designers who place an emphasis on designing products that are user-friendly and do not damage the environment. For example, the use of soy-based printing inks and recycled papers is becoming more common. Victor Papanek, through his writings and teaching, influenced many emerging designers in this direction. Increasingly, designers and others with this orientation are utilizing human factors and ergonomic principles in their design processes to ensure optimum functionality for the user.

THE END OF AN ERA

Two key Modernist designers died in their prime. Alvin Lustig died in 1955 and William Golden in 1959. The 1960s saw the loss of Lester Beall, Egbert Jacobson and A.M. Cassandre. The list grows in the 1970s with the passing of Dr M.F. Agha, Josef Albers, Lucian Bernhard, Joseph Binder, Will Burtin, Alexey Brodovitch, Albert Kner, Ladislav Sutnar, Charles Eames, Eileen Gray and Jan Tschichold. During the 1980s, the list included Herbert Bayer, Jean Carlu, Raymond Loewy, Herbert Matter, Charles Coiner, Allen Hurlburt, Dr Robert Leslie and Herb Lubalin. In the 1990s, the losses included Hans Barschel, George Giusti, Leo Lionni, Erik Nitsche, Saul Bass, Paul Rand,

David Carson is a designer who, in the 1990s, signalled the beginning of post-Modernism in graphic design from his California base. This two-page spread was from *Beach Culture* magazine, appearing in 1991. The article was titled 'Hanging at Carmine Street', and the layout reflected Carson's use of typography for unstructured, artful expression.

formcontent

see

read

authenticsimulated

mythologytechnology

culturalnatural

vernacularclassical

geometricbiomorphic

personaluniversal

globallocal

FIND structuralist

discoursedialog

AS D—SCOURS—

verbalvisual

languagethought

conceptualaesthetic

symbolicdiagrammatic

image

text

analyzesynthesize

artscience

Design: Katherine McCoy Typesetting: MacType Net Printing: Signet

Bradbury Thompson, Gene Federico and Cipe Pineles. The first generation of Modernist designers is now all gone. Their absence sadly denies emerging designers of necessary role models and direct connections with those men and women who, at mid-century, through their lives and works, blazed uncharted trails in establishing the profession of graphic design.

THE AMERICAN DESIGN ADVENTURE

It has been eighty years since the title 'graphic designer' was first used and forty years since Modernism was at its peak in the United States. Between the years 1930 and 1955, the first real generation of designers created the field of graphic design. These designers assumed a central role in the conception and development of a new form of printed communications. With the beginning of a new millennium has arrived a generation of designers who have not known of a world without computer graphics. These designers, with all the tools and possibilities of the digital age, are a pivotal force in both communications and marketing. With this enabling technology, designers have the potential to become major participants of collaborative problem-solving teams. 'Today they are a core force in moving messages – ideas – products – people. Their graphics may appear simple, but never underestimate the effectiveness.'[18] Massimo Vignelli envisions an even

Opposite Cranbrook Academy of Art in Bloomfield Hills, Michigan, was a centre for post-Modern influences in American graphic design in the 1970s and beyond. Designer/educator Katherine McCoy was the primary force in this new direction away from Modernism. This poster for Cranbrook was a typical example of the complex kind of theoretical imagery which emerged from this school, its teachers and students in the 1970s and 1980s.

Above VizAbility was a CD-ROM product developed in 1995 by MetaDesign in San Francisco. Its designer was Jeff Zwerner. It was an excellent example of interactive media design intended to educate users on the topic of creativity and problem-solving. An effective use of integrated still visual and video imagery with audio, VizAbility featured a very functional interface design, appropriate to the spirited format. The CD-ROM was included in a coordinated package with sketchbook and user manual. This product was seen by many as an excellent example of interactive digital media applied to educational purposes.

greater evolutionary role for the designer: that of an educator in society, one who enhances the visual environment by producing models of value for business and industry.

Author Robert Hughes observed a curious fact of art history that may or may not be a coincidence. 'Fresh creative cycles after periods of exhaustion often fall between the years '90 and '30. History proves that the first rush of creative ebullience was followed by winding-down, academization and a sense of stagnancy which fostered doubts about the role, the necessity and even the survival of art.'[19] Looking back, this theory works for the development and implementation of Modernism in the art and design of the twentieth century and bodes well for the times ahead as new forms become evident.

William James wrote, 'What really exists is not things made but things in the making.' If there is one lasting force of Modernism, it is the designer's necessity for self-reflection. Looking in the mirror, one can not only analyse one's own methodology of design, but also see at once the context in which Modernism historically emerged. The importance of the designer's process of thinking and working, therefore, is an enduring legacy of the Modernists and a central means by which designers have the opportunity of creating design artefacts that are timeless. In this way, all designers can pay homage to this important historical period and continue to seek meaning in it for themselves.

Notes

Preface

1 Paul Rand, *Design Form and Chaos* (New Haven, Yale University Press, 1993), p.3.

Chapter 1

1 David L. George, *Best Loved Poems* (Garden City, Doubleday & Company, Inc., 1952) p.108.
2 Robert Hughes, *The Shock of the New* (New York, Alfred A. Knopf, 1991), p.13.
3 *Ibid.*, p.9.
4 *Ibid.*, p.10.
5 *Ibid.*, p.10.
6 Steven Heller and Seymour Chwast, *Graphic Styles* (New York, Harry N. Abrams, Inc., 1988), p.89.
7 Rob Roy Kelly, *Design Quarterly/56* (Minneapolis, Walker Art Center, 1963), p.11.
8 'Art Deco', *Smithsonian*, October 2000, p.87.
9 David L. George, *Best Loved Poems*, p.108.
10 Robert Jensen, *Design Quarterly* (Minneapolis, Walker Art Center, 1970), p.7.

Chapter 2

1 Steven Heller and Seymour Chwast, *Graphic Styles*, p.89.
2 *Ibid.*, p.89.
3 Terence Riley, *The International Style and the Museum of Modern Art* (New York, Rizzoli, 1992), p.45.
4 Rob Roy Kelly, 'The Early Years of Graphic Design at Yale University' (Proceedings of the Annual National Symposium, Graphic Design Education Association, Chicago), 24 June 1989.
5 Leon Friend, *Graphic Design* (New York and London, McGraw-Hill Book Company, 1936).
6 *Typography – U.S.A.* (New York, Type Directors Club, 1959), p.18.
7 *Ibid.*, p.19.
8 Martin Grief, *Depression Modern, The 30's in America* (New York, Universe Books, 1975), p.43.
9 'Aging Modernism', *Critique*, Spring 2000, pp.30–1.

Chapter 3

1 Jan Cohn, *Creating American* (Pittsburgh, University of Pittsburgh Press, 1989), p.713.
2 Lester Rondell, *28 Annual of Advertising and Editorial Art* (New York, Art Directors Club of New York, 1949).
3 Roy R. Behrens, 'On Merle Armitage, The Impresario of Book Design', *Ballast Quarterly Review* (Spring 2001), p.8.
4 William Addison Dwiggins, *Layout in Advertising* (New York and London, Harper and Brothers Publishers, 1928), p.193.

5 *Books For Our Time* (New York, Oxford University Press, 1951). p.31.
6 Edmund Gress, *Fashions in American Typography* (New York, Harper and Brothers Publishers, 1931).
7 *Some Examples of the Works of American Designers* (New York, Dill and Collins Company, 1931).
8 William Addison Dwiggins, *Layout in Advertising*, p.193.
9 William J. Thomas (ed.), *Graphic Forms, The Arts as Related to the Book* (Cambridge, MA, Harvard University Press, 1949), p.27.
10 Philip B. Meggs, *A History of Graphic Design* (New York, John Wiley and Sons, Inc., 1998), p.312.
11 Andy Grundberg, *Brodovitch* (New York, Harry N. Abrams, Inc., 1989), p.42.

Chapter 4

1 Clarence P. Hornung, 'Clarence P. Hornung – An Interview', *PM 32* (April 1937).
2 —, *Trade=Marks* (New York, Caxton Press, 1930).
3 Will Burtin, 'Integration – The New Discipline of Design' (New York, The Composing Room, Inc., 1949).
4 Rollo May, *The Courage to Create* (New York, Bantam Books, 1976).
5 James R. Mellow, *Walker Evans* (New York, Basic Books, 1999).
6 Maurizio Scuderio and David Lieber, *Depero, Futurista and New York* (Roverto, Italy, Longo Editore, 1986), p.13.
7 *Typography – U.S.A.*, p.17.
8 *Vanity Fair* (New York, Conde Nast Publications, August 1935).
9 Dr. M.F. Agha, 'The Geneology of Modern Art', *Vanity Fair*, 1932.
10 Steven Heller and Seymour Chwast, *Graphic Styles*, p.89.
11 Lester Beall, 'Space, Time and Content', *Eye*, Spring, 1997.
12 *Ibid.*
13 Ladislav Sutnar, 'Design Ladislav Sutnar' (New York, The Composing Room, Inc., 1947).
14 Walter Paepcke, *Modern Art in Advertising* (Chicago, Paul Theobald, 1946).
15 *Great Ideas* (Chicago, Container Corporation of America, 1976).
16 Percy Seitlin, *AD* (New York, The Composing Room, Inc., June/July 1941).
17 Charles Coiner, 'Clipping Board', *Advertising and Selling*, no.17, 1956.
18 Lorraine Wild, 'Exploring the Roots of Modern American Graphics', *Industrial Design*, January/February 1983, pp.24–9.
19 Percy Seitlin, *PM*, January 1939/1940, p.26

(New York, The Composing Room, Inc.).
20 Interview with Hayward Blake, Evanston, Illinois, 12 November 2001.
21 Douglas C. McMurtrie, *Modern Typography and Layout* (Chicago, Eyncourt Press, 1929), p.189.
22 Edward M. Gottschall, 'Part Two', *Typographic i* (New York, International Typographic Composition Association, Inc., 1971).
23 Steven Heller and Seymour Chwast, *Graphic Styles*, p.183.
24 Arthur Pulos, *American Design Ethic* (Cambridge, MA, MIT Press, 1983).
25 Clarence P. Hornung, 'Clarence P. Hornung – An Interview'.
26 Henry Dreyfuss, *Architectural Form*, 1938, p.87.
27 Steven Heller and Seymour Chwast, *Graphic Styles*, p.155.
28 *Ibid.*
29 Arthur Pulos, *American Design Ethic*.
30 *Typography – U.S.A.*, p.35.
31 Martin Grief, *Depression Modern*, p.26.
32 Will Burtin, 'Integration – The New Discipline of Design'.

Chapter 5

1 *Art and Industry* (London, Austin Cooper, 1939).
2 Jessica Helfand, *Paul Rand, American Modernist* (Falls Village, Conn., William Drenttel, 1998), p.37.
3 Philip B. Meggs, *A History of Graphic Design*, p.68.
4 Laszlo Moholy-Nagy, *AD* (New York, The Composing Room, Inc., February 1941).
5 Herb Lubalin, 'Herb Lubalin's Typography Issue', *Print*, May/June 1979.
6 Lester Rondell, *Twenty-Eighth Annual of Advertising and Editorial Art*.
7 Charles Coiner, *Twenty-Eighth Annual of Advertising and Editorial Art*.
8 Laszlo Moholy-Nagy, *AD*, February 1941.
9 Jessica Helfand, *Paul Rand, American Modernist*, p.37.
10 Richard Neutra, *Survival Through Design* (New York, Oxford University Press, 1954).
11 Edward M. Gottschall, 'Part Two', *Typographic i*.
12 Mildred S. Friedman (ed.), *Graphic Design In America, A Visual Language History* (New York, Harry N. Abrams, Inc., 1989), p.111.
13 Philip B. Meggs, 'The Rise of the Modernists', *Print*, November/December 1989, p.71.
14 Percy Seitlin, *AD* (New York, The Composing Room, Inc., June/July 1941), p.32.
15 Lorraine Wild, 'Modern American Graphics', *Industrial Design*, July/August

1983, p.53.
16 Will Burtin, 'Integration – The New
 Discipline of Design'.
17 *Alvin Lustig, An Exhibition of His Work*
 (New York, The Composing Room, Inc.,
 1949).
18 Edward Frey, *Print*, 1969.
19 Philip B. Meggs, 'The Rise of the
 Modernists', p.89.
20 Andy Grundberg, *Brodovitch* (New York,
 Harry N. Abrams, Inc., 1989), p.43.

Chapter 6

1 Edward M. Gottschall, 'Part Two',
 Typographic i.
2 *Ibid.*
3 Lorraine Wild, 'Design in Gray Flannel',
 Print, November/December 1989, p.105.
4 Lester Beall, *Lester Beall* (Brookfield
 Center, Conn., Lester Beall, Inc., 1960).
5 Westinghouse Graphics Identification
 Manual (Pittsburgh, Westinghouse Electric
 Company, 1961).
6 *Idea 60*, 'A Generation of Graphic Arts'
 (Tokyo, Seechoro Ogawa).
7 Robert Hughes, *The Shock of the New*
 (New York, Alfred Knopf, 1980), p.376.

Chapter 7

1 Edward M. Gottschall, 'Part Two',
 Typographic i.
2 *Ibid.*
3 *Ibid.*
4 *Ibid.*
5 *Ibid.*
6 *Ibid.*
7 *Print*, January/February 1977, p.117.
8 Ellen Lupton, 'The 1970's: Age of the Sign',
 Print, November/December 1989, p.151.
9 George Lois, *The Art of Advertising*
 (New York, Harry N. Abrams, Inc., 1977).
10 *Print*, 1977, p.115.
11 *Print*, 1981, p.163.
12 Robert Venturi, Denise Scott Brown, Steven
 Izenour, *Learning from Las Vegas*
 (Cambridge, MA, MIT Press, 1977), p.53.
13 Alexander Dorner, *Bauhaus 1919–1928*
 (New York, Museum of Modern Art, 1928).
14 J. Abbott Miller, 'The 1980's, Postmodern,
 Postmerger, PostScript', *Print*,
 November/December 1989, p.185.
15 *Ibid.*
16 *Ibid.*
17 Lecture by Massimo Vignelli, Rochester
 Institute of Technology, Rochester, New
 York, May 2000.
18 Paul Rand, *Design Form and Chaos*, p.99.
19 Robert Hughes, *The Shock of the New*
 (1980) p.425.

Bibliography

Books

Art of the Twenties (New York, The Museum of Modern Art, 1979).

Banham, Reyner, Theory & Design in the First Machine Age (New York: Praeger, 1960).

Bayer, Herbert, Kunst und Design in Amerika 1938–1985 (Berlin, Bauhaus Archiv, 1986).

Bel Geddes, Norman, Horizons (Boston, Little Brown and Company, 1932).

Berthon, Simon and Robinson, Andrew, The Shape of the World (New York, Rand McNally, 1991).

Books For Our Time (New York, Oxford University Press, 1951).

Bucovich, Mario, Manhattan Magic (New York, M.B. Publishing Company, 1937).

Burns, Aaron, Typography (New York: Reinhold Publishing Company, 1961).

Chanzit, Gwen F., Herbert Bayer & Modernist Design in America (Ann Arbor, MI, UMI Research Press, 1987).

Cheiro, Palmistry For All (New York, G. P. Putnam's Sons, 1916).

Cohn, Jan, Creating American (Pittsburgh, University of Pittsburgh Press, 1989).

Covering the 60's: George Lois & the Esquire Era (New York, Monacelli Press, 1996).

Dada (Forth Worth, Texas, Fort Worth Art Museum, 1981).

Dorner, Alexander, Bauhaus 1919–1928 (New York, Museum of Modern Art, 1928).

Douglas, Ann, Terrible Honesty: Mongrel Manhattan in the 1920's (New York, Farrar, Straus and Giroux, 1995).

Dreyfuss, Henry, Architectural Form (1938).

Dwiggins, William A., Layout in Advertising (New York, Harper & Brothers, 1928).

Feininger, Andreas, New York in the Forties (New York, Dover Publications, Inc., 1978).

Fifty Years of Graphic Design in Chicago, (Chicago, Society of Typographic Arts, 1977).

Friend, Leon, Graphic Design (New York and London, McGraw-Hill Book Company, 1936).

George, David, L., Best Loved Poems (Garden City, Doubleday & Company, Inc., 1952).

Gottschall, Edward M., Typographic Communications Today (Cambridge, MA, MIT Press, 1989).

Mildred S. Friedman (ed.), Graphic Design In America, A Visual Language History (New York, Harry N. Abrams, Inc., 1989).

Great Ideas (Chicago, Container Corporation of America, 1976).

Gress, Edmund, Fashions in American Typography (New York, Harper and Brothers, 1931).

Grief, Martin, Depression Modern, The 30's in America (New York, Universe Books, 1975).

Grundberg, Andy, Brodovitch (New York,

Harry N. Abrams, Inc., 1989).

Helfand, Jessica, Paul Rand: American Modernist (Falls Village, Conn.: William Drenttel, 1998).

Heller, Steven and Chwast, Seymour, Graphic Styles (New York, Harry N. Abrams, Inc. 1988).

Hennessey, William J., Russel Wright American Designer (Cambridge, MA, MIT Press, 1983).

Hitchcock, Henry R., The International Style (New York, W. W. Norton and Company, 1966).

Hornung, Clarence P., Trade=Marks (New York, Caxton Press, 1930).

Horsham, Michael, 20's and 30's Style (Secaucus, NJ, Chartwell Books, 1989).

Hughes, Robert, The Shock of the New (New York, Alfred Knopf, 1980).

Jobling, Paul & Crowley, David, Graphic Design (Manchester and New York, Manchester University Press, 1996).

Johnson, J. Stewart, American Modern (New York, Harry N. Abrams, Inc., 2000).

Kelly, Rob Roy, American Wood Type 1828–1900 (New York, Van Nostrand Reinhold Company, 1969).

Kery, Patricia F., Art Deco Graphics (New York, Harry N. Abrams, Inc., 1986).

Lawson, Alexander, Anatomy of a Typeface (Boston, David R. Godine Publisher, 1990).

Leger & the Modern Spirit (Houston, TX, Houston Museum of Fine Arts, 1982).

Livingston, Alan & Isabella, Graphic Design + Designers (London: Thames & Hudson, 1992).

Lois, George, The Art of Advertising (New York, Harry N. Abrams, Inc., 1977).

Looking Closer (New York, Allworth Press, 1994).

Machine Art, (exh. cat., New York, Museum of Modern Art, 1934).

McMurtrie, Douglas C., Douglas C. McMurtrie, Bibliographer & Historian of Printing (Metuchen, NJ, Scarecrow Press, 1979).

—, Modern Typography & Layout (Chicago, Eyncourt Press, 1929).

May, Rollo, The Courage to Create (New York, Bantam Books, 1976).

Meggs, Philip B., A History of Graphic Design (New York, John Wiley & Sons Inc., 1998).

Mellow, James R., Walker Evans (New York, Basic Books, 1999.

Modern Art In Advertising (Chicago, Paul Theobald, 1946).

Morgan, Hal, Symbols of America (London, Penguin Books, 1986).

Neumann, Eckhard, Functional Graphic Design in the 20's (New York, Reinhold

Publishing Company, 1967).

Neutra, Richard, Survival Through Design (New York, Oxford University Press, 1954).

Official Souvenir Book of The New York World's Fair (New York, Exposition Publications, Inc, 1939).

Pevsner, Nikolas, Pioneers in Modern Design (London, Penguin Books, 1936).

Phillips, Lisa, Frederick Kiesler (New York, W. W. Norton and Company, 1989).

Pulos, Arthur J., American Design Ethic (Cambridge, MA, MIT Press, 1983).

—, The American Design Adventure (Cambridge, MA, MIT Press, 1988).

Powell, Polly & Peel, Lucy, 50's and 60's Style (Secaucus, NJ, Chartwell Books, 1988).

Rand, Paul, Design Form & Chaos (New Haven, Yale University Press, 1993).

Remington, R. Roger & Hodik, Barbara J., Nine Pioneers in American Graphic Design (Cambridge, MA, MIT Press, 1989).

Riley, Terence, The International Style: Exhibition 15 & The Museum of Modern Art (New York, Rizzoli, 1992).

Scudiero, Maurizio & Lieber, David, Depero: Futurista and New York (Rovereto, Longo Editore, 1986).

Sembach, Klaus-Jürgen, Style 1930 (New York, Universe Books, 1971).

Smith, Terry E., Making the Modern Industry, Art & Design in America (Chicago, University of Chicago Press, 1993).

Some Examples of the Works of American Designers (New York, Dill & Collins Company, 1931).

Sparke, Penny, Design in Context (London, Bloomsbury Publishing, 1987).

The Arrival of Bookmaking (New York, The Colophon, 1938).

The Complete Book of Covers from The New Yorker 1925–1989 (New York, Alfred A. Knopf, 1989).

The Fat and The Lean – American Wood Type in the 20th Century (Washington, DC, National Museum of American History, 1983).

The New Vision (Chicago, Aperture, c.1984).

This Fabulous Century (New York, Time Life Books, 1989).

Thomajan, P. K., American Type Designers, Rochester (New York, Rochester Institute of Technology, 1956).

Thomas, William J. (ed.), Graphic Forms, The Arts as Related to the Book (Cambridge, MA, Harvard University Press, 1949).

Tschichold, Jan, The New Typography (Berkeley, CA, University of California Press, 1987).

Twenty-Eighth Annual of Advertising and Editorial Art (New York, Art Directors Club

of New York, 1949).

Twitchell, James B. *Twenty Ads That Shook the World* (New York, Crown Publishers, 2000).

Typographic Directions (New York, Art Direction Book Company, 1964).

Typography – U.S.A. (New York, Type Directors Club, 1959).

Venturi, Robert, Scott-Brown, Denise and Izenour, Steven, *Learning From Las Vegas* (Cambridge, MA, MIT Press, 1977).

Weston, Richard, *Modernism* (London, Phaidon Press Ltd, 1996).

Periodicals

Advertising & Selling.

Art and Industry, 1939.

Ballast Quarterly Review, Spring 2001.

CA, The Journal of Commercial Arts, August 1959.

Communication Arts, March/April 1999.

Critique, Spring 2000.

Design Quarterly 56, 1963.

Design Quarterly, 1970.

Eye, Spring, 1997.

Gottschall, Edward M, *Typographic I* (New York, International Typographic Composition Association, 1971.

Idea 9, International Advertising Art: January 1955.

Idea 60, International Advertising Art.

Idea 90, International Advertising Art, September 1968.

Idea 100, International Advertising Art, 1970.

Idea, 30 Influential Designers of the Century, March 1984.

Lorraine Wild, 'Exploring the Roots of Modern American Graphics', *Industrial Design*: January/February 1983 (pp.24–9).

—, 'The Birth of a Profession', *Industrial Design,* July/August 1989.

Moholy-Nagy, Laszlo, *AD* (New York, The Composing Room, Inc., February 1941).

PM (New York, The Composing Room, Inc., 1939/40).

Print, 'Great Graphic Designers of the Twentieth Century', January/February 1969.

Print, 'A Treasury of Print', May/June 1969.

Print, February 1977.

Print, 'The Graphic Revolution in America', May/June 1979.

Print, 1981.

Print, 'Fifty Years of Graphic Design', November/December 1989.

Smithsonian, October 2000.

Vanity Fair, 1932.

Unpublished articles

Kelly, Rob Roy, 'The Early Years of Graphic Design at Yale University' (Chicago, IL, 24 June 1989).

Smith, Charles N., 'Structuralism' (Rochester, New York, 1986).

Catalogues/invitations

AD (New York, The Composing Room, Inc., 1941).

Beall, Lester, *Lester Beall Inc.* (Brookfield Center, CT, Lester Beall, Inc., 1960).

Burtin, Will, 'Integration – The New Design Discipline' (New York, The Composing Room, Inc., 1949).

Lustig, Alvin, 'An Exhibition of his Work' (New York, The Composing Room, Inc., 1949).

Sutnar, Ladislav, 'Design Ladislav Sutnar' (New York, The Composing Room, Inc., 1947).

'Visual Communication techniques – Steinweiss, A-D Gallery, New York, 14 October–28 November 1947.

Manuals

Westinghouse Graphics Identification Manual (Pittsburgh, PA, Westinghouse Electric Company, 1961).

Interviews/lectures

Clarence P. Hornung, *PM* (New York, The Composing Room, Inc., April 1937).

Hayward Blake, Evanston, Illinois, 12 November 2001.

Massimo Vignelli, Rochester, New York, 15 May 2000.

Index

A

A-D Gallery 69, 71, 130
 'Advance Guard of Advertising Artists'
 exhibition 70
 Alvin Lustig exhibition 131
 Modernist exhibition 130
 Will Burtin exhibition (1949) 130–1
Aalto, Alvar: New York World's Fair, Finnish
 Pavilion 80
AD magazine (*formerly PM*) 69
advertising 37, 39, 78, 102, 104, 137–8, 159–60
Advertising Arts 75–6
Agha, Dr Mehemed Fehmy 39, 56, 76, 98
 Vanity Fair, cover selection 56
 Vanity Fair, full-bleed cover (1940) 57
Alajalov, Constantin:
 The New Yorker magazine, cover (1938) 49
 The New Yorker magazine, cover (1946) 134
Albers, Josef 26, 59
American Institute of Graphic Arts (AIGA) 70,
 74, 98, 142
American Type Founders (ATF) 39
Anatomy for Interior Designers (Alvin Lustig)
 112, *113*
Archipenko, Alexander 59
architecture 17, 22
Armitage, Merle 40–1
 George Gershwin 41
 Modern Dance 51
Armory Show, New York 69
Art Deco 26, 35, 79
Art and Industry: 'The Artist's Function in
 Time of War' 84
Art Nouveau 26, 28, 39
Arts and Architecture magazine 118
Arts and Crafts Movement 13, 26, 37
Arts et Metiers Graphiques magazine 75, *75*
Auden, W.H. 48
Austria 17
Avant Garde magazine 170

B

Ballet (Alexey Brodovitch) 127
Barr, Alfred H. 53, 74
Barr, Frank 70
Barschel, Hans 59
 Fortune magazine 58
 PM magazine 59
Bass, Saul 62, 123
 Bell Telephone corporate identity *164*
 The Man With the Golden Arm 124
 Psycho 123
Bauhaus 26, 28, 29, 56, 58, 66, 98
 booklet cover (Herbert Bayer) 27
 Dessau building (Walter Gropius) 26
 promotional poster (Herbert Bayer) 26
Baumeister, Willy 22

Bayer, Herbert 26, 59, 63, 68, 69, 70, 73,
 130, 136
 'Bauhaus 1919–1928' exhibition 68, 69
 Bauhaus booklet cover 27
 Bauhaus promotional poster 26
 'Great Ideas of Western Man' *140*
 Harper's Bazaar 131
 PM magazine 69
 wartime advertisement *130*
 world geographic atlas 100
Beall, Lester 31, 63, 66, 69–70, 74, 78, 150–1
 corporate logos *152*
 'Don't Let Him Down' 90, *93*
 'Hitler's Nightmare' *94*
 PM magazine 63
 Rural Electrification Administration posters
 64–5
 self-promotion advertisement 63
 Sterling Engraving, brochure cover 52
 'The Bauhaus Tradition and the New
 Typography' 49, 50
 'Will there be war?' *95*
Beckmann, Max 16
Bel Geddes, Norman: *Horizons* 51, 84
Benton, Morris F. 40
Berlewi, Henryk 26
Berlin 16, 52
Bernhard, Lucian 39
'Betty Boop' 34, *35*
Binder, Joseph 60
 Fortune magazine 60
 New York World's Fair 80
 U.S. Army Air Corps 90
Black Mountain College 132
Bob Dylan concert poster (Milton Glaser) *168*
Boeing advertisement (Charles Coiner) 87
Böhm, Ernst 59
Bradley, Will 40
Braque, Georges 17
Brennan, Frances 98
Breuer, Marcel 59
Brodovitch, Alexey 55, 60, 72, 98, 125, 127, 155
 Arts et Metier Graphiques Magazine 75
 Ballet 127
 brochure cover 72
 Harper's Bazaar 5, 54, 55, *126, 127*
 Madelios advertisement 28
 Observations 154, 155
 Portfolio magazine *137*
Burchartz, Max 22
Burtin, Will 52, 67, 73, *73*, 82, 98–9, 101, 146
 instructional books, Office of War
 Information 84, *84*, 87
 'Integration – The New Discipline in
 Design' exhibition 130–1
 New York World's Fair 81
 Scope magazine *132, 145*

C

Caillaud, Louis: *Mise en Page 77*
Cambridge, Massachusetts 72
Carlu, Jean 70, 71
 Container Corporation of America,
 advertisements 67
 'Production: America's Answer' 88
 'Repaying America's Riches' *104*
Carson, David: *Beach Culture* magazine *179*
Cary, Melbert B. (Jr) 38, 45
Cassandre, A.M. 60, 62, 68, 71
 Container Corporation of America 67
 Harper's Bazaar 60
Catalog Design Progress 66, 121
Caulkins, Ernest 78
CBS identity 148–9
Charm magazine 141
Chase Manhattan Bank corporate identity 165
Cherryburn Press 38
'Chicago 27' 74, 132
Chicago 72, 123
chromolithography 13
 tobacco packaging 14
Chrysler Building, New York 35
Chrysler Corporation, 'Airflow' automobile
 79, *79*
Citizens Defence Corps, symbols (Charles
 Coiner) 87, *87*
Citrohan House (1922; Le Corbusier) 22
Club Dada 17
Coca-Cola 14
Cohen, Arthur A. 28
 The Avant-Garde in Print 25
Coiner, Charles 39–40, 62, 68–9, 90, 102, 104
 Boeing advertisement 87
 Citizens Defence Corps, symbols 87, *87*
 'Clipping Board' 71–2
 National War Fund 86
 U.S. Government symbol 49, 146
The Composing Room, Inc. 71, 128
Condé Nast magazines 98
Constructivists 17
Container Corporation of America 40, 45, 62,
 67, 68–9, 104, 105
 48 States campaign *104, 105*
 Center for Advanced Research in Design 123
 'Great Ideas of Western Man' 69, 138
 world atlas 100
Coolidge, Calvin 34
copywriters 39
corporate design 120
corporate identity 146, 149, 150, 152–3, 162–3
Cranbrook Academy of Art 176, *180*
Craw, Freeman: *The Journal of Commercial Art*
 145
Crystal Palace 8
Cubism 17
Czechoslovakia 17

D

Dada movement 16–17, 28
Danziger, Louis 32, 123, 125
 Flax Art Supplies trademark 125
 'The First Generation' poster 125
Debussy, Claude 16
De Harak, Rudolph 155, 161, *163*
Depero, Fortunato 45, 53–4
 Modernist art exhibition poster 53
 Vogue magazine 53
Design Quarterly magazine 49
designers: and the war effort 84, 86, 90, 92, 97
Deskey, Donald: New York World's Fair
 souvenir book 82
De Stijl movement 25, 26, 28
Deutscher Werkbund 26
Dexel, Walter 22, 25
Die Brücke (The Bridge) 16
digital revolution 176–8
Direction magazine 62–3, 108, 109
Disney Hats advertisement (Paul Rand) *106*
Dix, Otto 16
Domela, César 22
Dreyfuss, Henry: Twentieth Century Limited
 train 79, *79*
Dwiggins, William Addison 41, 45–6
 Layout in Advertising 41
 One More Spring 41

E

Eames, Charles 112, 140
Eastman Kodak Company, Brownie camera 78
eclecticism 174, 176
education, design 72–3, 131–3
 overseas influences 153, 155
Eiffel, Gustav 8
Eiffel Tower 8, *8*, 17
'Elementare Typographie' (Jan Tschichold) 23
émigré designers 52–62
Eros magazine 166, *172*
Esquire magazine 62, 158, 159, 166
Evans, Walker 46

F

Feasley, Milton: slogans for Listerine and Ivory
 Soap 39
'Federal Design Improvement Program'
 171, 174
Federico, Gene 62, 72, 73, 84, 141, 181
 'Great Ideas of Western Man' 138
 Woman's Day magazine *138*
Film Fun magazine 37
Film Guild Cinema 46
'The First Generation', exhibition poster 125
Fitzgerald, F. Scott 35
Flax Art Supplies, trademark 125

Fleischer, Max: 'Betty Boop' 34, 35
fonts:
 adoption of sans serif 22, 39, 45
 Bernhard Gothic 39
 Futura 22, 26, 39, 100
 Helvetica *161*, 162
 historic fonts revived 40
 Kabel 39
Ford logo 45
Fortune magazine 58, 60, 67, 92, 96, 101, 119,
 129, *144*
Freud, Sigmund 11
Friedman, Dan 174
 Visible Language magazine 174
 Yale Symphony Orchestra 175
Friend, Leon 72
 Graphic Design 31
Futurism 17, *18*

G

Gage, Robert: Levy's advertisement *137*
Geigy 162
General Motors Futurama: 'Highways and
 Horizons' exhibit, New York World's Fair 80
German Expressionism 16
Germany 16–17, 22, 26
Giedion, Sigfried 6
Giusti, George 60, 90, 142
 Fortune magazine 92
Glaser, Milton 164
 Bob Dylan concert poster *168*
Golden Section/Golden Mean 26
Golden, William 31–2, 56, 59, 62, 146, 149
 CBS advertisement *148*
 CBS corporate identity *148*
Goldsholl, Morton 123
 'Faces and Fortunes', animated film 123
 Paul Theobald & Company, trademark *122*
 Society of Typographic Arts 122
Goudy, Frederick W. 13, 43
 bible *12*
 Village Press 38, 49
graphic design:
 first use of term 14, 41
 Modernist characteristics 30–1
 new generation of designers 134
 renamed 'commercial art' 31
Great Depression 31, 35, 48, 79
Great Exhibition 8
Greif, Martin: *Depression Modern* 82
Greiman, April 174, 176, *178*
Grohe, Glenn: 'He's Watching You' 90, *90*
Gropius, Walter 22, 26, 59
 Bauhaus building, Dessau 26
 begins 'American Bauhaus' 72
Grosz, George 16, 17
Guess, Edmund: *Fashions in American
 Typography* 43

H

Hadank, O.H.W. 59
Hambridge, Jay: *The Elements of Dynamic
 Symmetry* 43
Harding, Warren G. 34
Harper's Bazaar 54, 55, *55*, 60, 126, 127, 131
Harrison, Richard Edes: *Fortune* magazine
 maps 92, 96, 97
Hausmann, Georges Eugène, Baron 17
Hausmann, Raoul 16
 Club Dada 17
Heartfield, John 17
Helvetica typeface *161*, 162
Hoch, Hannah 16
Hofmann, Hans 16, 53, 63
Holland 17, 26
Holmes, Oliver Wendell 69
Holton, Gerald: 'peace symbol' 158
Hornung, Clarence P. 50–1, 79
 Handbook of Designs & Devices 50–1, *51*
 Trade=Marks 50
Hughes, Robert 8

I

industrial design 78–9
Industrial Revolution 8, 10, 11
information design 120, 123
International Business Machines (IBM) 45
International Style 112
Italy 17, 176
Itten, Johannes 26

J

Jacobson, Egbert 43–4
Jacobs, S.A. 41–2
 Ampersand 43
 Orphan of Eternity 42
Japan 155
Jensen, Robert 14
Johnson, Philip 29
Jones, Bobby 35
Jones, L.B.: slogan for Eastman Kodak 39
Jones, Owen: *The Grammar of Ornament* 11
The Journal of Commercial Art 145

K

Kandinsky, Wassily 26
Kare, Susan: Apple Computer symbols 176
Kauffer, E. McKnight 66, 70
 48 States campaign *105*
Kelmscott Press *13*
Kent, Rockwell 40
Kepes, György 59, 70, 71, 97
 PM magazine 61
Kiesler, Frederick 45

design for theatre exposition, New York *46*
 Film Guild Cinema, poster *46*
Kirchner, Ernst Ludwig 16
Klee, Paul 26
Knoll Furniture 115, 128
Koch, Professor Rudolph 39
Kodak 10, *10*, 78, 81
Kunz, Willi: Merit gas stations sign *174*

L

Le Corbusier 32
 Citrohan House 22
 Pavillon de l'Esprit Nouveau 26
Léger, Fernand 11, 71
 Container Corporation of America 105
Leslie, Dr Robert 69, 128
Liberman, Alexander 75
 Vogue magazine 99
 VU magazine 28
Liebowitz, Matthew 71
Life magazine 67, 100
Lionni, Leo 69, 71, 142, 179
 Fortune magazine 144
 'Keep 'Em Rolling' 91
Lissitsky, El 28, 63
 exhibition flyer, Berlin 29
 Merz, self-publication 19, 25
 Pelikan Ink, advertisement 29
Lois, George 158–9
 Esquire magazine 159
Longhauser, William: exhibition poster *177*
Look magazine 41
Lubalin, Herb 164–6
 Avant Garde magazine *170*
 Eros magazine *172*
 Merrell Company advertisement *169*
 trade advertisement *160*
Lucky Strike cigarettes, advertisement *37*
Lustig, Alvin 112, 120, 123, 131, 132
 Anatomy for Interior Designers 112, *113*
 Arts and Architecture magazine *118*
 Fortune magazine *119*
 Frank Perls Gallery, exhibition
 announcement *114*
 Growth of the Soil *116*
 History as the Story of Liberty *117*
 Knoll advertisement *115*
 Roteron Company, helicopter design *115*
 scale model of exhibition *133*
 self-promotion piece *114*
 The Mind and Heart of Love *117*

M

McCall's magazine *143*
McKoy, Katherine 176, 181
McMurtrie, Douglas: *Modern Typography and
 Layout* 39, 76

Madelios, advertisement for (Alexey
 Brodovitch) *28*
magazines, design 75–8
Mangan, James T.: *DESIGN, The New
 Grammar of Advertising* 76, 78
Man Ray 40
The Man With the Golden Arm *124*
marketing research 138
Massey, John: Department of Labor identity *171*
Matter, Herbert 70, 71, 128
 Fortune magazine *101*, *129*
 Knoll Furniture advertisements *128*
May, Rollo 52
Meggs, Philip B. 46
Meidner, Ludwig 16
Merz, self-publication (El Lissitsky) 19
Metropolitan Museum of Art: exhibition of
 industrial art 78–9
Middleton, R. Hunter 38
Mies van der Rohe, Ludwig 22
Mobil corporate identity *164*
Moholy-Nagy, Laszlo 26, 40, 59, 63, 70, 98, 123
 experimental photograph *59*
 forms 'New Bauhaus' 72–3, 132
Morris, William 13, *13*
Mueller, Otto 16
Museum of Modern Art 74
 'Bauhaus 1919–1928' exhibition 68, 69
 exhibition of Lester Beall posters 69–70
 graphic design displays 127–8

N

National War Fund poster *86*
Neurath, Otto 22
'The New Typography' 26
The New Yorker magazine 48, 49, 53, *134*
New Wave style 174, 178
New York 52, 62, 63, 67
New York Art Directors Club 39, 70, 74, 102
 Ninth Annual of Advertising Art 46
New York World's Fair 79, 80, 81, 82
 Finnish Pavilion 80
 'Highways and Horizons' exhibit 80
N.W. Ayer advertising agency 68, 71

O

Observations (Alexey Brodovitch) 154, 155, *155*
Olivetti 146, *147*
'Organs of the United Nations', poster-chart *66*
Oud, J.J.P. 22

P

Paris 17, 52
Paris Exposition 8, 51
Parrish, Maxfield 40
Paul, Art: Playboy logo *171*

Paul Theobald & Company, trademark *122*
Paxton, Sir Joseph 8
Pechstein, Max 16
Pegay, Charles 14
Pelikan Ink 20–1, 29
Pemberton, John S. 14
Penfield, Edward 40
Pevsner, Sir Nicholas: *Pioneers of the Modern
 Movement* 51
Philadelphia 123
photography:
 and advertising 137
 documentary photography 67
 full-bleed photographs 56, 100
 Modernist preference for 22, 26, 37, 40
Picasso, Pablo 17
Pineles, Cipe 53, 142, 149, 181
 Charm magazine *141*
 Seventeen magazine 102, *103*
Pintori, Giovanni 146, *147*
Plakastil style 39
PM magazine (*later AD*) 59, *61*, 63, 69, 70, 75,
 81, *81*
 'The Bauhaus Tradition and the New
 Typography' *49*, 50
Pop Art 158
Portfolio magazine 137
postwar optimism 131, 136
post-Modernism 169, 171
Pound, Ezra 16
Press of the Woolly Whale 38
private presses 37–8
Prohibition 35
propaganda 90
Push Pin Studios 164, *166*, 176

R

railroad poster *10*
Rand, Paul 6, 31, 62–3, 70, 73, 149–50,
 166–7, 178
 48 States campaign *104*
 *A Design Student's Guide to the New York
 World's Fair* 81, *81*
 Direction magazine *108*, *109*
 Disney Hats advertisement *106*
 fabric design *107*
 Frazer automobiles advertisement *134*
 IBM corporate identity *150*
 RCA 107
 Stafford Fabrics advertisement *107*
 Thoughts on Design *107*, 141
 Westinghouse corporate identity *151*
Renner, Paul 39
Ring neue Werbegestalter 22, 26
'roaring' twenties 34–5
Robinson, Frank: Coca-Cola logo *14*
Rogers, Bruce 38, 38–9, 43
Rohde, Gilbert 81

Rondell, Lester 39
Roosevelt, Franklin Delano 48
Roteron Company, helicopter design 115
Russia 17
Russian Constructivists 17, 26

S

Salter, George 40, 59
Sandusky, L. 49
Scandinavia 17
Scher, Paula: Swatch poster 176, 177
Schmidt-Rottluff, Karl 16
Schwitters, Kurt 17, 19, 22, 26, 30, 63
 Pelikan Ink advertisement 20–1
Scope magazine 132, 145
Seventeen magazine 102, 103
Show magazine 173
Sinel, Joseph: *A Book of American Trade-Marks
 & Devices* 45
Society of Typographic Arts (STA; later the
 American Center for Design) 74, 122, 142
Solomon R. Guggenheim Museum 74
Somenzi, Mino: *Futurismo* newspaper 18
Steichen, Edward 40
Stein, Gertrude 8
Steinweiss, Alex 62, 72
 AD magazine 69
 album cover 62
 camouflage periodical 97
 'Hands off the Americas' 85
Stieglitz, Alfred: *Camera Work* 40
Storch, Otto 143, 166
Strand, Paul 40
Surrealism 53, 66
 and Modernism 112
Sutnar, Ladislav 30, 59–60, 67–8, 70, 81–2, 123
 addo-x 153
 Catalog Design Progress 66, 121
 Czech Pavilion, World's Fair 59, 81
 Nejmensi dum 30
 'Organs of the United Nations' 66
 personal identity mark 153
 Sweet's Catalogs, trademark for 121
 'Transportation of Oil' 120
Sweet's Catalogs 67–8, 121
Switzerland 17, 161, 162, 174

T

Teague, Walter Dorwin 43, 81
 Eastman Kodak Baby Brownie camera 78
television 159
Thompson, Bradbury 31, 62, 78, 112
 stamp design 112
 Washburn College Bible 112
 Westvaco Inspirations for Printers
 110–11, 142
 'Westvaco' logo 112

Tiege, Karl 26
Tolmer, A.: *Mise en Page* 76
Tschichold, Jan 22, 62
 divorce statistics diagram 22
 'Elementare Typographie' 23
 The New Typography 22, 31
Twentieth Century Limited train 79, 79
typography:
 antique forms 166
 designers take over 51
 eclectic forms 166
 typographic expressionism 161–2

U

Updike, Daniel Berkeley: *Printing Types Their
 History, Forms & Use* 40
U.S. Army Air Corps, enlistment poster 90

V

Van Alen, William: Chrysler Building 35
Vanity Fair 39, 39, 53, 56, 57, 76, 76, 100
Vignelli, Massimo 158, 162, 177, 178
 New York Subway map 162
 The Herald 163
Village Press 38
VizAbility 178, 181
Vogue magazine 35, 36, 53, 53, 99
VU magazine 28, 75

W

Walker Arts Centre, Minneapolis 49
Watt, James 10
Weingart, Wolfgang 174
 Visible Language 161
Westinghouse Electric Company logo 45
Westvaco Inspirations for Printers 110–11, 142
'Westvaco' logo 112
Whitman, Walt 8, 14
Whitney, Gertrude Vanderbilt 73–4
Whitney Museum of American Art 74
Wilson, Wes: concert poster 167
Wolf, Henry: *Show* magazine 173
women 34–5, 176–7
World's Fair, Paris 8
World War I 16, 17
Wright, Frank Lloyd 16, 32, 112
 on American Modernism 32

Y

Yale University:
 Graphic Design programme 31
 School of Art 132–3, 155

Z

Zwart, Piet 22
 experimental composition 24
 poster for real estate office 25

Picture credits

Acknowledgements

'I quote others only the better to express myself.'
Michel Montaigne

To M. Suzanne Remington

My thanks to all those who have helped me directly and indirectly with the writing and production of this book: the list is long but first in line are those pioneer Modernists who created this history. The generosity of these individuals and their families is truly appreciated. Their willing donations of archives and information over the years have been the foundation for my research and interpretive efforts: Walter Allner, Doty Attie, Hans Barschel, Lillian Bassman, Bob Cato, Elaine Lustig Cohen, Charles Coiner, Mildred Constantine, Louis Danziger, Estelle Ellis, Mary Faulconer, Helen and Gene Federico, Carol Burtin Fripp and Robert Fripp, Alberto Paolo Gavaschi, Robert Giusti, Tom Golden, Marc Kaczmarek, Edward Kasper, György Kepes, Leo Lionni, Harvey Lloyd, Joyce Morrow, Lida Moser, Cipe Pineles, Paul and Marion Rand, Alex Steinweiss, Ladislav Sutnar, Joanna Beall Westermann, Bradbury Thompson and Frank Zachary. Massimo Vignelli has, over the years, been consistently supportive of my various initiatives in the service of design history.

Lisa Bodenstedt, my colleague in this book project, has been involved from the beginning. Her writing, organizational talents, concern for detail and digital skills have made all the difference. M. Suzanne Remington diligently edited the first draft, provided enthusiasm and loving support for the book at every stage. Stephen Munson, M.D., has guided me to new understandings of myself. My valued colleagues, Professor Bruce Ian Meader who critiqued the prototype book layouts and Professor Douglas Manchee who was always available with wise counsel, technical and otherwise. Shannon Taggart at RIT's Educational Technology Center did an excellent job of making many of the illustration transparencies. Kari Horowicz at RIT's Wallace Library has provided ongoing support for my interpretive efforts. She has shared my vision of preserving the works of the Modernist pioneers of this period.

Jo Lightfoot, Commissioning Editor at Laurence King Publishing, made this book a reality. Cleia Smith contributed greatly in the editing and production stages.

And finally, remembering the line, 'If you are a teacher, by your students you will be taught', I thank my students, who have responded to this history and seen its value in their lives. They inspire me by their interest, their appreciation for the anecdotal and their patience at seeing too many slides and listening to me lecture for far too long.
R. Roger Remington